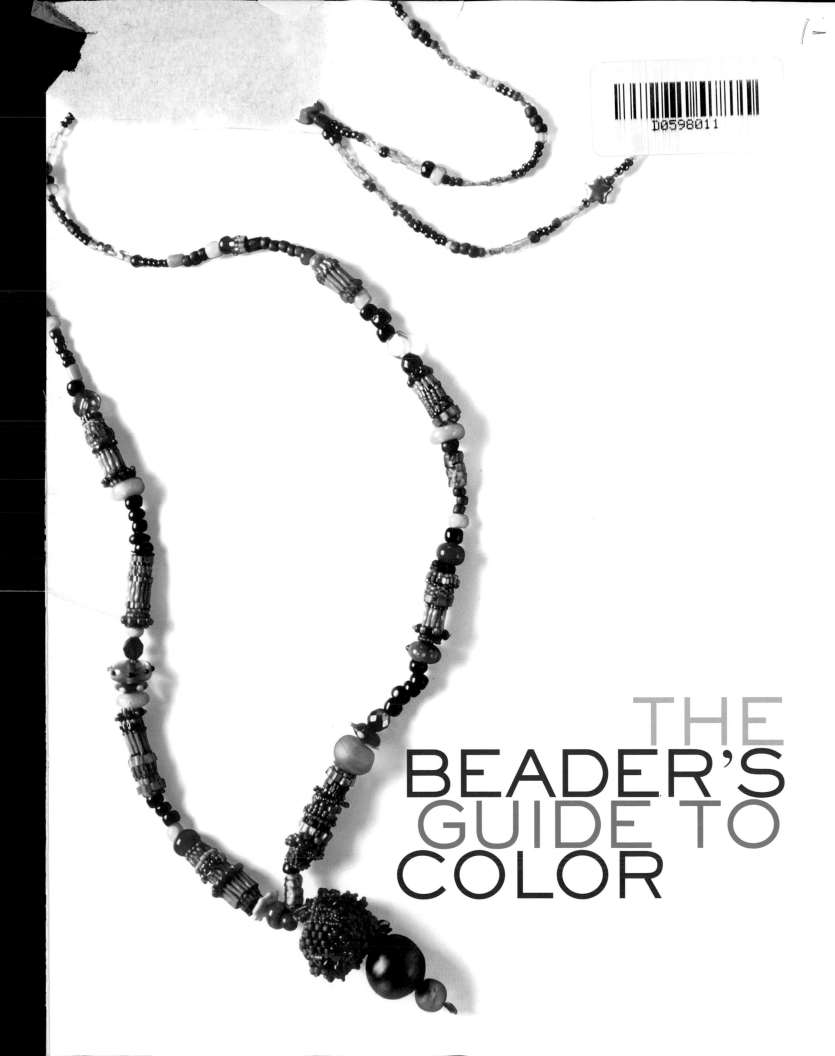

THE
BEADER'S
GUIDE TO
COLOR

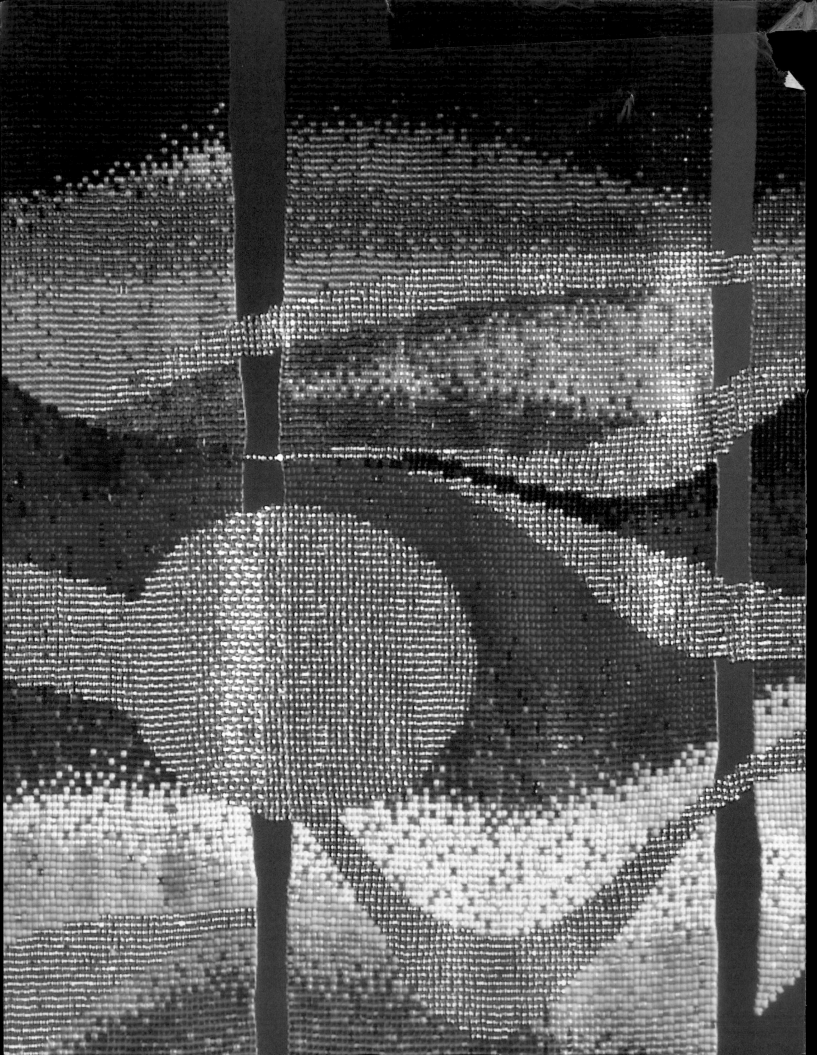

THE BEADER'S GUIDE TO COLOR

MARGIE DEEB

WATSON-GUPTILL PUBLICATIONS
NEW YORK

To Ginny, my eternal teacher and friend,
who speaks to my heart in color.

First published in 2004 by Nielsen Business Media,
a division of The Nielsen Company
770 Broadway, New York, NY 10003
www.watsonguptill.com

LIBRARY OF CONGRESS CATALOGING-IN-PUBLICATION DATA

Deeb, Margie.
 The beader's guide to color / Margie Deeb.
 p. cm.
 Includes bibliographical references and index.
 ISBN 0-8230-0487-2 (alk. paper)
 1. Beadwork. 2. Color in design. I. Title.
 TT860.D425 2004
 745.58'2--dc22

 2003027599

Senior Acquisitions Editor: Joy Aquilino
Editor: Michelle Bredeson
Designer: Alexandra Maldonado
Production Manager: Hector Campbell

Manufactured in the United Kingdom

First printing, 2004

5 6 7 8 9 / 12 11 10 09 08 07

Cover: "The Heart of Her" by Margie Deeb.
Page 1: "Fandango" by Jeanette Cook.
Page 2: "That Silver Ribbon of Road" by Margie Deeb; loomwork by Margie
Deeb and Frieda Bates.
Page 5: "Trellis" by Frieda Bates.
Page 10: "Spectral Tapestry" by Margie Deeb; loomwork by Frieda Bates.
Page 11: "Family Ties" by Frieda Bates.
Page 68: Iris brooch by Karen Paust.
Page 69: "Lovely Lacey Lavender Lavalier" by Elizabeth Anne Scarborough.
Page 98: "Dance of the Undines" by Margie Deeb; loomwork by Frieda Bates
and Margie Deeb.
Page 99: "Shepherdess Angel" by Mary Tafoya.
Page 122: "Jungle Study" by Margo Field.
Page 123: "Into the Vortex" by Margie Deeb.

I invite you to visit my Web site for more color and beading inspiration and
information: www.margiedeeb.com

Or feel free to write me at:
Margie Deeb
P.O. Box 70211
Marietta, GA 30007

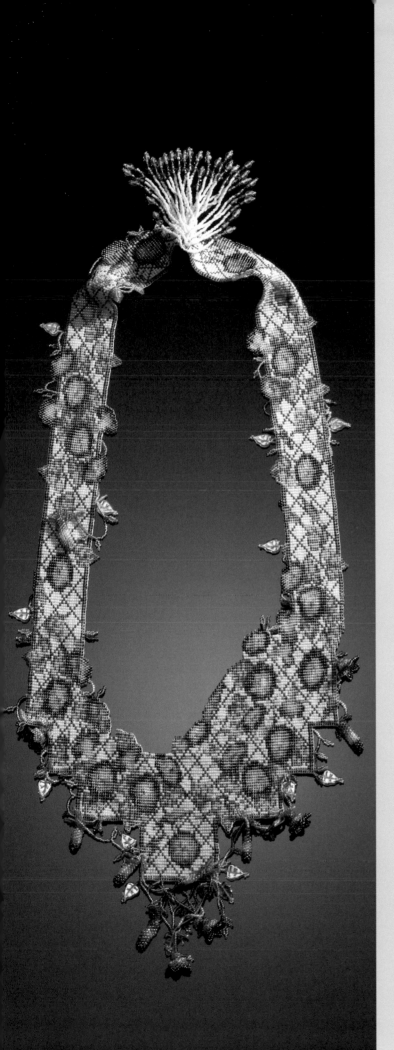

ACKNOWLEDGMENTS

I gratefully acknowledge the following people who played an essential part in making this book whole:

Frieda Bates, a most energetic, talented, patient, and giving artist and dear friend. This book would not have come to being without her expertise and skill, impeccable work, engineering help, gracious generosity, and love.

Ginny Deal, Sylvia Thorne, and Cameron Milles for their generosity, creativity, skill, and belief in me.

SaraBeth Cullinan for her patience, knowledge, creativity, and consistent help.

Mary Hicklin for her extraordinary creativity and attention to detail.

Lela Holcomb, Bobbie Neal, and Sandy Beatty for giving so freely of their beading skills and time.

Laurel Fleming for generously sharing her expertise in seasonal color.

DeeDee Jacobs and Carolyne Miller for their generosity and hospitality at the Heron Cove Guest House.

Allison O'Neill for her generosity.

Judith Durant for her encouragement.

My husband, Darren Nelsen, for his support, encouragement, kindness, patience, and love.

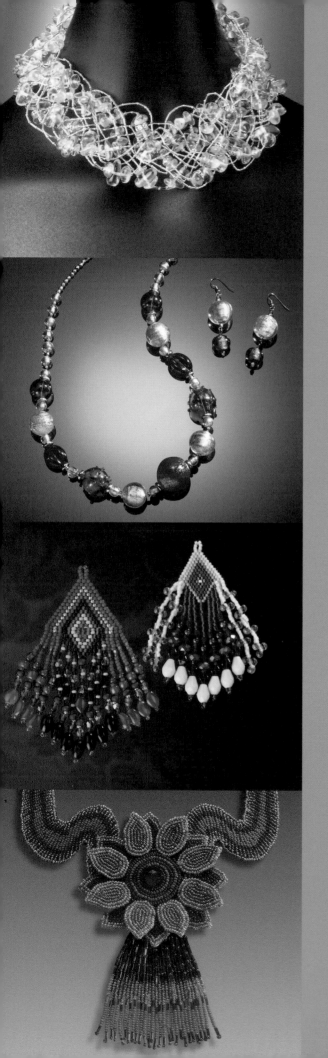

CONTENTS

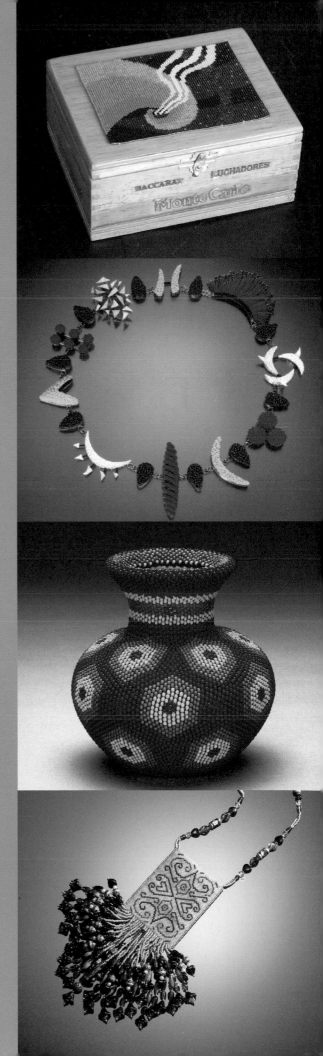

INTRODUCTION

"Only those who love color are admitted to its beauty and imminent presence. It affords utility to all, but unveils its deeper mysteries only to its devotees."
—*Johannes Itten*

You're embarking on a fascinating journey. Whatever your current relationship with color may be, it will expand. If all you know of color is what you like and what you don't like, then you are in for a fantastic ride. If you've had a love affair with color for years and, like me, swoon before the paint chip display at the hardware store, it gets even better.

This journey will teach you more than how to choose and combine colors harmoniously. You'll begin to understand how color is far more than a visual phenomenon. Your awareness of its impact and power will increase. Your curiosity will be piqued and your senses will be opened. Your creativity will be stimulated. You'll find inspiration in the most unlikely places. And as you increase your artistry, you may be surprised at how much you learn about yourself.

To be born with a good sense of color is a fine gift, but it isn't necessary for mastery of color. The world's greatest colorists—Delacroix, van Gogh, Matisse, and Cézanne, to name a few—diligently studied the tangible and theoretical aspects of color. They spent their lifetimes experimenting, applying, and integrating that knowledge into their personal artistry.

You can learn to use color in extraordinary ways. You already possess the most important tools: your passion and your sense of wonder. Learn the tangibles, and let your passion and wonder take you where knowledge cannot. Let color thrill you. Seek its magic. Talk to it and listen with all your senses. Thus begins your never-ending journey into the magic and mystery of color. As one of my students said at the end of a class, "Color is so amazing! I will never look at anything the same way again!"

Let the journey begin!

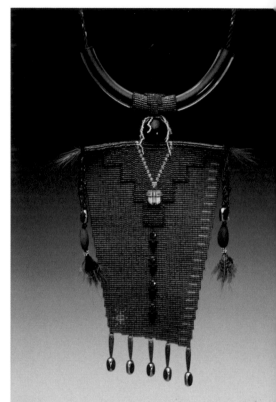

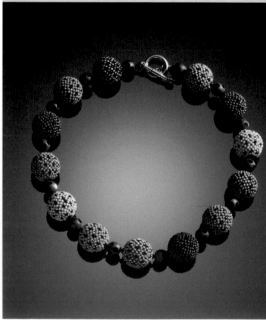

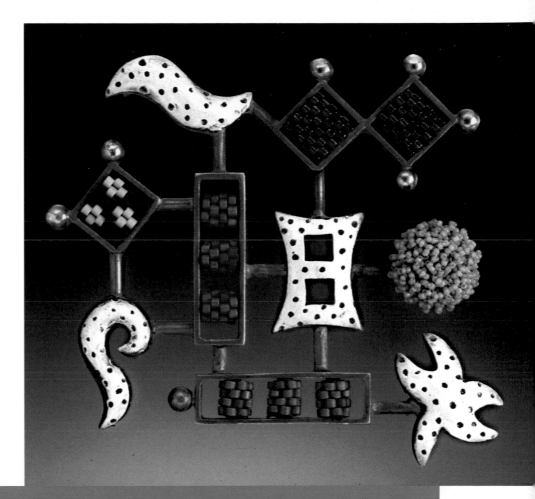

"Shaman" (top left) by Don Pierce pairs a muted green with its complements and near complements, achieving a color scheme that is both gentle and extraordinary. Loomwork on glass.

Jacque' Owens puts black to work in a circus of beaded beads (bottom left), where it makes a strong foundation that ties the different hues together. Right-angle weave.

Valerie Hector positions colors in an orderly visual matrix in her "Sinology" series pin (right).

ABOUT THE PALETTES

Palettes are offered to illustrate concepts and color interactions, and to suggest specific combinations of bead colors and surface finishes.

A bead's exact hue cannot be accurately reproduced in ink on a two-dimensional surface for several reasons. The surface finish of a bead reflects varying degrees of the colors of both the surrounding beads and the environment. Highly reflective beads reflect more light and less color. Less reflective beads display more color and less light.

The palette colors in this book are printed in four-color ink formulas that approximate Delica bead colors as closely as possible. Delica beads are cylindrical Japanese seed beads. Because they are identified by number, they are the choice for specifying exact hues and finishes. However, it is not necessary to use Delicas for these palettes. Match the color swatches and descriptions with any brand or size beads you like.

Each palette suggests approximate amounts of specific colors to be combined. Accordingly, the swatches are designed proportionately. The largest area of color is considered the background or dominant color, and is listed

first. It is depicted in the large oval shape surrounding the other colors. Use more of this dominant color than of any others in the palette.

One or two narrow, vertical strips designate the accent colors. Use the least amount of these colors.

The colors sandwiched above the background oval and beneath the accent strip are the subdominant colors, and there may be one, two, or three of them in a palette. Their suggested quantity is more discretionary. In deciding how much of these to employ, use your eye, your intuition, and this general rule of thumb: less than the background color, more than the accent color.

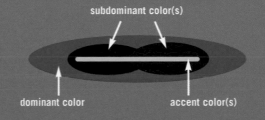

subdominant color(s)

dominant color accent color(s)

SAMPLE PALETTE

COLOR THEORY
&
DESIGN

The phrase "color theory" summons images of teachers droning abstractions such as "complementary" and "analogous" to the incessant hum of fluorescent lights. The mere thought of it may tempt you to skip this section altogether, paging quickly forward to the "good stuff"— colorful beads!

But learning just a little bit of color theory will help you choose the perfect blue bead among the hundreds of blue beads available. Being able to recognize what degree of blue and red make up a particular violet cane glass bead will allow you to choose just the right blue druks to harmonize with it. And despite the pedantic ring of the word "theory," the history of color is fluid, flexible, and, yes, fascinating.

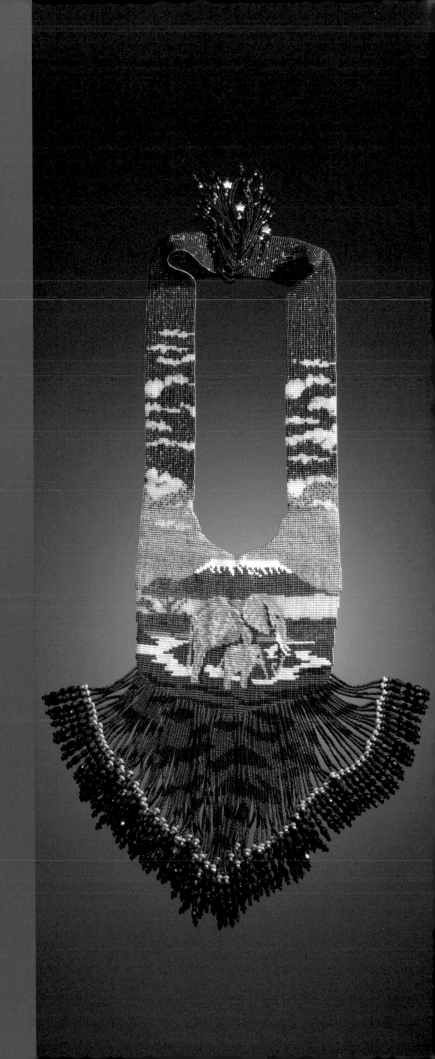

COLOR WHEELS

Traditional color theory holds that as light strikes the surface of an object, such as a bead, some of that light is reflected back and some of it is absorbed. A bead seen as blue reflects back the blue wavelengths of the spectrum. All the remaining colors of the spectrum are absorbed.

Color theory has progressed throughout history with technological advances in physics and other sciences. The ancient Greek philosopher Aristotle espoused the theory that combining black and white could produce all colors. Renaissance painter Leonardo da Vinci never decided exactly how many primaries existed, believing there were either six or eight. In 1613, François d'Aguillon, a Jesuit teacher, declared yellow, red, and blue to be the three primaries. Fifty-three years later, Sir Isaac Newton expanded that number to seven fundamental colors, based on his discovery that light projected through a prism forms a spectrum of seven dominant bands of color. Newton then took that spectrum and twisted it into a circle, giving us the foundation of the color wheel.

ADDITIVE COLOR

In the late 1700s, physicist Thomas Young discovered that red, green, and blue light mixed together produce white light. Today we consider red, green, and blue to be the primaries of the *additive* spectrum of visible light.

The additive system is based upon emitted light—the kind put out by devices such as TV monitors or theatrical stage lights. Computer monitors display color in "RGB," which stands for the tiny red, green, and blue lights that form all the different colors you see when you look at the screen.

In additive color mixing, colored lights are added together to create other colors. For example, when the beam of a blue spotlight is added to that of a red spotlight, magenta light is produced.

SUBTRACTIVE COLOR

The *subtractive* system of color is based upon reflected light—light that is reflected back from a surface (paper, canvas, beads, etc.) and not absorbed by an object or other pigment. Subtractive colors are opaque or transparent pigments and dyes that absorb (subtract) some light waves and reflect back others. When blue and red pigments are mixed on white paper, the light waves of all but violet are absorbed. Thus the violet waves are reflected back to your eye.

Yellow, red, and blue have long been considered the *primaries* of subtractive color mixing because they are pure; they have no other colors in them. Theoretically all other colors can be created by mixing combinations of yellow, red, and blue. This mixing of pigments or dyes to create other hues is called the subtractive method and is the basis for the traditional artist's color wheel.

PRIMARY COLORS

A *secondary* color is created by combining two primary colors. For example, in the subtractive spectrum, red and yellow (both primary colors) mixed together create orange (a secondary color). Yellow and blue mixed together form green; blue and red together form violet. By studying a color wheel, you can see why theory says all colors can be made from just three primary colors.

But color theory is just that—theory. In practice this is not true. The photographs and diagrams on the pages of this book require four colors—not three—to produce them accurately. These colors are referred to as the ink primaries of cyan, magenta, and yellow, plus black. These three colors are the three secondary colors of the additive system. This method of achieving color is known as the four-color ink printing process. The mixing of cyan, magenta, and yellow creates a broader and more

luminous range of colors than is possible from combining the traditional yellow, red, and blue primaries of the artist's wheel. It is difficult, if not impossible, for example, to mix vibrant purples and red-violets using a true blue and red pigment. Because magenta is more luminous than red, using it as a primary rather than red greatly expands the range of reds, pinks, and purples.

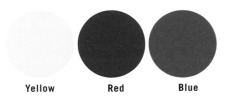

Yellow Red Blue

Traditional artist's pigment primaries: yellow, red, and blue.

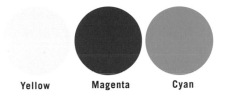

Yellow Magenta Cyan

Ink color wheel primaries. These afford a greater range of hues and luminosity than traditional primaries.

The subtractive primaries of the traditional artist's color wheel (see page 14)—yellow, red, and blue—combine to create the secondaries of orange, violet, and green.

The additive primaries—green, red, and blue—combine to create the secondary colors yellow, magenta, and cyan.

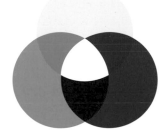

The secondary colors of the additive color system now become the primaries of the ink color wheel (see page 15)!

Mixed together in equal parts, two primary colors create a secondary color. In this case, the ink wheel primaries magenta (M) and yellow (Y) are mixed to form the secondary warm red in the center of this diagram.

A primary and a secondary combined form a tertiary. A primary and a tertiary combined equally form a quaternary. A secondary and a tertiary combined in equal parts form a quinary.

The designations important to remember are primary, secondary, and occasionally tertiary. The rest become nuances of the above.

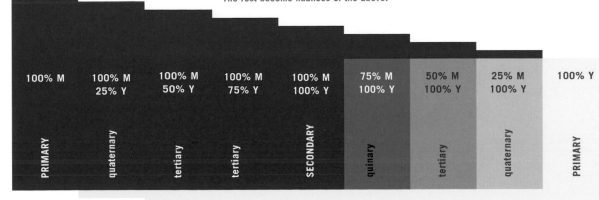

100% M	100% M 25% Y	100% M 50% Y	100% M 75% Y	100% M 100% Y	75% M 100% Y	50% M 100% Y	25% M 100% Y	100% Y
PRIMARY	quaternary	tertiary	tertiary	SECONDARY	quinary	tertiary	quaternary	PRIMARY

TWO COLOR WHEELS

Color wheels are a sequential arrangement of hues. They are useful in learning how colors (hues) relate to each other. Understanding and using them can spark your imagination and kindle your creativity, making your color choices extraordinary. As art historian Faber Birren wrote, "The facility [the color wheel] gives to the eye and mind well serves anyone who wishes to give wings to his fancy."

The traditional primaries and the ink primaries form the basis of two workable color wheels, each having its advantages. Both are used throughout this book. As you become familiar with them, you'll notice their subtle nuances in color composition. As a result you'll be able to make more knowledgeable color choices.

Below is the traditional artist's pigment color wheel. Its primaries are the familiar yellow, red, and blue taught in grade school. The ink wheel (on page 15) uses yellow, magenta, and cyan as its primaries. In this book, the traditional artist's wheel will always appear as a wheel of circles, while the ink wheel will always appear as a wheel of colored wedges.

On both wheels, shades of each color are placed toward the center. Shades are created by darkening a hue. In this case they are darkened by adding black. Toward the outside of the circle, the colors

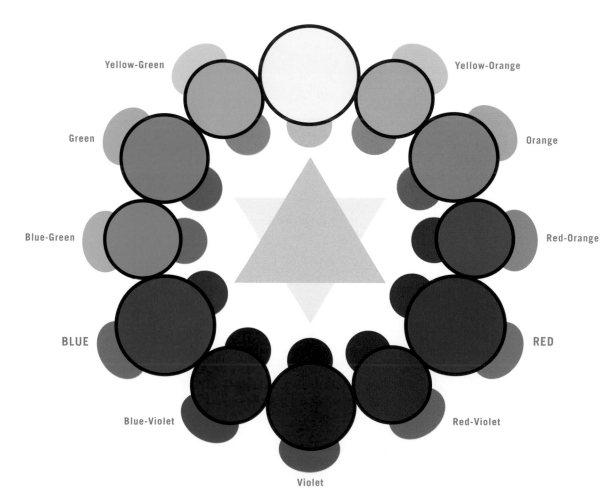

YELLOW

Yellow-Green Yellow-Orange

Green Orange

Blue-Green Red-Orange

BLUE **RED**

Blue-Violet Red-Violet

Violet

Traditional artist's pigment color wheel. The darker triangle in the center points to the primaries: yellow, red, and blue. The lighter triangle points to the three secondaries: orange, violet, and green. Lighter tints (outside each pure hue) were created by adding white. Darker shades (inside each pure hue) were created by adding black.

are lightened with the addition of white, becoming tints.

On the traditional artist's wheel the largest circles indicate primary colors. Secondary colors, those created by mixing equal parts of two primaries, sit halfway between two primaries. Tertiary colors, those made by mixing a primary and a secondary, are represented by the smallest circles.

On the ink wheel, the ink formula for each color is placed outside of its wedge.

Notice that secondary colors are comprised of 100% of each of the two primaries that make them. For example, green requires a 100% coverage of yellow ink and a 100% coverage of cyan ink.

Complementary colors, which will be discussed in depth later in this book (see page 46), are located directly opposite each other on the color wheels.

Study the formulas as you train your cyc to determine the composition of a color. You will make better color decisions if you know which hues combine to create a color.

Note the differences between the two wheels, especially in the orange–red and the violet–blue areas.

Now that you have a basic understanding of the two color wheels and how they are formed, we will discuss each color in depth. It's time to meet the colors!

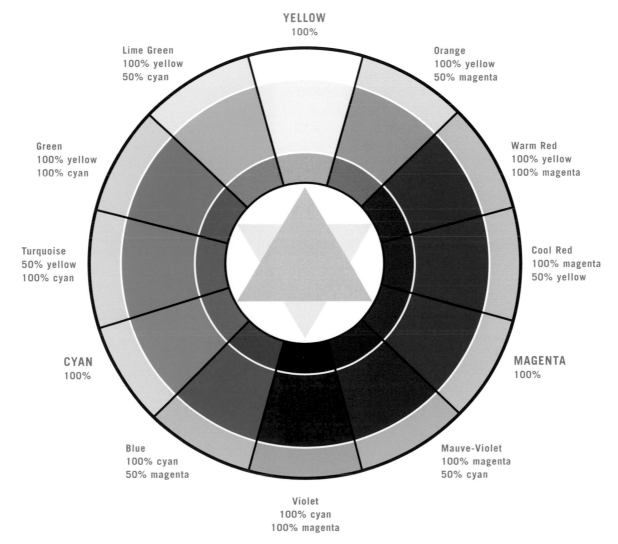

The ink color wheel, with yellow, magenta, and cyan as primaries. Tints (outer ring) of each color were created by adding white. Shades (inner ring) of each color were created by adding black.

YELLOW

Dawn's spectacular yellow rays provide the light and warmth we need for this lavish gift called life. Yellow lights our existence. It illuminates, clearing the shadows of uncertainty. It breathes a warm promise of new beginnings and hope.

In nearly all cultures yellow (along with gold) represents the sun and signifies enlightenment, wisdom, or divine power. In ancient China only the emperor and the royal family were allowed to wear yellow. Yellow and gold are sacred colors in the Christian faith because they are seen to represent God's light.

Yellow is the brightest and most visible color, and the first the human eye notices. It moves forward, appearing larger than other colors. Choose yellow when you want to capture your viewers' attention or rivet their focus to a specific spot. As an accent color, small amounts of yellow inject vitality.

In its full saturation, this brightest and most luminous color of the spectrum radiates and dazzles. Exuberantly cheerful, yellow lifts our spirits, helps us gather self-confidence, and stimulates our mind to focus and think more clearly.

The character of yellow changes drastically according to its tone. In its pure state it suggests sun and brightness, light and life. It conjures up images of early spring flowers. Vincent van Gogh felt that yellow was "capable of charming God." Mellow tones leaning toward orange, such as amber, saffron, mustard, and curry, envelop us in more subdued warmth.

Duller tones of yellow can evoke deceit, treachery, jealousy, and cowardice. The betrayer Judas Iscariot is sometimes depicted wearing dull yellow robes.

If a bright yellow leans a bit toward green, it bites, becoming sharp and acidic, like sulphur or the sting of a sour lemon. Yellow darkened with black lacks vigor, becoming muddy and foul. Black and yellow used in contrast, however, are colors of warning. Think bumblebees and poisonous frogs. But in fashion, black and yellow, used in savvy proportions, say "style!" rather than "danger!"

Because it reflects so much light, large expanses of bright yellow stimulate and strain the eye. The most visually fatiguing color is bright lemon yellow.

In spite of its rambunctious energy, yellow is found in the upper echelons of highbrow color. When mixed with white, it is transformed into tints of ivory or cream—paragons of understated elegance. Most "off-white" colors are touches of yellow mixed with white. While less energetic, these tints retain the light, airy quality of yellow, conveying ease and grace.

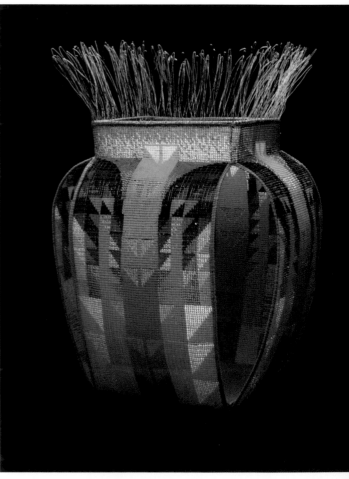

"V12" by Jeanette Ahlgren illustrates the indomitable drama yellow initiates when paired with blue and violet in a rhythmic counterpoint of color and design. Loomwork on wire.

In jewelry and fashion, opaque bright yellow appears casual and friendly. It is perfect for sportswear and summer clothes because of its movement and high-spirited personality. In these fashions, yellow is often paired with the other primaries or with its complement, violet. Such vivid combinations make high-contrast, energetic palettes. Combine bright yellow with other intense hues—perhaps grass green or magenta—for festive flamboyance.

The gemstones amber and yellow topaz are natural versions of yellow, warmer and more refined than their pure counterpart. While in its natural state, citrine is a luminous pale yellow, much citrine currently available is fxormed by heating low-grade amethyst or smoky quartz, and leans toward orange.

Ignite your palettes with yellow. If its vibrant shout is too aggressive, try its tinted whispers and mellowed tones.

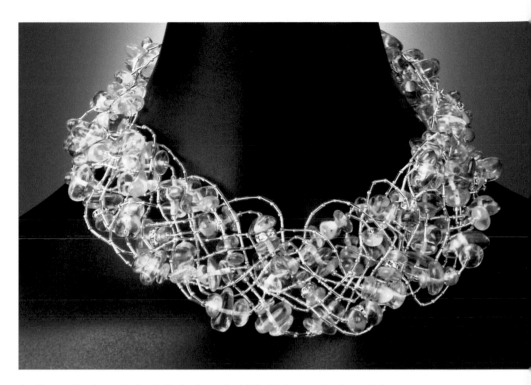

Luminous yellow forms the foundation for Peter Ciesla's braided maze of amber and silver serpentine strands.

1. Though cheerful in this diminutive disk, viewing pure yellow in large proportions may require sunglasses. 2. A small addition of magenta or red makes pleasing warm marigold or egg yolk tones. 3. Because yellow is the lightest of colors, just a speck of blue will transform it; in this case, it becomes a yellow-green of questionable character. 4. The addition of black and blue to yellow often produces sickly effects, suggestive of illness and cadavers.

SUGGESTED PALETTES

1. **DELICAS: DB-160, DB-876, DB-177**
A yellow the color of lemon (DB-160) and a light lime green (DB-876) make a zesty combination. Spring and summer jewelry zings with these crisp colors. A splash of aquamarine with an AB finish (DB-177) adds a note of tropical coolness.

2. **DELICAS: DB-272, DB-769, DB-797**
Honey-toned amber (DB-272) works well with natural tones, especially brown (DB-769) and olive green (DB-797). This palette is inspired by the colors of the African plains.

3. **DELICAS: DB-762, DB-203, DB-109, DB-331**
Begin with matte eggshell (DB-762) and add pale yellow with reflective and AB finishes (DB-203 and DB-109). Accent with 22-karat matte metallic yellow gold (DB-331) to make a sophisticated palette fit for a queen.

4. **DELICAS: DB-232, DB-906, DB-165**
This graceful palette has a translucent quality. Begin with pale buttery yellow (DB-232). Add shimmering violet (DB-906) for a hint of magic. Blue-violet with an AB finish (DB-165) provides contrast.

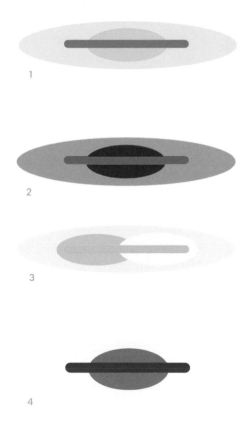

ORANGE

A pat on the back, an arm around our shoulders, gregarious orange beckons us to come in and sit by the fire.

From the softest peach and coral tints, to deep siennas and tawny umbers, orange is always friendly and welcoming. Orange lusts for life and its laughter is full-bodied. It entices us with sensual pleasure: dancing flames of fire, flamboyant autumn leaves, shimmering goldfish. Psychotherapist and author Ambika Wauters describes it as "a laughing color...which stimulates appetite for the good things in life and increases an interest in sexuality as well as a desire for abundance. It can also stimulate a sense of creativity, playfulness, and fun."

Orange is a food color—think of all the orange-colored fruits, vegetables, and spices, cooked on an orange hearth over orange flames. Orange nourishes. It stimulates our appetite and aids our digestion.

Earthy orange also stimulates sexual desire. Featured in erotic art during the Restoration, the word itself was used as sexual slang.

Orange's vigor extends to the realm of aromatherapy. Many blends of essential oils blends are suffused with the joyful essence of orange. In ancient China orange symbolized life's joys and was believed to possess magical properties. It is used today in color therapy as an invigorating antidepressant.

Orange's outgoing nature can be functional as well as fun. Strident, highly visible orange, glowing like neon, is used internationally to designate danger. Advertising takes advantage of orange's ability to grab attention. In her book *Color Harmony 2,* Bride Whelan writes, "Orange along with its color wheel neighbors is frequently used in fast-food restaurants because it projects an inviting message of good food at a friendly price." Want to draw attention to your latest creation? A robust splash of orange declares, "Look at me!"

Throughout the world, rich, tawny, red-orange conveys the comfort of hearth and home: terra-cotta clay earthenware, Moorish tiles, adobe homes of the southwestern U.S., and kilim rugs of Turkey.

Orange represents strength and endurance. Yet darkened with touches of black and blue it relaxes into earth tones.

On the spectrum between bright yellow and hot red, orange draws warmth from both. It simmers as the hottest color on the wheel. Balance orange's warmth with shades

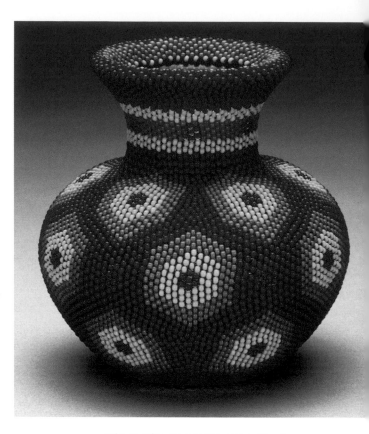

Intimate with the friendly personality of orange, Liz Manfredini has matched its gregarious nature to that of this sensuous, rotund vase. The peyote-stitched "Orange Hexagon Vase" pulsates a hot color scheme. Spots of magenta, brilliant and unexpected, surprise and delight the observer.

of cool blue. Combine vigorous vermilion with blue-green to suggest an exotic, Middle Eastern flavor. This balance of warmth and coolness abounds in Native American jewelry, so abundant in turquoise, coral, and carnelian.

Orange tints, which suggest a quiet luxury laced with romance, flatter skin tones. Elegant apricot, salmon, and peach are slightly restrained and less zealous in their warmth than bright orange. Sprinkle one of these lighter tints with pearl and dark gold metallic accents for an upscale and sensuous palette.

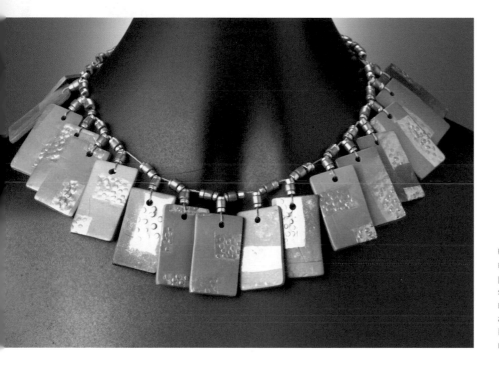

Carol Zilliacus makes magic with orange using her unique technique for blending polymer clay. Less intense than their fully saturated counterparts, these oranges are mellowed by blending white, gold, copper, and black into the clay. Beads are embellished with hand-stenciled mica powders and raised circles.

To keep pastel palettes from becoming overly sweet, use pale orange, rather than pink, as a dominant color.

Blazing pure orange conveys youthful vitality. Accents of this bright shade pack a lively punch.

If you've shunned orange, it's time to get to know a new friend. Answer its invitation—sit by the fire!

| 1 | 2 | 3 | 4 |

1. Peach connotes soft, restrained elegance. 2. Shades of salmon are sensual, hinting of blossoming, fragrant roses, or skin. 3. Terracotta, which means "cooked earth," is a color of substance, solid and enduring. 4. Opaque, deep earthy oranges evoke rock formations of the American Southwest, or carpets in a Marrakech marketplace.

SUGGESTED PALETTES

1. DELICAS: DB-010, DB-753, DB-752
With a supporting cast of black (DB-010) and red (DB-753), orange (DB-752) takes center stage. It enacts an exciting drama, especially in abstract, simple designs. Orange is at its most forceful when blocked against the darkest of blacks, because of its high intensity. Paired with red, it ignites.

2. DELICAS: DB-744, DB-876, DB-160
A field of matte transparent orange (DB-744) makes a great place for light lime green (DB-876) and sparkling, daffodil yellow (DB-160) to frolic. A playful summertime palette.

3. DELICAS: DB-752, DB-1340, DB-696
Spicy and exotic, orange (DB-752) and silver-lined magenta (DB-1340) riveted to blue-violet (DB-696) transport you to northern India, resplendent with vividly colored saris and turbans.

4. DELICAS: DB-913, DB-249, DB-793
Cool your orange-based palette with a perfectly balanced trio of beads: low-intensity, shimmering salmon (DB-913) with violet pearl (DB-249) and accents of opaque ocean aqua (DB-793).

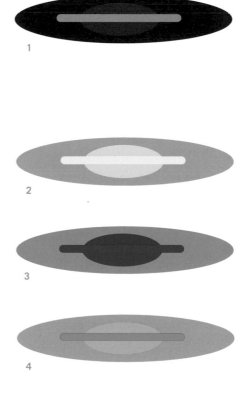

RED

Red demands attention, broadcasts danger, commands strength, declares devotion, quickens the heartbeat, incites aggression, inflames passion, and proclaims love.

Red surges from our hearts to the extremities of these bodies we wear, warming, invigorating, and exciting us. It is as if we each live our lives encased in the color red. Some of our strongest emotions—lust, love, anger—and our physical health are accompanied by the robust vigor of red.

Red is the passionate call to action: Buy this product! Stop your car! Exit here! Do not smoke! Stand up and fight! Indulge in this pleasure! Do something!

The passion of red is overt in the world around us, as it is a powerful attractant. Berries wear shades of scarlet to tempt birds to eat them and spread their seeds. Brazen red signifies sexual temptation for birds as well as humans. A male cardinal attracts females with his red plumage.

Healers who work with gemstones are aware of red's natural connection to the human body. Ruby, garnet, and certain carnelians are colors of vigorous health and are said to energize and regenerate cells and tissue.

The spectrum of red parallels the spectrum of life itself. The name of Adam, the first man, translates to "red clay" or "alive" in Hebrew. Clear, lighter pinks associated with babies are tender, innocent, and sweet. Neon pinks, like bubblegum

and candy pink, are associated with adolescence. Robust true reds symbolize the vigor and vitality of young adulthood. Darker, more mellow tones, like wine and burgundy, suggest maturity and wisdom.

White added to red tempers its passion ever so slightly, giving us tints of pink. Pinks are both demure and sensual. Venus, the Roman goddess of love, is depicted in nurturing pink tints, which speak of unconditional love, friendship, and forgiveness.

Maroon gemstones, like rhodolite and almandine garnet, harmonize beautifully with their complements: the greens of malachite and emerald. Paired with ivory-colored beads or pearls, they are reminiscent

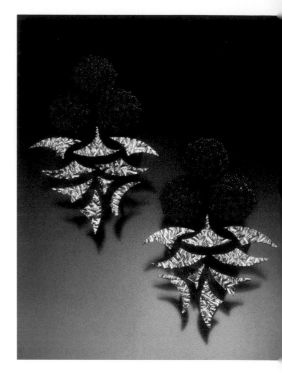

Valerie Hector creates unusual textural sculptures that double as earrings in a stunning combination of pure red and the achromatic silver shards representing the sails of a ship. 18-karat white gold soldered to sterling armature. Earrings from the "Ship of Transition" jewelry series.

Red, front and center, advances, demanding your undivided attention. Receding black thrusts red forward even farther, and analogous yellows and oranges heat this piece to a vibrant glow. Fused glass by Vilma Dallas; necklace by Margie Deeb based on a technique by Diane Fitzgerald.

of Victorian parlors, lush and ornate. Deep reds against metallic bronzes and golds convey affluence and wealth. When dark, rich reds are combined with amethyst purples, the look is regal and dignified.

Red's expressions of passion vary according to whom it hangs out with. Face-to-face with black, red is full of drama, proclaiming confidence and strength. With magentas and oranges it simmers and seduces. With lime greens and teals it banters and clashes. With bright blues and yellows it laughs. With browns it relaxes. With purples and violets it rises to its most regal. With grays it matures to a worldly sophistication.

Quantity and intensity determine the impact of red. To shout, use a grand splash of potent tomato-red beads. To whisper, use accents of soft, shimmering pink.

If your palette feels lackluster and drained, take action! Reach for passion. Reach for vitality. Reach for, no *grab* for red!

"Kimono Kite" by Liz Manfredini draws its strength from the powerful combination of red and black. Red rivets your gaze, then pulls it up and around the neckstrap. Perfectly balanced with black; more red would diminish the drama. The artist adds complexity to this simple geometric shape by combining several finishes of black, changing the direction of the densely packed beads, and adding two sensuous caterpillars of fringe at the bottom.

1. A soft, gentle baby pink connotes sweet innocence. 2. Lively sweet-sixteen pink suggests lipstick, bubblegum, and slumber parties. 3. Orangey tomato red is intrepid and flamboyant. 4. Dense, deep burgundy is an exotic rich tone, reminiscent of velvet draperies, Turkish carpets, and aged wines.

SUGGESTED PALETTES

1. DELICAS: DB-295, DB-785, DB-074
A feminine and substantial trio: Carmine (DB-295), a hot red-orange, paired with rich violet (DB-785) and an accent of light magenta (DB-074). Violet infuses this seductive palette with mystery.

2. DELICAS: DB-116, DB-376, DB-204
A rustic, powerful, reddish brown (DB-116) is tempered by cool, orderly, Wedgwood blue (DB-376) and smooth vanilla ceylon (DB-204) in this sophisticated and dignified color scheme.

3. DELICAS: DB-775, DB-691, DB-331
Opulence and restrained drama emerge from Chinese rose (DB-775) and Arcadia green (DB-691), accented by a matte metallic gold (DB-331).

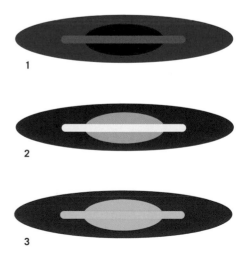

MAGENTA

She flirts, arousing the senses. She winks, delighting the eye. She is the siren that lures you to sensual pleasures. She is magenta.

An alluring purplish red, more luxurious than true red, magenta exudes luxury. The color itself seems to have a texture of damask, silk, or taffeta. If magenta is new to you, it is only the name, not the hue, with which you are unfamiliar. Think hot pink, neon pink. Geraniums, cyclamens, fuchsias, primroses, orchids, peonies, and bougainvilleas are but a few of nature's blossoms that seduce with magenta.

Magenta is a sexual color, arguably more so than even red, for it has none of red's associations with anger. In nature, magenta flowers invite pollination. Cosmetics and lingerie—two things women wear closest to their flesh—are emblazoned with sensuous shades of magenta.

Magenta is a free-spirited libertine. In the 1960s, she and her acid-inspired cohort, lime green, were the emblems of psychedelia and flower power. Today you'll find her stirring up the revelry at Mardi Gras.

Because its brightness is particularly stunning in brilliant sunlight, magenta abounds in the textiles of Guatemala, Mexico, Hawaii, and India. Long before Westerners used it as a dye, magenta was a standard in the architecture and fabrics of India. The building materials for entire cities were tinted in magenta and red.

The Victorians reveled in fabrics colored with the newly discovered synthetic dyes of magenta and fuchsia.

Magenta is the "red" primary of the printer's ink color wheel (see page 15). As a primary it creates brighter, more luminous oranges, purples, and violets than does its red counterpart. Most publications printed in color use a four-color printing process referred to as CMYK, in which the "M" stands for magenta. Magenta is responsible for every color in this book that has a reddish tint.

Magenta and colors derived from it pose one problem.

They are insufficiently lightfast, especially in the medium of glass beads. Many magenta and pink glass beads will fade from exposure to cleaning agents or sunlight. Test beads for lightfastness by setting a bowl of them in the sun for a few days. If they are to be used for embroidery, sew a few on fabric and run them through the washer and dryer or take them to the dry cleaners. If the beads are to be worn, wear a strand against your skin for a few days. While some pinks will surprise you and retain their brilliance, many dyed beads will not pass these tests, as dyed beads are coated with

The shape of an opening blossom reflects the essence of sensuous, alluring magenta, who loves to be paired with iridescent bright hues, like those whirling in the center of this "Lotus Pincushion" by Jennie Might. Flat peyote, herringbone, and netting stitches.

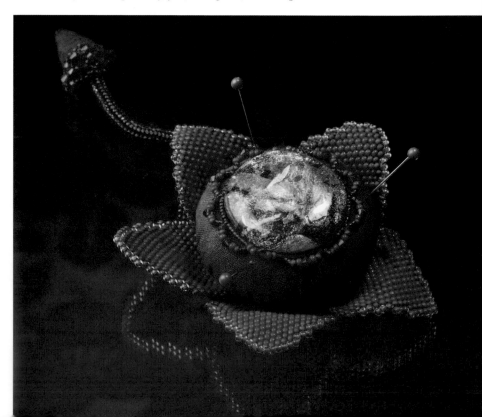

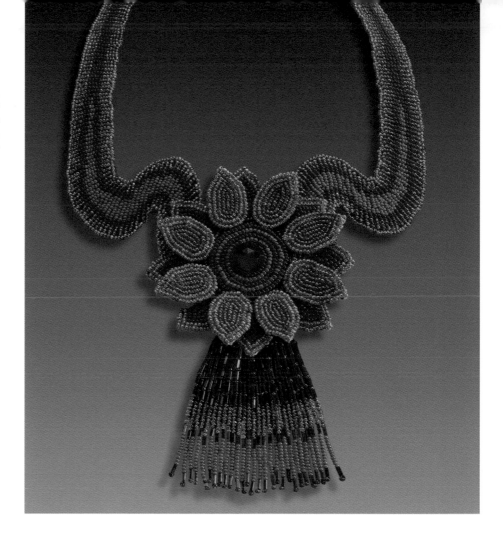

Liz Manfredini harbors a passion for intense, blooming colors, as evidenced by her "Zinnia Neckpiece." These pink-purples borrow their seductive charm from magenta, and, with orange, they ignite into bead-embroidered flower power.

color, which can rub off. Glass beads, however, are impregnated with pigment, which produces a more stable color.

Because it is often an unstable hue, you won't find many natural materials in shades of magenta. Wood, shell, and howlite beads are dyed shades of magenta. Glass, or plastic if you want a less sophisticated look, is the best way to charge your work with magenta.

Pure magenta loves to dance with colors that match her intensity. Set her up with black and a bevy of brights—red, lime-green, turquoise, and yellow—and she'll cha-cha all night. With yellow-green, her near complement, she hops a jitterbug. Get her on the dance floor with analogous partners red, orange, and mauve-violet for a smoldering tango. Lighten magenta with lavenders and pale blues to calm her into a charming coquette.

With but a hint of magenta, you'll hear her siren's call. May her sensual charm seduce you.

1. Pure magenta ink at 100% strength. 2. Half-strength magenta is a rosy pink. 3. Pale magenta becomes a gossamer, light pink tint. 4. Darkened magenta is reminiscent of the maturity of maroon.

SUGGESTED PALETTES

1. DELICAS: DB-073, DB-904, DB-651
A bold magenta-purple (DB-073) with a cool, shimmering sea green (DB-904) contrasts boldly against low-intensity goldenrod in an opaque finish (DB-651), creating an unusually striking trio of hues.

2. DELICAS: DB-074, DB-001, DB-751
This clamorous combination begins with DB-074, a magenta-ish bead with an AB finish. Gunmetal gray (DB-001) is highly reflective (not black, as it appears here in print). A pure, high-pitched yellow (DB-751) electrifies the whole scheme.

3. DELICAS: DB-1340, DB-1345, DB-687, DB-693
DB-1340 is slightly cooler than a true magenta, but just as shocking. Experiment with this Delica palette of silver-lined finishes, then find beads of similar hues with more permanent finishes—such as opaque or luster—to make your final piece.

4. DELICAS: DB-281, DB-734, DB-378, DB-233
Royal fuchsia (DB-281) and deep chocolate brown (DB-734) deliver rich flavors. The warmth of burnt orange (DB-378) adds complexity, while the lightness of delicate buttery yellow (DB-233) balances this powerful palette.

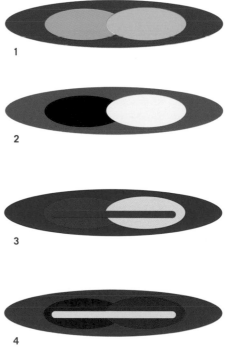

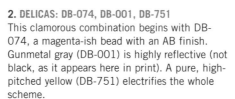

VIOLET & PURPLE

Purple is magical. Whether because of its unique position in the spectrum, its illustrious past, or its associations with the gemstone amethyst, the messages purple conveys are varied and enigmatic.

Red rises in dynamic passion. Blue reclines in passive repose. And right in between these extremes stands purple, bearing the qualities of both. This coalescence of liveliness and tranquility creates a complex color whose meaning is enigmatic, and whose presence makes some uncomfortable. Purple is more fiery and active when it leans toward red, more retiring and peaceful when closer to blue.

People often use the terms "purple" and "violet" interchangeably, but they are different colors. Violet leans towards blue—look at the flower. Purple is more reddish, like the gemstone amethyst.

Purple's dramatic history has fueled its magical reputation. In ancient times it was the most expensive color to produce, requiring 10,000 murex shells to make one gram of dye. In their book *Colors: The Story of Dyes and Pigments,* François Delamare and Bernard Guineau state that the right to wear purple was reserved for Roman emperors alone and "was associated with supreme power in cultures from Israel to Persia." The texts tell us of its "irresistible attraction among the upper echelons of society and of the emperors' relentless refusal to allow others to use it. Nero went so far as to punish offenders with death."

Equally dramatic to purple's past is the allure of the most famous purple gemstone, amethyst. It has long been revered as a mystical gemstone and is still used by many in meditative work to connect with higher realms.

Purple's visual magic is revealed in the way it interacts with itself. Try combining light and dark purples, or purple and violet, for a curiously mesmerizing palette.

Because purple is one of the darker hues, it will monopolize most schemes. Use this to your advantage. Versions of grape and eggplant convey regal sophistication, and, like royalty, can rule a palette. So let purple reign!

Use the seductive charm of lighter tints of lilac and lavender to create an enchanting aura of mystery. Tints work well with most pure hues and other tints, especially when they tend toward blue rather than red.

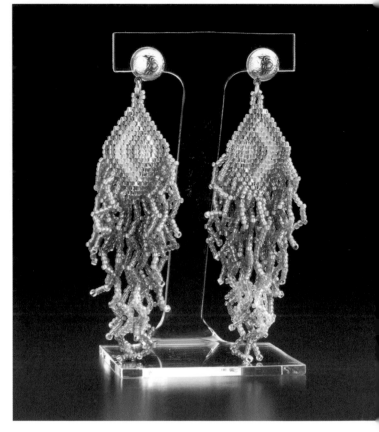

Lavender and periwinkle, lightened versions of purple and violet, are the colors of charm in these brick-stitched and kinked fringe earrings by Margie Deeb. Icy flecks of silver add a scintillating sparkle.

Yellow is purple's complement. When it comes to gemstones (and beads!) these two are a natural pair. Faceted amethyst and a splash of gold create a majestic combination. Amethyst has the amazing ability to transform itself into citrine when heated to certain temperatures, and the effect of citrine (or yellow topaz) paired with amethyst is dazzling.

Another natural friend of purple is green. Purple and green are beautifully coupled in a variety of flowers. Use nature as inspiration and consider flanking amethyst with peridot, malachite, or green agate.

A note of caution about using purple beads: Certain shades of purple are difficult to obtain in glass, and any manufactured purple beads fade. This disappearing act is not the most desirable expression of purple's magic, so test for lightfastness by setting a bowl of beads in the sun for a few days. Or place some in a bowl of acetone, bleach, or alcohol for a day.

Purple is a favorite of creative people. Whether wearing it, living in it, or creating with it, purple is a color for the adventurous heart with spiritual leanings and a flair for drama. This is the heart that knows the magic of purple.

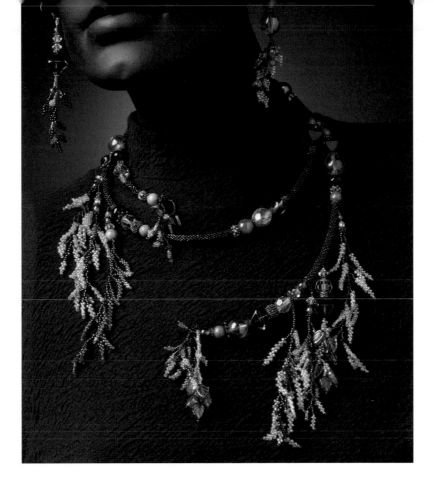

The tones of the peyote-stitched "Willow Study: Opus One" by Margo Field illustrate the mellowed and sophisticated side of purple—slightly muted and less intense, but still enchanting. The unusual asymmetrical design is as compelling as the palette.

Combining cyan and magenta inks makes possible the purple and violet colors you see in this book. 1. The violet of the ink wheel is comprised of equal parts cyan and magenta. 2. The artist's wheel violet contains slightly less cyan, making it a reddish-violet that can also be called purple. 3. A very bright purple that contains far more magenta than cyan. 4. A richer, more regal purple.

SUGGESTED PALETTES

1. DELICAS: DB-923, DB-694, DB-074, DB-174
Dark, shimmering violet (DB-923) creates a background for lavender (DB-694), valentine AB (DB-074), and a slice of light neon lime (DB-174) to sparkle. This is a springtime palette, upon which "Chanin Study" (see page 80) is loosely based.

2. DELICAS: DB-912, DB-728, DB-376, DB-204
These desaturated middle tones evoke an antique sweetness. The foundation is a shimmering smoked mauve (DB-912) paired with an opaque mauve (DB-728). Matte metallic fog blue (DB-376) is accented with a high note of vanilla ceylon (DB-204).

3. DELICAS: DB-135, DB-116, DB-011, DB-908
In this elegant but unusual palette, midnight purple (DB-135) supports a Tuscany red transparent luster (DB-116), metallic olive (DB-011), and a surprising, shimmering, grasshopper green (DB-908).

4. DELICAS: DB-695, DB-281, DB-253, DB-301
This palette ranges from the neutralized purple of a silky mauve (DB-695) to brilliant red-violet (DB-281), then moves to cooler, paler red-violet (DB-253). Accents of a strong, gargoyle gray (DB-301) tie it together.

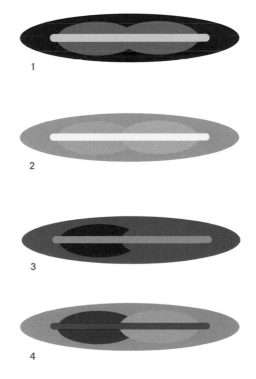

BLUE & CYAN

A canopy of blue attends us all our lives. Looking skyward, we shift our perspective. Frustrations fall away. Calm sets in. We are part of this tranquility, this never-ending wonder, this blue.

Blue recedes, thereby drawing us to it. It seems to be filled with space as much as with tint. The wonder it conjures leaves us wanting more.

The color of the heavens, blue is associated historically with the spiritual in most cultures. It symbolized sacredness and spiritual protection to the ancient Egyptians, immortality to the ancient Chinese, truth and harmony to the Druids, and supreme wisdom in India. In Christian art of the Middle Ages ultramarine, symbolizing truth and justice, was reserved for the depiction of the Virgin Mary's robe.

Ultramarine blue became one of the most valued colors, as it was created by extracting pigment from precious lapis lazuli. Even today, blue chrysocolla and azurite are ground to make blue pigment.

Light blues, like those of blue lace agate, suggest tranquility and spiritual awareness. They emanate tenderness.

Darker shades of blue, found in sodalite and lapis, exude prestige and strength. Those who wear them, such as business executives, the military, and the police, assume power and authority.

Blue—like every color—has its negative as well as positive connotations. Blue has a darker side, one in which tranquility leads to melancholy, hope to despair, and relaxation to lethargy. Darkened, dull blues are so close to black they have a heavy, suffocating effect. These blues signify sadness and loneliness. When a blues singer croons of lost love, he's got the right color.

Blues are at their most heavenly when united with other rich blues and amethyst purples. Beads of lapis separated by gold elevate blue to a kingly status. Silver and blue emanate silent, compelling power.

Research shows blue as the most favored color of all in America. As earnest and reliable as a pair of trusty blue jeans, hardly any shade or tint is offensive to anyone.

Wondrous, heavenly blue soars above us. Look to it for peace, hope, and inspiration.

Now imagine a sparkling swimming pool. That is the color of cyan. It is closely

Blue imparts a peaceful dignity to this symmetrical design. "Dutch Blue Amulet Purse" designed and beaded by Janet Baty.

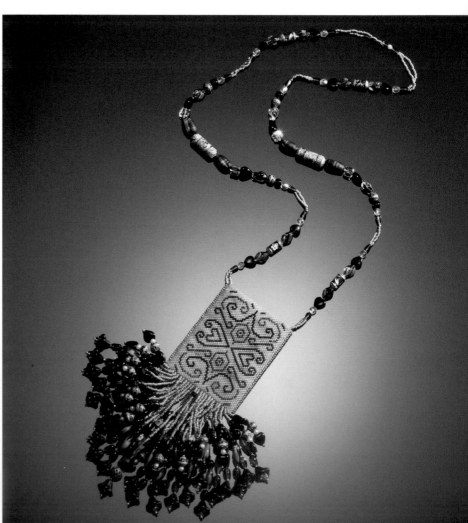

related to turquoise, possessing a hint of green. More luminous than the true blue primary of the artist's color wheel (see page 14), cyan acts as the blue primary in the ink wheel (page 15). The painter using cyan as a primary to mix colors will achieve a more luminous range of purples and greens. Give cyan its due and incorporate it as part of your color studies, and you too will have a broader palette—and a broader knowledge of color relationships.

Shades of cyan, aquamarine, and turquoise are livelier than our peaceful true blues, but just as soothing. A gaze into Caribbean waters will affirm this. These blues relax and refresh the body and mind. They encourage us to get out in the fresh air, sunshine, and water. No wonder they are such popular colors for beach towels and summer garb.

Apatite and aquamarine are gorgeous cyanish gemstones that work well with both gold and silver and are especially evocative with amethyst. Turquoise and coral or carnelian is an ever-popular complementary combination.

The luminosity and sparkle of cyan adds a refreshing dimension to the blue range of the beader's palette.

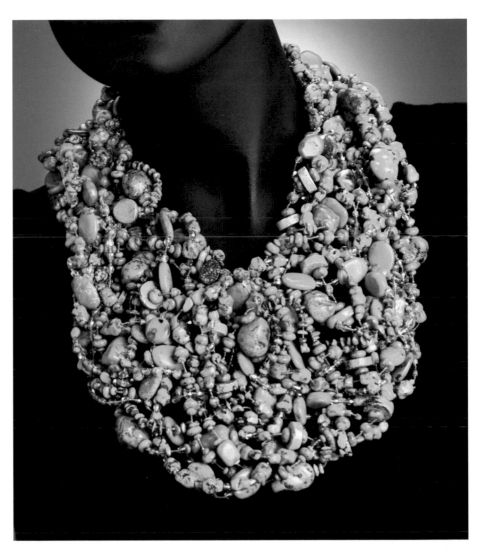

Peter Ciesla of Bazyli Studio makes a stunning display of cyan tones in the form of braided turquoise nuggets.

1. In four-color process printing, a true blue is made up of 100% cyan ink and 60% magenta ink. 2. Blue with less magenta. 3. Pure cyan. 4. Cyan with 20% yellow added, making a warm, tropical blue that leans toward green.

SUGGESTED PALETTES

1. DELICAS: DB-277, DB-685, DB-881, DB-106
The strength of this palette is anchored in complementary pairs of blue and peach. A deep blue-violet luster (DB-277) is a background for a slightly dull coral (DB-685), periwinkle matte AB (DB-881), and muted pink luster (DB-106).

2. DELICAS: DB-215, DB-746, DB-174, DB-751
No Delica bead is a true cyan. DB-215 is a slightly lighter version. This spring-fresh, analogous palette is clean and inviting. The greens of DB-746 and DB-174 form a harmonious bridge from blue to sunny yellow (DB-751).

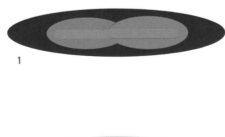

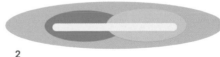

GREEN

Green is the color of fertility and new life, growth and abundance. Nature uses it as a background for all that buds, blossoms, crawls, and flies. Green harmonizes with everything in nature's rich cornucopia.

If there existed a life-giving nectar to restore harmony and balance and renew the weary soul, it would be the color of emerald green.

The human eye perceives green using the cones located at the center of the pupil, making it the easiest, most restful color to view. Other colors require us to use cones at the perimeter of the pupil, leading to strain, pressure, or fatigue. Green has become a standard color in hospital interiors because it allows the eye to relax. Medical uniforms employ green for a similar purpose—to relieve and balance eyes that focus on pinks and red during surgery.

As reported in the journal *HortTechnology*, green plants help us tolerate pain. Research at Washington State University compared how long human subjects in a room could keep their hands submerged in ice water. Those in a room filled with greenery could do so for a significantly longer period of time than those without plants. After surgery, patients in a room with a view of green recover faster and with fewer drugs. Studies have proven that people work more efficiently when they can see houseplants.

The human eye discerns more shades and tints of green than any other color. And with that perception comes a multitude of responses ranging from nausea to euphoria. How so?

Perched between blue and yellow, green connects cool and warm, positive and negative. When it leans toward blue, as in teal and turquoise, green has positive associations, because it is refreshing, clean, and soothing. As green approaches yellow it becomes the controversial, ever-faddish yellow-green (page 30).

Gemstones offer a luscious assortment of greens: cool opaque malachite, mottled dull serpentine, translucent twinkling aventurine, lustrous over-the-top chrysoprase, and jade in its wide range of hues, to name just a few.

As nature's background color, green pairs beautifully with most colors, especially variations of its complements: red in shades of crimson, ruby, or maroon, and magenta in shades of rose, hot pink, or pale powder pink. Captivating combinations use green with variations of its two near

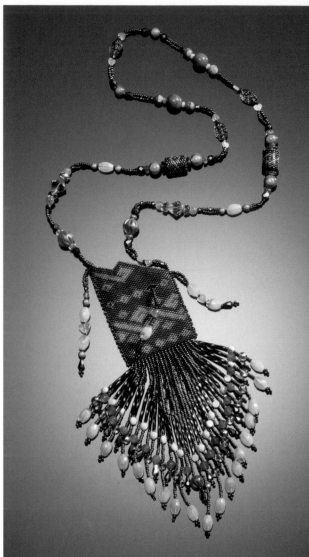

A wide range of greens is fitting for a design inspired by Celtic art. Peyote-stitched amulet purse designed by Jacque' Owens, executed by Jennifer Fain.

complements: red-orange and red-violet. How about jade and carnelian, or malachite and amethyst? Let green showcase shades and tints of the near complements.

The nectar of life may not be within reach, but to provide harmony and balance, and to rejuvenate the soul, try something just as powerful: life-giving green.

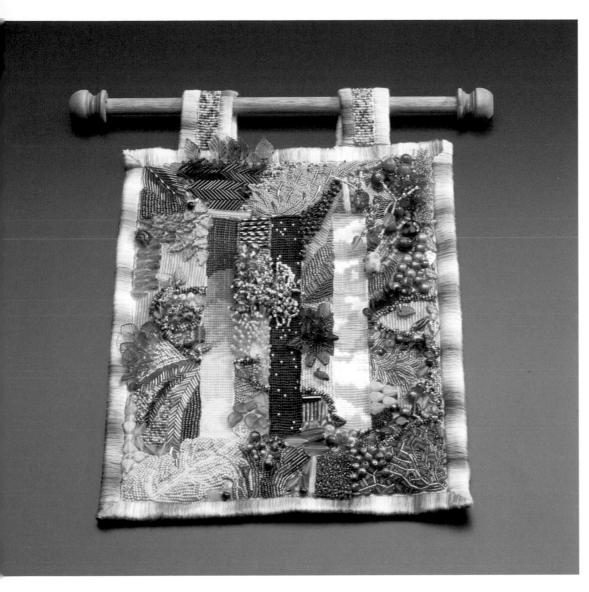

Lush, verdant foliage born of beads and embroidery thread grows untamed in "*Ciel et Forêt* (Sky and Forest)" by Mel Jonassen. Loomwork, embroidery, and various fringe techniques.

More yellow is added to each swatch of green from left to right. 1. Blue-green. 2. Cool green. 3. True green. 4. Yellow-green.

SUGGESTED PALETTES

1. DELICAS: DB-919, DB-923, DB-116, DB-331
Deep, regal shades, reminiscent of a medieval tapestry, begin with a rich, shimmering teal-green (DB-919). Include precious tones of dark, shimmering violet (DB-923), dark, lustrous red (DB-116), and 22-karat matte metallic gold (DB-331).

2. DELICAS: DB-656, DB-233, DB-249, DB-754
A relaxed informality is reflected in this cheerful collection of colors based on a background of kelly green (DB-656). Buttercup (DB-233), light violet pearl (DB-249), and yellow-green (DB-754) bring to mind tulips and daffodils on a grassy slope.

1

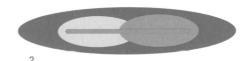

2

YELLOW-GREEN

No color draws more opposing reactions than yellow-green. How curious that a color so pulsing with freshness and life has such strong associations with fear, sickness, and death.

From the positive end of the spectrum, yellow-green infuses yellow's light-bearing warmth with green's life-giving balm to radiate a unique frequency all its own. This frequency is the color of springtime leaves and summer's first grasses. It is sunny, vibrant, and brimming with life. It is the adornment of the rain forest teeming with young tendrils and damp mosses.

Life-affirming yellow-green rouses feelings, thoughts, and memories when encountered. Smells of freshly mown grass come to mind, or perhaps memories of climbing in trees or rolling down grassy slopes in the exuberant joy of youth. You can almost taste certain shades, with their tart, pungent sting.

Yellow-green spurs unpleasant associations as well. It may conjure memories of seasick bile, or infection, or a terrifying encounter with a slithering grass snake. Horror and sci-fi movies commandeer it to elicit intense reactions to their most loathsome creatures and ickiest substances. Who could forget its appearance in *The Exorcist* and *Ghostbusters?*

How does one work with this vital color held as both virtuous and vile? In the same way you work with other colors. First, clarify the feeling you want your finished work to elicit. Then choose precise tones that will achieve your intended impact. Follow your intuition; it knows more about the workings of yellow-green than your conscious mind does. If you want to evoke cheerful feelings, choose clearer, brighter versions of yellow-green. If you want to startle, bright pure yellow-green is your color. To convey an ominous foreboding, use dark, murky, olive tones. When yellow-greens (and yellows) are darkened and muted, not only are they duller, their life force is choked out, and they appear diseased. The darker and more muted the shade becomes, the more it repulses. Consider darkened camouflage or marine shades of yellow-green for this effect.

Yellow-green diamond shapes like quilted blocks of foil are laced together in a latticework of faceted crystals by SaraBeth Cullinan.

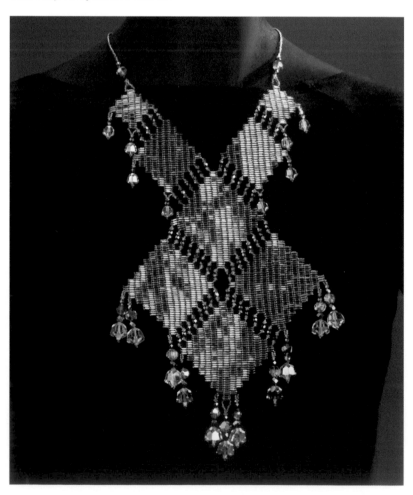

The cast of supporting colors in your design also determines how yellow-green is perceived. Yellow-green's vitality is increased when combined with reds and magentas of similar tone. Try lime with other citrus shades like orange and lemon, or chartreuse (a slightly darkened yellow-green) with terra-cotta–like reds, and deep olive with burgundy. Tints of pale pistachio paired with cream, ivory, or pearl set an elegant tone that benefit from being kept simple.

Happy harmonies will come from uniting yellow-green with analogous greens and yellows. Peridot, the most beautiful of yellow-green gemstones, finds congenial companions in lemon quartz or citrine, and malachite or emerald.

Bright cyans and yellow-greens make refreshing combinations. Try turquoise and serpentine, or the sparkling liquid tones of apatite and peridot.

Used appropriately, yellow-green's power to provoke strong reactions, from delight to disgust, is a potent tool in your palette.

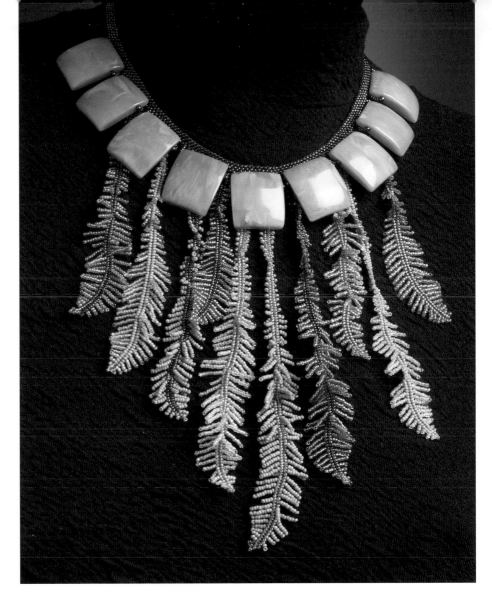

In "Bakelite and Ferns" Margo Field exploits yellow-green's eccentric nature. An unusual design for an unusual color. Ferns constructed by a variation on the herringbone stitch.

1. Yellow-green as it sits between yellow and green on the color wheel. 2. Lime is more brilliant, being comprised of more yellow than green. 3. Darkened slightly, yellow-green turns to chartreuse. 4. Further muted and darkened it curdles to shades of olive. Go too much darker and the color begins to putrefy.

SUGGESTED PALETTES

1. **DELICAS: DB-011, DB-281, DB-371, DB-285**
Low-intensity olive with a metallic finish (DB-011) supports royal fuchsia (DB-281), matte metallic olive gold (DB-371), and a lined cobalt (DB-285). An old-fashioned palette one might find in a European beaded purse from the early 1900s.

2. **DELICAS: DB-133, DB-253, DB-903, DB-236**
Because the background olive (DB-133) flashes pink AB highlights, natural palette partners include pink. DB-253 is a gentle mauve luster. DB-903 lightens the overall scheme. Accents of light watermelon pearl (DB-236) finish off this sixties retro combination with flair.

EARTH TONES

How reliable, this rugged, solid earth! We have been fed, clothed, and sheltered by her colors since first we stood upright.

From the ochres of mineral-rich soil and the browns of furs and hides to the weathered grays of homes built from trees and mud, enduring earth tones signify protection, making our existence less temporal. The use of earth tones in decorative art spans every culture on the planet. Our attachment to earth tones mixes urgent dependence with reverent respect.

We count on the colors of the earth to convey substance and reality. In raw or refined materials, shapes, and finishes, these colors are never pretentious. Earth tones in primitive, rough, natural forms, such as rocks, fossils, nuts, and shells, suggest our tribal ancestry. Interestingly, the same colors in more polished forms are sophisticated, evoking culture and maturity. Imagine smooth beads of leopard-skin and brecciated jasper, or polished smoky quartz, tigereye, and metallic brown glass beads.

If an assembly of earth-toned beads is too dull, lacking texture or shine, the effect is predictably uninspiring. Earth tones often need lighter notes of cream and ivory to balance their substance. Add the sparkle of metals, especially warm golds, to lift the heaviness. Brown glass beads with a metallic iris finish are sumptuous.

Deep olives and maroons combine beautifully with earth tones because they are so closely

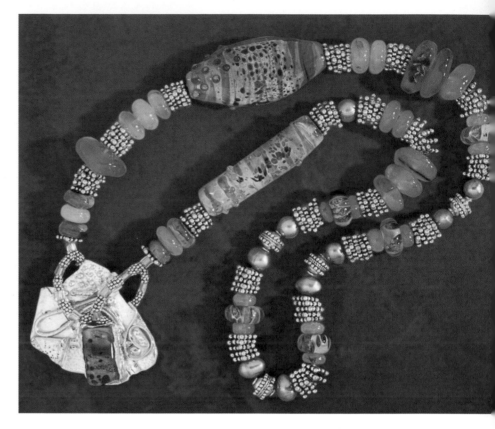

Nancy Tobey's exquisite handmade glass beads strung alongside silver display light earth tones in her "Grand Canyon" necklace. Cast silver pendant with Bali silver, agate, aquamarine, and pearl.

related, as the minerals terre verte and iron oxide yield green and red pigments, respectively. Beads of zoisite or serpentine enrich a palette of tobacco and coffee browns. Umber glass beads are elevated to elegance when residing next to garnet and gold. Mischief sneaks in when carnelian is introduced and counterbalances the no-nonsense colors of tigereye or smoky quartz.

Earth tones are workhorses that combine well with other low-intensity tones. Muted,

complex colors of the natural palette (page 102) are perfect companions.

When combined with vivid colors, earth colors need to be full-bodied, like dark chocolate, not feeble, like taupe. Use earth colors with colored undertones. To reduce clutter, limit vivid colors to one or two hues.

For a palette of substance, rely on colors as steadfast as Gaea herself—earth tones.

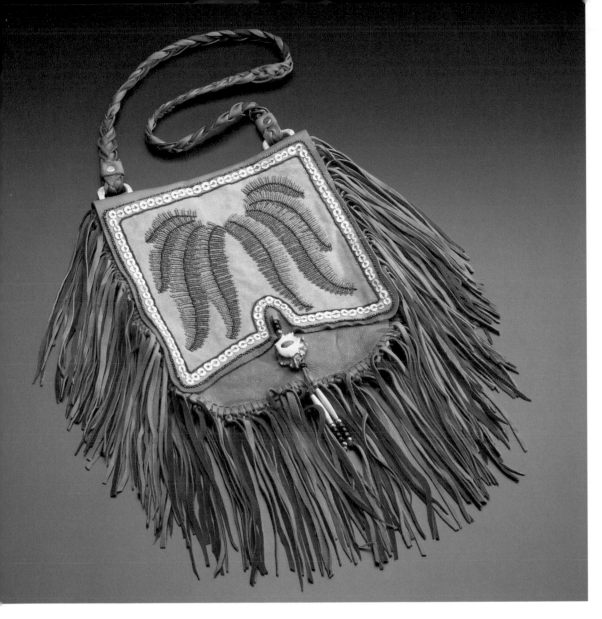

Deerskin begs a palette of earth colors and materials; Mary Tafoya has answered the call by embroidering beads of cool and warm green with shell, hairpipe, and bone to create the "Maidenhair Fern Purse." Handmade deerskin purse by Mark Bondy.

Earth colors are derived from mineral sources and are generally based on 1. yellow (ochre), 2. red (sienna, red oxide), 3. brown (umber), and sometimes 4. green (terra verte).

SUGGESTED PALETTES

1. DELICAS: DB-123, DB-371, DB-378, DB-913
A foundation of earthy olive gray (DB-123) is a fitting match for olive green (DB-371) because they share green undertones. Near complements dark burnt orange (DB-378) and shimmering salmon (DB-913) quicken the pace, bringing the passive grays and greens to life.

2. DELICAS: DB-764, DB-915, DB-376, DB-278, DB-208
Coppery browns with matte (DB-764) and shimmer (DB-915) finishes provide a warm background for quiet, matte metallic fog blue (DB-376), dark denim luster (DB-278), and an opaque pale tan (DB-208). A toned-down, restrained selection of hues.

3. DELICAS: DB-734, DB-272, DB-654, DB-204
Beginning with a strong dark brown to concoct a tasty palette suggesting chocolate (DB-734), honey (DB-272), cherries (DB-654), and vanilla cream (DB-204) is perfect for those drawn to autumn colors. Dynamic and delicious!

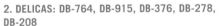
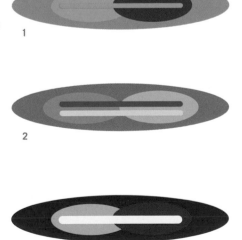

NEUTRALS

Chromatic neutrals are nature's lighter tones, occurring everywhere there is life. Unlike achromatic neutrals (grays), chromatic neutrals are full of color. They are lightened earth tones, and, like earth tones, have a grounded, uncomplicated style. Neutrals are the functional colors of ivory, tan, and bone (with yellow undertones), taupe and mushroom (with gray undertones), and khaki (with green undertones).

When you tell a friend you're neutral about tonight's dinner options, you are being flexible and can "go either way." Neutrals can too. They're willing to go any way when you offer them light or dark, bright or dull colors. Easygoing and versatile, they respond amicably to all tones, especially earth tones.

Neutrals enjoy accents of vivid colors. They extract some of the heat of blazing reds and oranges, and quietly resonate with profound blues and greens. Try opalescent white moonstone with vivid coral, carnelian, lapis, or malachite, and watch them respond!

One of the easiest ways to work with neutrals is to combine them with each other. Focus more on surface texture than a featured dominant color. Natural materials abound with unusual textures and patterns. In a neutral palette, textures and patterns compensate for the uniformity of color. Natural mother-of-pearl is the color of iridescent champagne. Striped onyx, and picasso and picture jaspers display fascinating patterns. Allow these geniuses of subtlety to draw you close. You can study them for hours.

In an elongated fringe of gradating color, Mary Hicklin echoes the neutrals and earth tones of the focal slice of Graveyard Point Idaho plume agate cut by Eidos.

WHITE

White is the purity of light. It symbolizes the sacred, the divine from which we originated. True white light is the greatest luminosity known, holding within it the entire spectrum. Pass white light through a prism and watch it fan out into a peacock tail of rainbow colors.

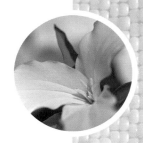

Such purity is highly reflective. White clothing keeps one cooler in warm climes because it reflects back sunlight and heat (black absorbs both). This reflectivity can cause glare and eye strain. In seed-bead weavings where large expanses of white are required, break up the snowdrift—and the monotony—with white beads of differing finishes.

White makes a clean background from which other hues can shine, and it harmonizes with nearly every color. Vivids look exceptionally vibrant and tints especially charming against white. Low-intensity colors work better with an off-white, one that leans toward another color, like ivory or beige (see "Neutrals," previous page).

White's penchant for cleanliness will inspire you to clean up your act! Mistakes, knots, and unclipped thread tails are easier to see amidst white beads.

The simplest palette of maximum contrast is white and black. For chic sophistication, string together beads of these opposing colors. To avoid clinical starkness, select luxurious finishes or shapes. Lustrous pearls of white and black are far more intriguing than the absolute white and black of opaque or matte finish beads. Color-lined and hex-cut beads offer visual interest. Grays (including snowflake obsidian and hematite) also add depth to the white and black duo.

White whispers innocence. Combine it with pink (such as rose quartz) to create a petal-soft, pastry-sweet delicacy. White and red, in tandem, can become either distinct (pearl and garnet) or flashy (snow quartz and scarlet red jasper).

Use white to freshen and lighten a color scheme. Look at how the white of Jeanette Ahlgren's "Release" (page 48) lightens the whole piece. Or use white as a fashion statement of refined grace. Nothing says elegance like pearls. Attired solely in white, one is perceived as cool and polished.

White occurs naturally in beads of milky, semitranslucent agate, dolomite, chalcedony, howlite, and trocha and puka shells. Warmer white beads are those of bone hairpipe. The iridescence of mother-of-pearl is a colorful alternative to stark white.

As long as there is light there will be white, luminous and bright.

Barbara Grainger uses crystal-lined and translucent beads to create a glistening icescape in "Willow Winter." Branches drooping under the weight of petals frozen in full bloom, and flecks of iridescent colors hint at life beneath the hush of winter. Peyote and carpet stitch, surface embellishment, and fringe.

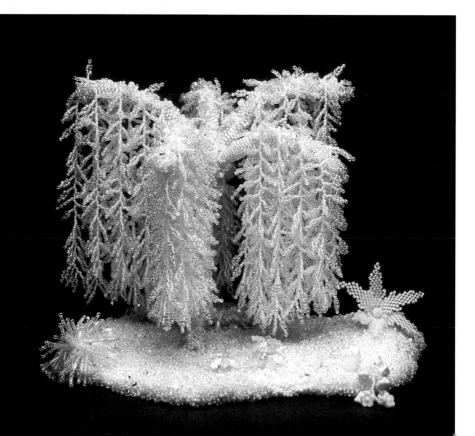

BLACK

Black is cloaked in mystery. We hunger to know its secrets, yet we fear what may be revealed. As human beings, we yearn to unravel life's secrets even as we fear the unknown. This desire/fear response is the essential enigma of darkness. We are simultaneously drawn to and afraid of the mysteries within black.

There is power within this tension and mystery. Black is a powerful presence: heavy, dominating, and pervasive. Like blue, it recedes, luring us toward it. Like a cloak, it cocoons and protects, hiding what we don't want exposed. Because of its associations with mourning and funerals, too much black becomes overwhelming, even oppressive.

Used judiciously, black reveals more of the colors in its proximity. When surrounded by black, bright colors advance, leaping forward. Black draws the eye to a particular color, setting it off and making it prominent. Against a black glass base, colorful, iridescent dichroic glass seems to pulsate. The black strips of lead in stained glass windows separate and delineate each color, increasing its brilliance.

Optically speaking, black is the absence of color. But no black is absolute; even soot reflects 3 percent incident light. And many blacks, upon close inspection, reveal themselves to be extremely deep blues, violets, greens, and even reds, especially in the medium of glass.

The darkest of all colors, shrouded in mystery, black is a color for drama. It provides contrast in any palette; the brighter the palette, the more drama accompanies its entrance. Wendy Ellsworth

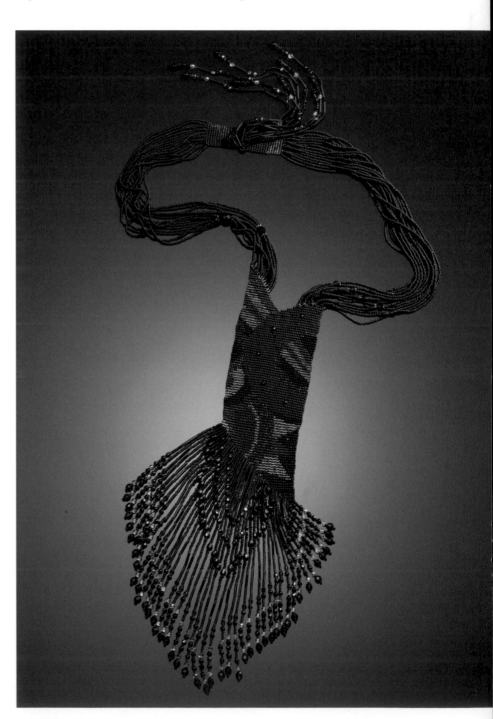

"Midnight Sun" by Margie Deeb launches an achromatic palette to new heights by using over eighteen different surface finishes within only two main colors: black and silver. This surface and texture variation draws you in to explore black and its mystery.

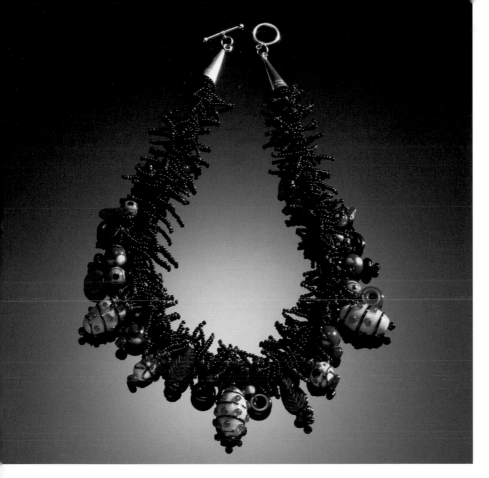

"Spikey Fringed Collar," Kimberley Price's textural feast, begins with a fuzzy black collar from which bright, bulbous bellies dangle like cartoon cocoons. The bustle of yellow and orange depends on solid black. It provides the stability and contrast for these brights to buzz in this bumblebee-inspired frenzy. Spiked fringe around a flexible core. Collection of Susan James.

accomplishes a sumptuous balance of black and brights (see page 52), using the most luminous of purples and magentas.

At the height of its power, black requires a companion that will stand up to it, one charged with intensity and luminosity. Red has both. Black and pure red make a most dramatic color statement.

With tints and pastels, black will make a striking statement, providing the pastels have enough color to stand their ground. Black will wash out weaker tones completely.

To tone down drama while retaining flair, try black with maroon instead of bright red. Pair garnet and black onyx. Modulate them with the sophistication of pearl and gold.

Because of their shared low luminosity, shades harmonize with black. Try smoky quartz, sodalite, or red jasper with obsidian and black onyx beads.

SUGGESTED PALETTES

1. DELICAS: DB-310, DB-022, DB-031
A matte black (DB-310) creates a velvety background for restrained, metallic bronze (DB-022) and radiant 22-karat bright gold (DB-031). Simple, conservative, and mature.

2. DELICAS: DB-010, DB-918, DB-116, DB-157
A flat ink representation of this unusual palette does little justice to the actual palette made of beads. It begins with DB-010, an opaque black with a reflective surface. Shimmering teal (DB-918) and transparent luster red (DB-116) lavish it with sumptuous color and sparkle. Accents of cream with an AB finish (DB-157) effuse tiny pink-blue rainbow sparks.

Stones with black in their matrix, such as certain types of turquoise, thrive when combined with black; so does tigereye, with its dark striations.

Black blends beautifully with natural materials like agates, earth-toned jaspers, coco and pen shells, and bone.

Variation is the secret to successful black-on-black beadwork. Even among blacks alone, an array of textures and finishes achieves contrast. The shine of an opaque finish next to a flat matte finish makes the latter appear dark gray, and furnishes a slight bit of value contrast. Try rough against smooth textures, and cool blacks against warm blacks.

In fashion, black will always be the ultimate statement of chic. Perhaps wearing it intimates that one has unveiled the secret to black's mystery. The simplicity of a strand of black and gold, black and silver, or black and pearl beads is timeless, and never out of vogue.

We yearn to know what is obscured by shadow. Let black entice with the promise of secrets revealed.

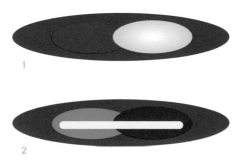

GRAY

Gray is at peace with itself. Like the wise crone or sage, it remains quietly in the background observing, detached, having no need to compete or prove anything. Like a standing stone, its strength is quiet, timeless, and classic. Gray is the refined achromatic tone of introspection and intellect.

Although gray is the color of neutrality, few shades are comprised of only black and white. They usually lean toward a hue. The most beautiful grays have a color identity, and a recognizable temperature (see swatches below). Cool grays harmonize most comfortably with blues, purples, and cool reds; warm grays prefer yellows, oranges, and brownish tones. Determine the undertone of a particular gray to select a harmonious palette.

In glass beads, the color undertones and the finish of a particular gray determine whether it appears hard as stone or soft as mist. Warmer grays with finishes of low reflectivity (like matte beads) are visually softer and more approachable.

Light grays have an atmospheric quality of dove-like innocence. Dark grays close to black are substantial and sophisticated. Charcoal is a smart choice when you want the effect of black without the heaviness. Deep, bluish grays deliver rich masculinity. Dark green-grays are complex and unusual, best combined with other low-intensity colors.

If gray is dulled and lacking in color identity it sinks into drabness, conveying unconscious messages of dirtiness or inhumanity.

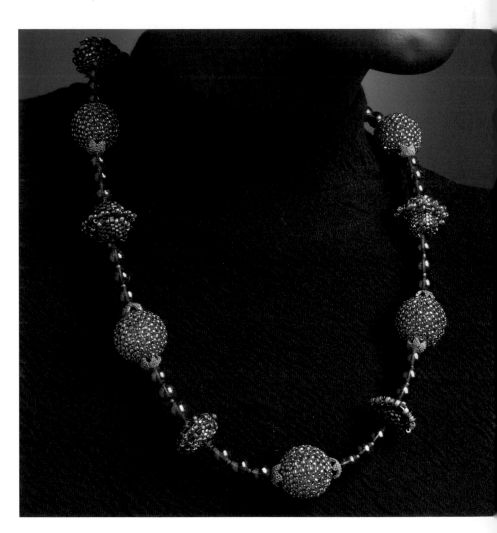

Monochromatic, cool blue-grays and silver derive interest from variations in texture, size, and finish. The simplicity of this restrained palette by Jacque' Owens delivers an uncluttered elegance. Right-angle weave and peyote stitch.

Gray's calm neutrality makes a perfect background for livelier colors. But be aware that adding it to a color scheme will tone down the overall palette.

1. Warm gray with yellow/orange undertones.
2. Cool gray with cyan undertones. 3. Warm gray with green undertones. 4. Warm gray with yellow undertones.

METALLICS

The rich glimmer of metallics elevates any palette. A color scheme can be raised to inspirational heights by the merest hint of silver stardust or glint of golden sunshine.

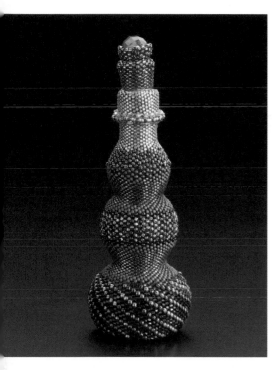

The metallic colors and finishes lacing this bottle hint of hidden treasures. Within such glittering, rainbowed opulence must surely reside a genie willing to grant one's wishes. Peyote stitch and right-angle weave.

Like gray, metallics have either warm or cool undertones. Gold is related to yellow, a warm color; silver is cool because it has a bluish cast, or is void of color and warmth.

Gold elevates and enlivens as wondrously as the sun's illumination. Like rays of sunlight, gold advances and warms those in its presence. It lifts the saturated jewel tones of emerald, amethyst, sapphire, and ruby to glorious heights, conjuring illuminated manuscripts with their glowing, gilded letterforms.

Sparkling gold injects vitality into gentler color schemes with rose quartz and blue lace agate. But always be conscious of the color cast of gold beads. Some have an orange cast, some a yellow cast. Some gold—and all brass—has a green cast. Gold varies in brightness and lightness, as you'll see when you compare yellow gold to rose gold. Dark antique and burnished golds lend an air of timelessness to jewelry.

Cool silver suggests the moon, the night, and the feminine. Like gray, it is introspective and calm. Its sparkle is less harsh and more effusive than gold's. Unite silver with any tone— light, dark, muted, or intense. It flourishes with cooler blue and evening's violet tones. Silver's versatility is seen in Balinese and Turkish silver beads that seem to combine with everything.

Copper and bronze are warm colors. Copper's undertones are orange; bronze's are green. When exposed to certain elements, a verdigris deposit forms on each. Thus the color green naturally harmonizes with both. In jewelry, add the aristocratic presence of bronze, dark and masculine, to achieve the appearance of a treasured antique.

Glass beads offer metallic finishes in a variety of rich colors. Most extraordinary is the range of greens and browns, which, being earth colors, have a natural connection with metal. Iris metallic finishes display scintillating rainbows that mesmerize.

Lavish your beadwork with metallic opulence. Like an alchemist who turns lead into gold, metallics will turn trinkets into treasures.

Representing supreme beauty, gold has long been valued for its enduring brilliance. No other tone can singularly enthrall like gold, as illustrated in this strand of beaded brilliance. Twenty-two-karat-gold peyote-stitched beads. Both pieces on this page by Jacque' Owens.

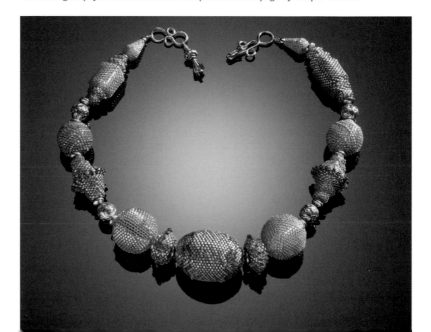

COLOR HARMONY

Color is personal and subjective. Just as we have color preferences, we also have preferences for combinations we think are harmonious. Only we can determine what colors and color combinations are pleasant and attractive to us.

One of the most powerful aspects of learning color theory is that it allows informed choice. Among many personal preferences, knowledge of theory expands the discovery of preferred combinations.

Of the millions of colors around us, we are able to distinguish but a few thousand. We see only a few spectral colors (pure hues) and their few modifications, and we group these into tidy categories to make sense of it all. We observe this vast, colorful universe and, as if recovering from a bead-buying binge, we sort the colors into only seven containers: hues, shades, tints, blacks, whites, grays, and tones.

In our quest for order, we humans seek balance. Stare at a yellow square for a minute, then close your eyes. You will see an afterimage of violet, yellow's complement. Your eye has restored its equilibrium by creating the complementary color as an afterimage. The procedure works with any color; the afterimage will be the complementary color.

While harmony includes objective order and balance, it also includes subjective order and balance, to which we now turn our attention.

In the color courses I teach, participants start by selecting several favorite colors from a tray of paint and fabric

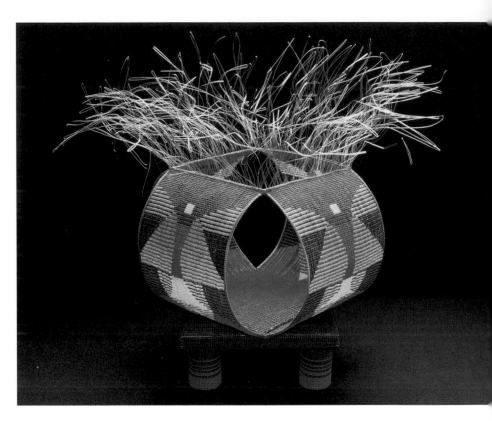

"Primaries" by Jeanette Ahlgren. This vessel of absolutely pure color dispels the notion that the traditional red-yellow-blue primary color palette must look child-like. Ahlgren's mastery and finesse are expressed in bold spectral hues, which are blocked, striped, stacked, and perfectly balanced.

swatches. I ask them to choose colors they adore. With no instruction to choose "harmonious colors," each person inevitably does just that. Though an occasional swatch may raise an eyebrow, it is rare that any one batch is glaringly discordant. As the class examines these uniquely personal color groupings the room resounds with "ooh!" and "ahh!" and "I never thought those colors would work so well together!" Most participants claim they never would have

deliberately chosen these particular swatches as harmonious groupings—they were just picking colors they liked! The point is demonstrated time and again: Even those who feel insecure in their ability to make sound color decisions have a unique, innate sense of harmony.

Learn the basics of color theory—the objective criteria—but trust your color instincts. They are alive and active, and they are yours alone. Above all, listen for your creative voice. It speaks in colors.

PROPERTIES OF COLOR

The key to color harmony is knowing how colors are similar to and different from each other. You can exploit those similarities and differences to make extraordinary combinations. Colors (also called hues) differ from one another in many ways. Every color can be categorized between extremes of contrast: light or dark, intense or dull, warm or cool.

VALUE

A color's lightness or darkness is called its *value*. A lighter color has a higher value; a darker color has a lower value. Yellow has the highest value of all the pure hues. Violets and blues, depending on their shade, have the lowest value.

Like all properties of color, value is relative. It changes under different intensities of illumination. Look at a charcoal briquet in the brilliant sunlight; areas that you know to be black appear to be very light gray. The whitest sheet will seem dull gray in a dimly lit room.

The value of a color is also relative to the color against which it is placed. Next to dark blue, yellow appears lighter than it does against pale orange.

Arrangement of values has a potent effect on composition. Guide your viewer's eye by strategically arranging contrasting values. Begin by consciously establishing the focal point. The eye is often attracted first to the lightest area within a piece, just as it is to bright stars in a dark night. Place the lightest and brightest beads where you want the viewer to look first. But, if a piece is all light beads with one dark bead, the eye will go straight to the dark bead; that is where the most contrast lies.

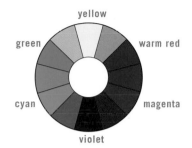
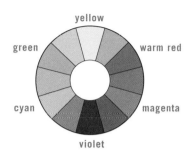

The pure hues of the ink wheel (left) and their respective values (right). The lightest (highest) value, yellow, is at the top, and the darkest (lowest) value, violet, is straight across the wheel on the bottom. Green and magenta are almost identical in value.

Work with value to deliberately achieve the balance you desire. Lower values give the appearance of being heavier than higher values, and can weigh down an area. Too much high value in one area creates imbalance because of an apparent lightness in weight.

Colors similar in value are naturally harmonious. Comparable value is the basis for the success of the lush palettes of fiber artist Kaffe Fassett, a master at combining many colors and patterns. However, exclusively using colors that are too close in value can put people to sleep. The eye can find neither a point of focus, nor a direction to follow. There is not enough contrast to attract attention.

Train yourself to discern the value by examining paintings and photographs and noting the distribution of lights and darks. Squinting helps separate lights from darks. Start by determining the lightest value, then the darkest, then look for tonal differences in between.

When designing a project, arrange your selected beads from lightest to darkest value. This helps you make conscious value choices. If you are stumped about the mid-value colors, examine a black-and-white photocopy of your beads. Value is easier to distinguish when hue has been removed.

The composition on the left is composed of values so similar the effect is stagnant and forgettable. The one on the right commands the viewer's eye through careful use of a full range of values: the eye goes immediately to the circle (lightest value) and follows the ribbon (second lightest value) out the top.

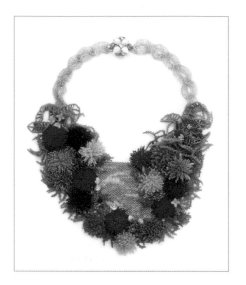

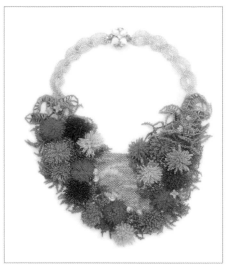

In "Escape from a Minnesota Winter," Diane Fitzgerald has used a full range of values, from the light of yellow to the dark of purple (and many shades in between). The three darkest and three lightest values are spaced to provide visual balance.

Look at the color version while covering the black-and-white version. To which color is your eye drawn first? Do the same with the black-and-white image and see if the results differ.

Even with the absence of color, this piece is pleasing. This is a result of the healthy amount of value contrast and tonal difference (lots of shades of gray).

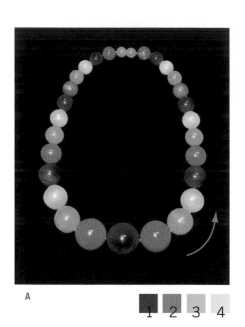

A 1 2 3 4

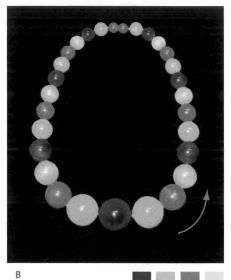

B 1 2 3 4

When working with colors in sequence, always consider value.

Values placed in natural order—darkest to lightest, or lightest to darkest—are the most pleasing to the eye, as in examples A and C. In example A, the beads are placed in sequential order by value, with the darkest bead in the center.

In examples B and D the values are not sequential. The transition from bead to bead is more awkward and jumpy. The overall look is not as sophisticated. In some cases the effect may be desired, as with strands of festive Mardi Gras beads.

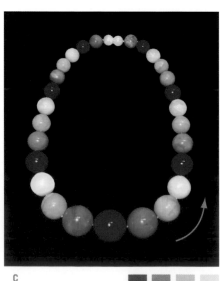

C 1 2 3 4

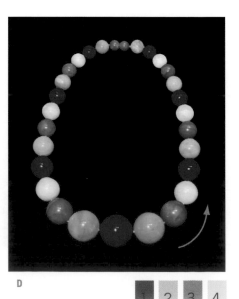

D 1 2 3 4

The eye may be slightly distracted from value by color in examples C and D, but it still reads the smooth or awkward transitions from dark to light.

In these examples, the hues alone are pleasing because they are analogous. Example C is especially appealing because of the combined use of analogous colors and sequential values.

INTENSITY

The *intensity* of a hue refers to its relative purity or grayness. Also referred to as chroma or saturation, intensity simply defines the degree to which a color is pure. Intense colors are fully saturated with their pure hue. Less intense colors are less saturated.

Low-intensity colors are produced by diluting the pure hue in any of four ways. Adding white creates a tint, making the color slightly cooler. Adding black creates a shade. Adding gray creates a tone, rendering the hue more neutral and dull. Finally, mixing the color with its complement generates unusual chromatic neutrals.

Intensity is often mistaken for value. However, value is the relative lightness or darkness of a color. Value can influence the intensity of a color, but a lower value does not necessarily mean lower intensity. The purest violet of this circle is a color with low value, and it is an intense, fully saturated color. Intense colors can be any value and retain full saturation.

The apparent intensity of a color is relative to the colors around it. For example, when placed next to vivid, pure orange, maroon appears to have low intensity. But next to dull green, the same maroon becomes more intense.

The intensity of a color may be muted by placing it next to a larger area of more luminous or darker colors containing a percentage of the color itself. For example, to tone down a bright yellow bead, scatter many darker, duller yellows around it.

When a primary is mixed with its complement, intensity is reduced. Here, each primary (on the ink wheel) is mixed with increasing amounts of its complement. The lowest intensity or saturation (weakest chroma) is in the very center (column 4), where the pure hues are no longer visible. They have been completely dulled by their complements.

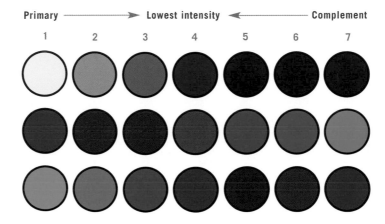

It is important to distinguish between intensity and value.

In these two examples, the circles in column 1 are pure hues, thus they have a high intensity. In column 2 the value of the pure hue has been lowered. In column 3 the intensity has been lowered.

The value of the column 2 circle is the same as that of the column 3 circle for each color, even though their intensity differs. To test this, make a black-and-white reproduction of the diagram and note that circles 2 and 3 are the same value of gray.

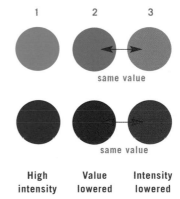

High intensity	Value lowered	Intensity lowered

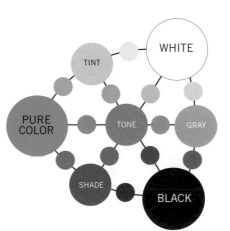

The Birren Color Equation, created by Faber Birren in 1937, shows the relationship of a pure color (in this case, pure cyan) to its tones, shades, and tints.

Harmonious sequences can be determined by following the lines. A tint harmonizes with its pure color and white, as it contains some of each in its mixture. A tint can work well with black if a tone is used to unify and balance the two.

The Birren Color Equation applied to stringing beads offers aesthetically balanced sequences in lieu of random placements. A pure cyan bead positioned next to a bead of darker cyan, followed by a black bead, is more visually pleasing than a random placement of the three, because the human eye naturally seeks order.

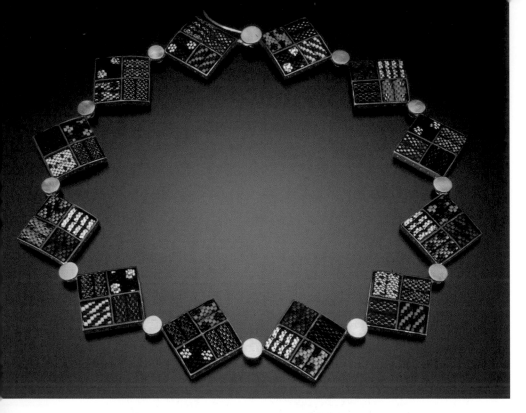

These two "Confetti" necklaces by Valerie Hector demonstrate the difference between using fully saturated (high-intensity) colors, and colors with less saturation (lower intensity). Bright, vibrant colors dominate the necklace above. Unique and intricate, the dramatic colors create a lively pattern of visual movement within each square and around the entire piece.

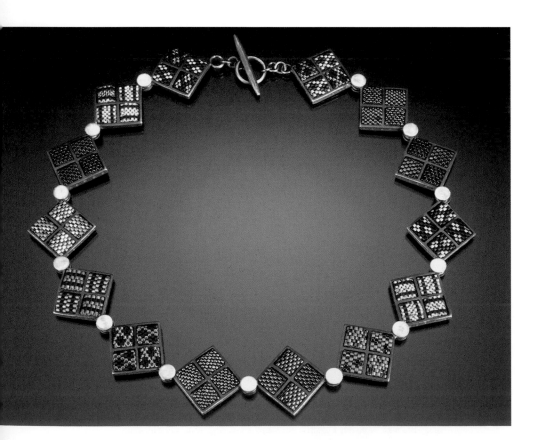

Less bold, but no less intricate, this necklace uses more subdued tones. Lower intensities slow the visual movement within and around the necklace, creating an elegant subtlety. Both pieces use a full range of values.

When combining low-intensity tones (especially grays) with more saturated, vivid colors, be aware of how they affect each other. In a large area of vivids, a small amount of dull gray takes on a lively appearance. A larger field of dull gray weakens the intensity of small portions of vivid color it surrounds.

Contrasting low- and high-intensity colors produces sophisticated results. Bright colors stand out against low-intensity backgrounds, particularly when the colors are complements of each other.

In glass beads, the intensity of color is affected by three distinctive factors: reflected light, thread color, and the color against which the bead is placed. For example, dark thread lowers the intensity of transparent, semitransparent, and even opaque beads. White thread used in the same beads increases their intensity, because more light and color is reflected back to the eye.

Contrasting intensities produce dramatic effects. High-intensity colors become more lively. Low-intensity colors can become rich and subtle. Practice stringing high- and low-intensity colors side by side and watch the colors shift. Study the effects of vivid colors woven into low-intensity palettes.

TEMPERATURE

Like fire and ice, orange and blue are the hottest and coolest colors on the wheel. The closer a hue is to orange, the warmer its temperature. Likewise, a hue closer to blue is cooler.

Temperature contrast is not just seen, it can be felt. Because warm colors stimulate circulation and cool colors slow it down, people in a room painted red-orange feel 5 to 7 degrees warmer than those in a room painted blue-green. Horses in stables painted blue cool down faster after a race than those in red stables.

Warm colors are dynamic. They grab your attention. Cool colors are calming and refreshing. Certain blues seem frigid or austere. The woman in the red gown is invariably perceived as easier to warm up to than the cool, unattainable one swathed in icy blue.

Surface finish (see page 54) affects a bead's perceived color temperature. Highly reflective surfaces appear hotter because they are active and reflect light. Matte and luster finishes appear cooler because they are calmer and absorb light.

Color temperature is relative; every color has a warm and cool version. Create depth and vitality by mingling different temperatures of one color family. For example, interlace warm yellow-greens with cool blue-greens and teals.

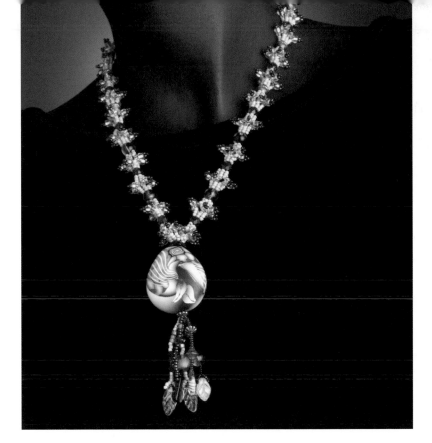

Brilliant splashes of hot red are tempered by subtle pinks, muted greens, and refreshing blues. Fluid, swirling forms and gentle gradations of blue transform polymer clay into a magical amulet. Necklace stitched in a variation of Zulu flowerette stitch using Japanese glass, German pressed glass, and vintage glass beads. By Karen Lewis of Klew Expressions.

The "Tanjung Kundur" sea form by Wendy Ellsworth illustrates the pulsing movement born of the interplay of warm and cool colors. The undulating outer rim of the creature blazes yellow and orange. Moving inward the fire is quenched by blue and lavender. A surprising hot spot of yellow and pink draws your eye to its heart.

COMPLEMENTARY RELATIONSHIPS

Complementary colors sit opposite one another on the wheel. Reconcile these opposites, and you can work wonders!

In *Elements of Color*, Johannes Itten writes of complements, "Two such colors make a strange pair. They are opposite and they require each other. They incite each other to maximum vividness when adjacent; they annihilate each other to gray-black when mixed, like fire and water."

On the artist's color wheel (page 14), red is green's direct complement because it is situated directly across from green. On the ink wheel (page 15), magenta is green's direct complement.

A complementary harmony provides the most contrast in hue possible; its colors sit farthest apart from each other on the wheel. Red is less like green than any other color. As you move away from red toward green, the colors are more similar to green, and therefore provide less contrast.

Complementary relationships offer the balance and equilibrium your eye seeks. The phenomenon of after-image (described on page 40) illustrates that staring at a single color for a few minutes will produce an image of its complementary color. When the complementary relationship is established, equilibrium is restored and balance is achieved.

As discussed under "Intensity" (see page 43), when mixed as pigments, complements negate each other and yield a neutral gray. Though not particularly appealing, this neutral gray is the color of established equilibrium.

Complementary relationships are the most dynamic of all hue contrasts. Successful combinations depend on getting the proportions right. The smallest, tingling accent of a complementary color can resuscitate the weakest color scheme. Too much of one or both complementary colors can collide and pulsate uncomfortably.

Nature loves complementary relationships. Red, pink, and magenta flowers look spectacular against their green foliage. Most purple and violet flowers have yellow centers. The orange rock against the blue sky of the American Southwest is a sparkling sight to behold.

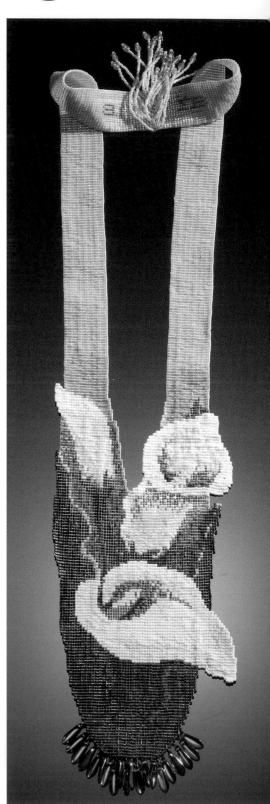

"Frieda's Callas" by Margie Deeb (with inspiration by Frieda Bates) beautifully illustrates the harmony of the magenta/green complementary relationship. Tints of magenta provide a gentle balance to more than twenty shades of green. Loomwork by Frieda Bates.

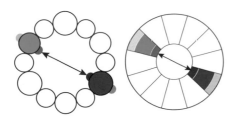

Green is the easiest color for the eye to process; red is the most jarring. An interplay of peaceful rest and dynamic stimulation occurs when these two are juxtaposed. In correct proportions, the result is just enough tension to excite while remaining balanced.

Unique to this complementary pair is a similarity of value. Pure red (and magenta) and pure green are both colors of medium value, so they naturally harmonize. To achieve more value contrast when pairing them, use shades with tints: Pair dark greens with blushing pinks or rose tints; use deep garnet reds with mint and sage greens.

Because of their proximity of value, when red (or magenta) and green are simultaneously presented in minute areas they become diffused by the eye and the effect is a dull, muddy brown. However, if the areas of red and green are large and dissimilar, they create a bold presence.

This classic complementary harmony is popular in interior design. Any home decor magazine displays shades of mint, sage, and forest green combined with pinks, mauves, and maroons.

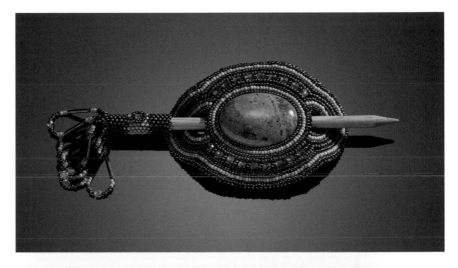

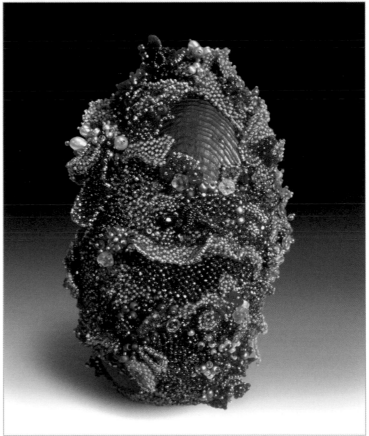

Jennifer Fain creates a simple and elegant near-complementary scheme (top) inspired by the cabbed jasper in the center. The coral hue dominates the stone; the shades of olive green dominate the beadwork, creating exquisite balance and harmony. Hairbuckle made of seed-bead embroidery and circular peyote stitch.

Red erupts and unfurls from a bed of rippling green and yellow-green moss, proclaiming the power of complementary colors. Beaded vessel (above) by Cheryl Cobern-Browne. Right-angle weave and sculptural peyote stitch over a form.

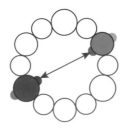

YELLOW/VIOLET

The glorious yellow of sunshine, the mystical violet of twilight—this spectacular complementary relationship is noted for its extremes. This pair vibrates with dramatic contrast in hue, value, and movement.

Pure yellow has the highest value of all colors. Violets can be the darkest, depending on their shade. Yellow moves; violet is still. Yellow is bright, happy, and gregarious; violet is dark, contemplative, and inward. Like sentinels, they balance the top and bottom of the wheel, holding it together with the attraction of extreme opposites.

In its purest states, the yellow/violet pair is playful, magical, and festive. When subdued into tints and shades, it becomes charming, sophisticated, and sublime.

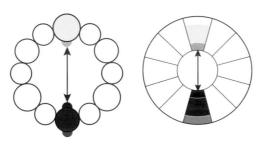

Jeanette Ahlgren orchestrates the tension and movement of the yellow-violet relationship in "Release." Hue, pattern, temperature, and value are sculpted to draw your focus immediately to the violet geometrics.

ORANGE/BLUE & WARM RED/CYAN

This complementary relationship is that of fire and ice. Being situated on opposite sides of the wheel, all complementary pairs have some degree of temperature contrast. This pair has the greatest. Of all the colors, oranges and warm reds are the hottest. Blues and cyans are the coolest. This juxtaposition of hot and cold makes a particularly sparkling contrast.

On the pigment wheel, orange and blue sit across from one another. On the ink wheel, warm red complements cyan.

In the American Southwest, orange rock against blue sky could have been the source of inspiration for the enduring turquoise and coral combinations (representing heaven and earth) of Native American jewelry. A darker version of this combination is carnelian paired with lapis lazuli.

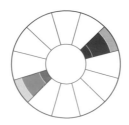

In this necklace and earring set by Margie Deeb, the abundance of bright gold ties warm red and cyan together, adding elegance to what could have been a garish combination of complementary colors.

COLOR & DESIGN

What makes a well-designed piece of beadwork? How do you create a unified, harmonious piece that is so completely balanced and whole that nothing added or taken away would improve it? A few basic concepts of design will launch your journey as you seek the answers.

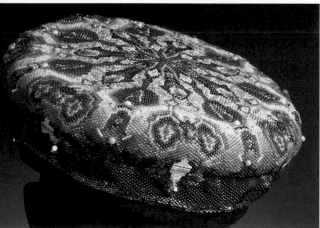

CONCORDANCE

Harmony is created when there exists a balance of similarities and differences. Whether the similarities and differences are of color, shape, size, texture, or movement, enough concordance and enough contrast must be at play to achieve balance and a dynamic tension.

Too many visual differences confuse the eye. What if every bead in the bead store were dumped into one huge bowl? Though enticing, the arrangement wouldn't be harmonious or well designed. Such a completely random mix offers delightful textures and colors, but provides no focused direction, and no place for the eye to rest.

After feasting for a moment on that random mix, your eye will spot all the bright yellow beads and begin grouping the yellows. You are seeking order. And you are finding order through concordance—colors (or shapes or sizes) that are similar.

The most obvious way to achieve color concordance is through hue; choose colors similar in hue. Three analogous colors—yellow, yellow-orange, and orange, for example—are concordant because they are similar in temperature and value, and sit next to each other on the color wheel.

Achieve concordance by organizing colors of similar temperature, intensity, or value into well-defined areas. Burgundy and olive green are the offspring of highly contrasting colors, but they harmonize beautifully because of their similar low value and low intensity.

Apply the harmony of similarities to movement, pattern, rhythm, texture, and shape by repeating and echoing some of these elements.

Expertly juxtaposing tints and shades of only three colors, Madelyn C. Ricks weaves a rhythmic pattern that guides your eye through "Celtic Band Neckpiece" (top left).

Fifty colors of complex patterns and harmonies rotate around "Genevieve's Hat" (bottom left) by Anne Hawley. Your eye is drawn in and around, led by the colorful rhythms (see page 51). An assemblage of seed beads, semiprecious beads, and Swarovski crystals in flat round peyote stitch on suede lining.

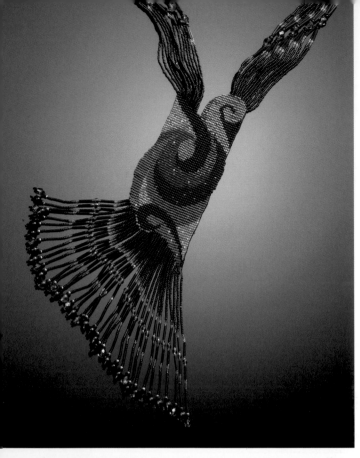

CONTRAST

Contrast is the opposite of concordance. A composition needs contrast because too much visual similarity becomes monotonous. Imagine everything being the same shade of the same color! There would be few cues to help you make a visual distinction between your beads and your lunch. (Despite how delicious they appear, beads never taste as good as they look.)

The more contrast you use, the more dynamic and energetic your work. If you like high drama, begin by emphasizing differences.

In "Properties of Color" (page 41) we covered the major ways to create contrast among colors—value, intensity, and temperature. To create contrast, vary these properties of color. The easiest contrasts to discern are those of value and hue.

But don't limit differences only to color. Contrast basic design elements. Weave straight lines against curves, diagonals against horizontals, blocks of color against spheres of color. String patterned beads next to solid colored beads and square shapes next to ovals.

Play with contrasting finishes and materials. Combine smooth beads with faceted, irregular, or chunky beads. Place shiny metallics next to flat matte finishes.

In single-strand necklaces, a contrast in size piques interest. A strand of large, faceted amethyst chunks separated by spacers and seed beads is far more intriguing than a strand of amethyst beads that are all the same size.

Texture contrasts are both visually and tactilely fascinating. Everyone loves to touch fringe laden with beads of different sizes. Add texture to seed-bead weaving by introducing larger beads, peyote ruffles, kinky fringe, or netting.

But be careful with contrast. Too many contrasting elements overwhelm and confuse the viewer. When exploring contrast, aim for balance and unity.

MOVEMENT

Movement infuses your creations with life. Without life, a creative work is just a pretty bauble. You can ensure movement in your compositions through the skillful use of color, shape, size, and pattern.

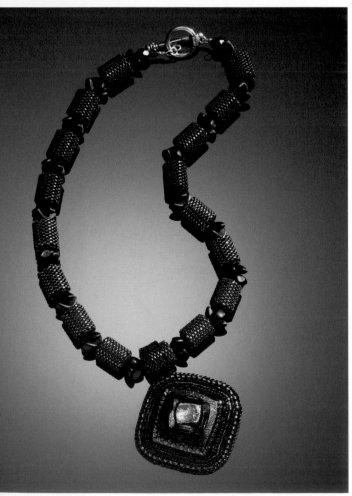

Movement, concentric and swirling, plays the dominant role in the split-loom necklace "Pursuit of Beauty" (top left) by Margie Deeb.

Movement of tonal gradation is the intrigue of Jacque' Owens's beaded-bead necklace (bottom left). The eye follows dark to light and magenta to violet, seeking the beginning and end of the progression. Peyote stitch and bead embroidery.

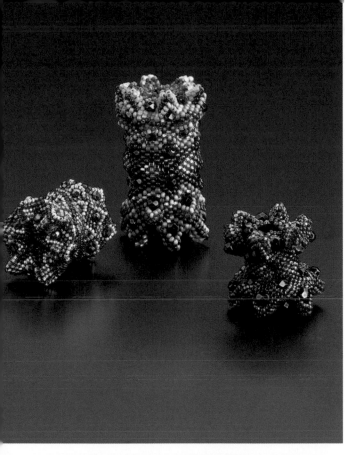

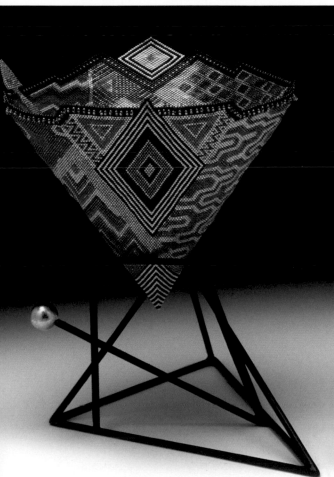

Diagonal arrangements are the most active. Horizontal arrangements, suggestive of landscapes, are serene. Vertical compositions convey stately elegance.

Follow the movement in "Spectral Tapestry" (page 10). All elements of color and design are carefully arranged to lead your eye from the outer edges toward the center panel. The width of the vertical panels changes from narrowest on the outside to widest in the middle, causing movement to slow as it reaches the center. Fields of color form a shape that sweeps inward while thrusting upward. Your final focus is secured by the lightest and darkest colors paired in the center.

Gradations of color create movement, from high to low intensity, or light to dark. The eye follows the order of gradation, seeking the beginning and end. Use this natural tendency to guide the viewer's eye and create movement.

RHYTHM & REPETITION

Pattern is created by repetition. Like a tour guide, it invites you in, shows you around, and points you to the exit when it's time to leave.

In a pattern, the eye seeks a focal point. Focal points may be the brightest (or darkest) colors, or the largest expanses of color. In fact, any element that stands out from its surroundings becomes a focal point.

When creating patterns, consider the relationship between positive and negative space: The shapes created by foreground and background are equally important. When movement is present, so is rhythm. When pattern is present, so is rhythm. What better way to make your beadwork dance than to drum it to life with rhythm? Rhythm is the pulse of a composition.

Perhaps you like regular, predictable rhythms. "Celtic Band Neckpiece" by Madelyn C. Ricks (page 49) delivers a steady, march-like cadence. Perhaps you eschew the predictable. Then vary your rhythm by changing the spaces between repetitions, or change the rhythm entirely. Madelyn C. Ricks changes the rhythm (and movement) in her kimono (page 65) countless times.

Each bead in Jacque' Owens's cyan and purple necklace (page 52) taps its own tempo. Strung together in concert they beat a cohesive and lively rhythm.

In "Terry Beads" (top left), a tribute to London shoe designer, Terry DeHavilland, Linda Breyer creates regular and rhythmic patterns based on the diamond shape. Focal points are the large, faceted beads that lead your eye around each piece.

In "Vessel #2" (bottom left) by Madelyn C. Ricks, rhythm is established and interrupted countless times. Like variations on a musical theme, each section has its own pace and rhythm, tied together with a dominant melody of saturated colors.

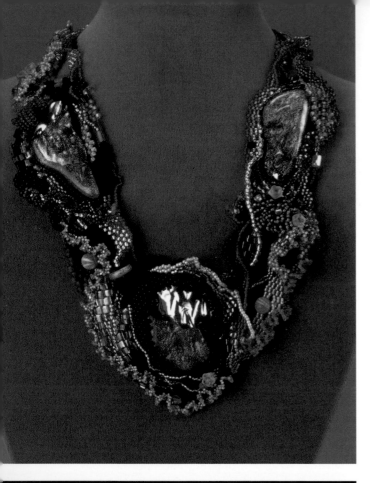

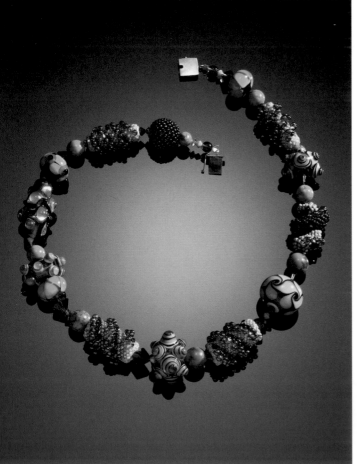

DOMINANCE

Dominance, whether in color, composition, or both, unifies a finished piece, giving it a sense of oneness. Design elements and concepts mean little if your work lacks this wholeness. All the elements must be somehow unified. How? Elevate one or two elements above all others. Let this dominant force govern everything else in the piece.

Dominance is crucial to all art. Even the squirt, blob, and swash paintings of abstract expressionists employ dominance—that of texture or movement, or a prevailing color family—to unify their work.

Try using color as your dominant, unifying element. Color dominance assumes many faces, simple and complex. Establishing a dominant color or color family is the simplest approach. According to Johannes Itten, "emphasizing one color enhances expressive character."

The tonal approach is a more complex use of color dominance. This method uses dominant tones (muted and darker, or intense and brighter) rather than specific hues. Lower intensity colors dominate Ann Tevepaugh Mitchell's beaded sculpture, "Evening" (page 139). Fully saturated, high-intensity colors (with an obvious dominant hue) are the tones of "Into the Vortex" (page 123).

Oneness is also created by a dominant compositional element. Texture dominates Cheryl Cobern-Browne's beaded vessel (page 47). The rhythmic repetition of similar-size patterns and solids unifies Valerie Hector's "Confetti" necklaces (page 44).

Texture and color unify the diverse components of the "Pink Pizzazz" neckpiece sculpture (top left) by Wendy Ellsworth. The effect of a mass of dissimilar rhythms, surface finishes, and bead sizes is a fascinating aggregation of energy.

A variety of rhythm, from soothing regular beats to staccato percussive accents, contribute to the lively cadence of Jacque' Owens's necklace of lampworked and beaded beads (bottom left).

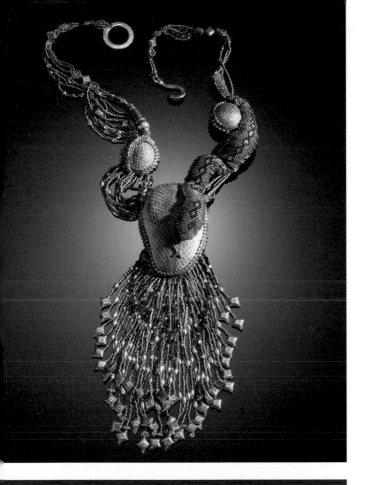

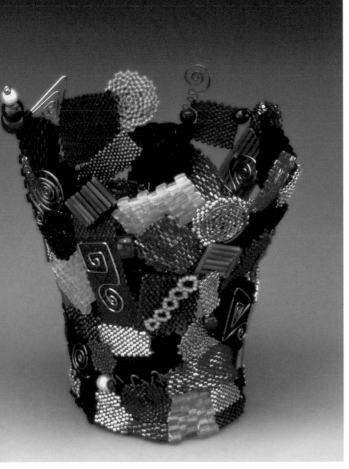

PROPORTION &
AREA OF EXTENSION

When it comes to color, size matters. The size of the area a color occupies relative to surrounding colors, referred to as "proportion and area of extension," strongly affects the harmony and balance of a composition.

Johannes Itten explains: "Contrast of extension involves relative areas of two or more color patches. It is the contrast between much and little, or great and small... Two factors determine the force of a pure color, its brilliance and its extent."

Pure red dominates many a palette, especially if it claims more than half of the color space. But what if it reveals only a sliver of itself? A small amount of red flirts rather than seduces, and the message of the entire color scheme changes.

As light as yellow is, it can visually dominate its heavier complement, violet. Because of its brilliance, it is three times stronger. If you are looking at the same amount of yellow and violet, the yellow will demand your attention, outshining its partner. Because of this, be sure to consider how much space they each consume when pairing them. Color theory suggests that one tablespoon of yellow for every three tablespoons of violet induces balance and harmony. You needn't swallow this medicine whole, but it's a good starting point when pairing yellow with violet.

Your journey has begun. With traveling partners of concordance, contrast, movement, rhythm, repetition, pattern, dominance, and size and proportion, you can discover your pathway to creating extraordinary design.

In this pure-on-neutral color scheme (top left), Suzanne Cooper charms "Jake the Snake" to life. Warm mauve-grays undulate with just enough contrast and detail to pique interest. Without warning, a minute area of pure reptile green leaps toward the viewer. Had Jake been created with green scales, or a variety of colors, his presence would be less striking. Peyote stitch, snakeskin, wood, glass, and silver.

The balance of this piece (bottom left) hinges on expert use of the contrast of color extension. A seemingly capricious arrangement, "Patchwork Collage Vessel" is actually carefully and precisely balanced. Similar-sized patches of color are evenly spaced; no area is heavily comprised of one hue. The brightest color occupies the smallest area of extension, and the darkest colors occupy the largest, balancing value and brilliance. Original design by Jeannette Cook of Beady Eyed Women.

COLOR & SEED BEADS

The colors of seed beads come premixed and cannot be altered. In pictorial representation using seed beads, we must trick the eye into seeing colors and gradations of colors that are not actually present.

We experience visual tricks every day in newspapers and magazines: Colors in a newspaper photograph are actually tiny dots, like seed beads, but much smaller. The eye mixes the dots optically, and perceives smooth transitions of intermediate colors and blends. Color blending is best explored using seed beads because they are the only beads small enough to generate smooth visual blends.

Ambient light, surface finish, reflectivity, thread color, and our brain all cause a bead's color to visually shift. The best way to know how beads will look in context is to weave sample swatches. Blend your colors irregularly and watch how the colors and surface finishes interact with each other. Study how the level of reflectivity of the beads causes surface finishes to behave. Even then, you may not be able to accurately predict the outcome. Yet this is what makes working with seed beads so much fun. How delightful when a transparent bead surprises you by adding more depth to the shadow of a landscape than you had anticipated!

Thread color has a significant impact on the finished piece, as is evidenced in the crocheted strand. Thread peeks out from between and behind beads, and often its color may show faintly through the beads, even those with opaque finishes, altering their hue. Crochet by Frieda Bates.

SURFACE FINISHES

A bead's color is altered by its surface finish. Depending on the bead's finish, the same hue of green can appear hard and rough or soft and smooth, as incorporeal as cellophane or as solid as velvet.

Admittedly, our premixed medium of beads limits our color selection. However, surface finishes give us a creative playground unavailable in other mixable mediums such as paint. Red paint is altered only by another color or substance (oil, glaze, varnish). In contrast, red beads come in many finishes: a matte, semi-matte, opaque, transparent, iris, luster, pearlescent, or some combination of the above.

In general, highly reflective, shiny surfaces advance and cause colors to appear brighter and warmer. Rough textures of low reflectivity absorb light and cause colors to appear flatter and more saturated. Surface finishes make a world of difference in how colors interact and what your eye perceives.

TRANSPARENT

Transparent beads allow light to pass through them. The glass is full of color, but the true color is only perceived if light (or the color white) is behind it. Nothing is more beautiful than a transparent bead if your work is to be backlit. This flash of true color seldom occurs, as beadwork is usually placed against one's clothing or skin. Thus, transparent beads visually recede, and look much darker when worn than in their tube. Their hue changes not only with their backdrop, but also with the color of the thread stringing them together. Their color is more pure when strung on white thread.

In "Octopus," Rebecca Brown-Thompson uses striped seed beads to suggest the organic, mottled texture of skin. The irregular blending of these beads with semi-matte transparents and opaques affords a realistic portrayal of the animal, complete with tonal gradations. Notice how middle tones are created by alternating black and striped beads.

OPAQUE

Opaque beads have a moderately reflective surface and afford robust color. They advance when placed next to mattes or transparents. Lighter opaques take on more of the surrounding colors than do darker opaques. The exclusive use of opaque beads gives a piece an ethnic look, such as Huichol or other traditional Native American beadwork, and sometimes projects even a primitive or child-like quality.

LINED

Silver-lined beads are highly reflective flashes of light and color that make scintillating accents. All that dazzle demands attention: Use sparingly. Because the silver lining eventually wears away, they are not recommended for jewelry that touches skin.

Color-lined beads are either clear or colored beads that have a stripe of color lining their center. Colored color-lined beads, because of the double layer of hue, have depth and offer a complex flash of color.

MATTE

The least reflective surface is a matte finish, a reliable workhorse that delivers flat, pure color with little fanfare. Matte beads—and semi-mattes—recede and make stable background areas for other beads to advance and shine. Large expanses of matte beads can be spiritless. Vivify them with accents of more reflective beads. A matte bead is ready and waiting to offer a rich foundation of color.

LUSTER

Luster finishes have a milky, translucent quality: not too shiny, not too dull. They reflect light gently and have a soft quality that carries pastel colors well. Pearl is used to describe opaque lustered beads, ceylon to describe translucent, and both have the same effect when used in weaving. Because they emit a soft glow, they generally blend easily.

GALVANIZED

Beautiful to look at, but not so beautiful to touch, the finish of galvanized beads rubs off easily, especially when placed in contact with skin. Do not use these if you are interested in the longevity of your work.

METALLIC

True metallic finishes like hematite, copper, and bronze add richness and depth. Theirs is a non-distracting reflectivity that enhances subdued, darker tones, lending an air of traditional elegance.

IRIS & AB

Iris and AB (Aurora Borealis) finishes have rainbow colors or a gossamer veil of iridescence over their main color. Each bead is a carnival of colors that shimmer and shift; thus they work well all by themselves in solid expanses.

A graph of regular blending of seed beads (left) is tidy and consistent. Irregular blending (right) places the beads more randomly, making a more natural transition. For the smoothest transitions, use as many rows as possible to change from one color to the next.

Regular blending (left) and irregular blending (right) of seed beads. Two shades of each of three colors are used to transition from yellow-green to orange.

BEAD SIZE

When using beads for pictorial representation, think of them as the tiny dots in newspaper photos, or the pixels on a computer monitor. The more dots or pixels a photograph has per inch, the better the image quality and the smoother the transitions from one color to another. Smaller beads, like smaller pixels, create smoother transitions from one color to the next, and more detail.

It is also important that bead size relate to the overall size of your finished piece. For example, if you are making a 1- by 2-inch earring in which you blend five colors, you will need the tiniest beads possible to achieve a smooth transition, because the workable space is small. But if your piece is a 5- by 5-foot wall tapestry, smooth transitions of five colors will be very easy to make with large seed beads, because so much space is available.

TRANSITIONS

To achieve a smooth transition from one color to another, simultaneously reduce the number of beads of one color while adding more beads of another color. Each subsequent row must contain more of the color to which you are transitioning. Such rows are called transition rows because they include beads of all colors being blended. The goal is to arrange the beads so that the colors being blended are visually indistinguishable from one another.

There are two main methods of blending: regular and irregular. Regular transitions are rendered in a precise, rhythmic pattern. They are tidy and have a computer-generated look. Irregular transitions are less predictable. They reduce the amount of one color while adding more of another color, but do so in a less calculated, more random manner. Irregular blending results in a more natural appearance, but requires more transition rows to achieve smoothness.

Use fewer transition rows to create a more abrupt shift of color. A smooth blend between similar colors, such as analogous hues, requires fewer transition rows than a blend of dramatically different colors, such as complements. When blending contrasting colors, use more rows for the transition.

When using seed beads to realistically portray skin, value is the most important factor. If your values are accurate within the context of the whole picture, the colors you choose need not be as exacting. For example, the values of "Waning Crescent" (page 81) were precisely arranged to depict a three-dimensional face. Remarkably, the actual colors are not flesh tones at all, but shades of blue!

To achieve accurate values, create your pattern first in black, white, and grays. Determine the lightest and darkest areas first, and decide how many mid-tones you want between them. Surprisingly, only a minimum number of mid-tones are necessary to create a relatively realistic form.

If you are portraying several races in one image, your values must be carefully balanced against each other. Note the relative values of the pale skin of Caucasians, the mid-toned skin of Latinos, Indians, and Asians, and the dark skin tones of those of African descent.

After you've determined the exact placement of all values, assign a color to each value that approximates its lightness or darkness.

To choose flesh tones, consider the race of your subject. Flesh tones vary widely. All contain some amount of yellow. Caucasians have more pink tones. Latinos, Indians, and Asians have more red than Caucasians. Lighter-skinned Blacks have more yellow than most, while darker-skinned Blacks have red and sometimes blue undertones.

In all races, human flesh is made up of many hues. If you have the available space, blend several flesh colors of similar value to achieve greater realism. For instance, select several light mid-tones, some leaning toward pink, others toward yellow.

In "Journeys End," Laura Willits creates a mystical nightscape. From a distance, her work appears to contain areas of solid color. But, like a pointillist painting, these areas are comprised of many independent colors, both contrasting and congruous, in precise juxtaposition. The tiny dots of differing hues coalesce, tricking the eye into experiencing a shimmering expanse of luminous color.

highlights	light mid-tones				dark mid-tones			deep shadow
DB-204	DB-206	DB-205	DB-069	DB-067	DB-915	DB-764	DB-287	DB-734

An example of flesh tones in Delica beads and their corresponding values. Determine which values will constitute the highlights, mid-tones, and shadows, then assign colors according to their value.

COLORS OF THE SEASONS

Nature is the source of all true color. In her harmonies are supreme beauty and artistry. Each flower's stem displays just the right match of greens. Each animal's fur sports its own sublime tonal gradations.

Not only are nature's harmonies beautiful, they are also functional. She uses precision and purpose to color each life-form. Plants and animals are designed with colors that accentuate or attract, hide or disguise. The colors of sky, earth, and water fluctuate constantly, reflecting the function of each season: seeding, abundant growth, harvest, and rest. Our world is a glorious work of architecture, majestically beautiful and marvelously functional.

Each of us is drawn intuitively, almost instinctively, to certain colors and color groupings. Why does an array of spicy earth tones make one person tingle with pleasure and another cringe? Beyond conditioned responses lies a deeply personal connection to color. Looking closely at the color constellations we find irresistible, we may discover they correspond directly to those aspects of nature we find most alluring. It is possible that through nature's colors we can discover more about ourselves.

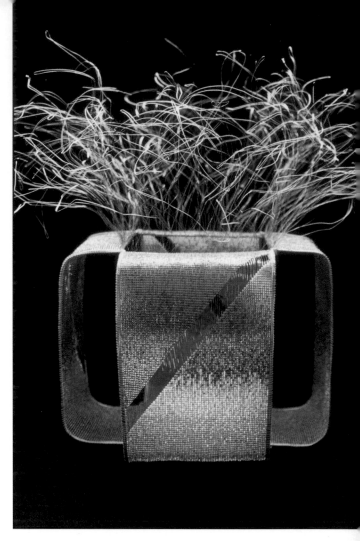

Jeanette Ahlgren finds her inspiration in many places, including the fuel lines of a 931S engine, which was the basis for her wire-weaving series. The colors of "Mantra" reflect the subtle tonal variations of the sky at dawn. The colors are delicate and feminine, reminiscent of gardens teeming with wildflowers.

The stark contrasts and cool undertones of "La Llorona" by Mary Tafoya make an icy winter palette. Layered bead embroidery on leather.

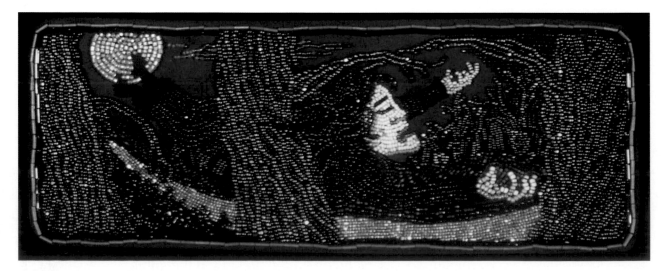

We are not just observers of nature. Each one of us is part of nature's beauty. And she has colored us as purposefully as any insect, plant, or animal—uniquely and functionally. Though our unique colorings may not serve to accentuate, hide, or disguise, they do serve a purpose, for coded into our coloring are clues to who we are.

The idea of using color for a better understanding of self and others began in 1928 when Swiss artist Johannes Itten observed a relationship between color preference, personality, and appearance.

In his book The Art of Color, Itten expounds on what he termed "subjective color," the colors to which one is naturally drawn. Itten found there was a strong relationship between the way students looked, their personality, and the colors with which they liked to work. "In my studies of subjective color, I have found that not only the choice and juxtaposition of hues, but also the size and orientations of areas may be highly characteristic" [of people with certain colorings]. He further discovered that in many cases, one's subjective colors point to aptitudes for specific vocations. He postulated that much of a person's mode of thought, feeling, and action can be inferred from their subjective color combinations and the coloring of their skin, hair, and eyes.

Itten also saw that one's subjective colors correspond to the colors of the seasons. He encouraged educators to use color analysis to uncover and respect the uniqueness of each student.

In the 1970s and '80s the fashion industry co-opted personal color analysis. It was a novel approach that appealed to the masses: Label yourself according to your hair, skin, or eye color, and dress more in tune with "your season."

But seasons, like people, are complex, each abundant with countless specific nuances. And seasons are made up of many weeks of temperature and light fluctuations that alter color. No week is exactly like the week before. The complexity required for accurate analysis according to season could not be reduced to a one-size-fits-all approach. Some tried to accommodate the masses, and in their attempt, grossly over-simplified the approach to personal color analysis. Everyone was crammed into four simple palettes. "Getting your colors done" was all the rage, and "I'm an autumn, I can't wear blue!" was heard ringing above the racks in boutiques everywhere. The limitations of a simplistic four-season approach became evident, and, ultimately, seasonal color analysis became no more than a passing fad. But the concept itself was not the problem.

Color expert Suzanne Caygill knew the profound value of seasonal color analysis and denounced its oversimplification. In her book Color: The Essence of You, she classifies sixty-four seasonal color types, each according to specific weeks of the season, some overlapping. "In discovering, through nature's harmonies, color as a key to self, we find a way of understanding exactly who we are, a way of getting outside of personal rigidities to connect with those energies that permit us to be ourselves. The more we can accept the colorful messages in the rhythms of the universe, the more authentic we become as persons, the more pleasure we derive for ourselves, and the more we give to others."

The study of nature's colors is not only a path to self, but also a path to the mastery of your art. Embedded in nature's colors are Itten's "objective rules of general validity." As you learn her palettes, yours will expand, and your work will become more congruous and coherent. You will understand what textures, patterns, shapes, designs, and styles work most harmoniously with certain colors.

The study of nature's colors brings to each day an exhilarating sensory experience. How alive you can become, scrutinizing the leaves, the air, the grasses, the bark of trees, and the creatures. Watch how the colors change from week to week and season to season. Indeed, the Impressionists worked to express the minute-to-minute profusion of nature's changing colors!

Through the study of nature's colors we become more connected to our world, its elements, and forces. Let her palettes inspire you.

SPRING

Clear, fresh colors washed by melting snows; new life unfurling on trees and springing from the soil—all enveloped by sunshine warming an awakening world. This is springtime.

To instill your work with the essence of spring is to imbue it with clarity, effervescence, and warmth, which will inspire hope and optimism in those it touches.

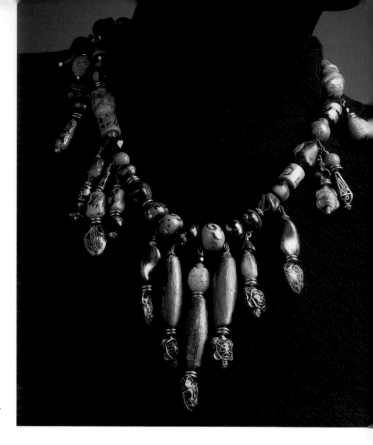

COLOR

With hues delicate and gentle, or vibrant and lively, the spring season is a colorful profusion of life and activity. Keep the palette clear and bright, avoiding low-intensity, dark colors and shadows. Throw in a few pastels with your mix of more vivid colors. Use a high-key palette (see page 96) and think warm! Spring colors have warm undertones, as they are bathed in sunlight.

ENERGY

Movement—carefree, buoyant, and peppy—is vital to this season bustling with life. People who resonate with spring are energetic and enthusiastic. Include moving parts, like charms, drops, and dangles, and use patterns that move, such as spirals and curlicues, and especially florals. Some spring palettes may prefer a more sinuous movement, like the winding, intertwining curves of Art Nouveau motifs.

DESIGN & STYLE

Spring palettes reflect new birth and cheerfulness. They are bursting with life, color, and light. They can even be frilly. There's nothing sleek about spring. Texture is lush, yet delicate. It is built up in light layers, or made with many tiny beads, rather than large, chunky beads. Carved beads in the form of butterflies, birds, and plants, especially flowers, convey the whimsy and charm of spring. If those are too cute for your tastes, convey whimsy and charm through form: curved lines, rolls, and fluted petal shapes. The spring style is light and carefree: filigree, openwork, netting, beaded crochet, delicate fringe that rustles, and charm bracelets that make tinkling sounds.

Spring Color Wheel

METALS

Springtime is sunshine, so gold, in all its shades of light, dark, and rose, is a must. Green-golds and brass, in small portions, convey sunshine. Silver harmonizes best when the palette contains blue tones. Bronze does not agree with the energy of spring because it is too heavy and dark.

STONES

Peridot is the quintessential spring stone. Its clear, liquid yellow-green looks like new leaves moist with dew. Ebullient citrine and gentle, petal-like rose quartz are next. Team them with mother-of-pearl shell or clear quartz for an extraordinarily clear, fresh palette. Cooler spring tones include blue lace agate, amazonite, translucent moonstone (in the white range), aquamarine, apatite, pale amethyst (avoid the heavier tones), and chrysoprase.

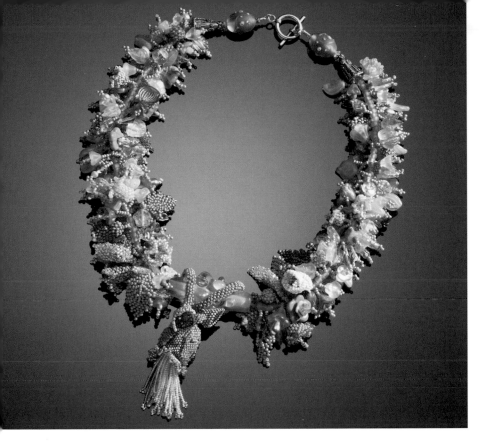

Alice Walker captures the exuberance of spring in this necklace (far left) of glass, cloisonné, and painted wood. Abundant movement, color, and life (in the form of turtles, frogs, and flowers) are the prevailing themes. These colors combine beautifully because of the clarity of each hue. Sunny accents of gold tie them together.

Jacque' Owens's version of spring (near left) is delicately lush and feminine. This is early spring, with its buds tightly furled and leaves just beginning to uncurl. All colors have warm undertones, and the whole palette is light and airy. Flowers are built with layers of tiny seed beads in peyote stitch.

SURFACE FINISHES

When choosing bead finishes, hold in mind visions of spring: dew on new buds (color-lined beads look like morsels of color suspended in drops of dew); a breezy afternoon of spilling sunshine (opaques are bursting with color, and silver-lined finishes flash like reflected sun). Judicious numbers of tiny cut beads add lively sparkle—but don't overdo it. Spring sparkle needs to be that of dappled sunlight on water, not of glittering starlight. Transparent and transparent luster finishes seem to be drops of liquid color, so use in abundance! The soft luster of opalescent, ceylon, and pearl finishes enhance floral spring palettes.

SUGGESTED PALETTES

1. DELICAS: DB-053, DB-174, DB-235
Springtime at its most effervescent: Two AB finishes and a pearl finish bounce light off each other like sunshine on dew. The AB finishes on the lined pale yellow (DB-053) flutter like a butterfly, while light neon lime AB (DB-174) is the green of a tiny new leaf. Pale coral (DB-235) softens the palette a bit with its pearlescent finish.

2. DELICAS: DB-249, DB-274, DB-233, DB-057
This palette has "Easter egg" written all over it. A light violet pearl (DB-249) makes room for its near complement, yellow-green, in a wet-looking lined finish (DB-274). Buttercup (DB-233) is violet's true complement, so the three work well as a trio. DB-057, with its iris finish, brings the blue of heaven into the group.

3. DELICAS: DB-074, DB-161, DB-1345, DB-031, DB-233
A background of lined fuchsia (DB-074) jumpstarts a boisterous troupe of hues. Opaque orange AB (DB-161) is a brilliant orange with gold highlights that cannot be accurately reproduced in ink. Bright silver-lined red-violet (DB-1345) invites highlights of gold (DB-031) and buttercup (DB-233) to play.

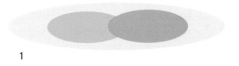

1

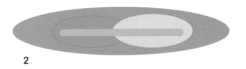

2

3

SUMMER

The heat of the unflinching sun envelopes the land in a suspended veil of haze. In the languid warmth life slows to a relaxed cadence. Summer softens the landscape.

Summer is a time to slow down. Designs that are relaxed and refined, gentle and muted, bring out the essence of her grace. This is not a palette to use when you're in a hurry. Unwind and let the ease of summer's essence slowly swirl your creativity into manifestation.

COLOR

The heat of summer changes the quality of light, thus changing the quality of all color. The yellow-greens of spring have turned to blue-greens. Indeed, in the haze, all colors seem washed in pale blue tones. The key to this season's sun-ripened colors is cool, muted tones. Hues are muted by their complements or the addition of gray: mauve, ash rose, gray-blues, and grayed lavender. The tones of the "Pensive" color scheme (page 116) play an important role. Signature colors are chalky, delicate, and feminine, bringint to mind cottage gardens teeming with wild roses, larkspurs, and hollyhocks. Dimmed blues of periwinkle and delft and soft tans such as beige, taupe, and fawn impart the unhurried mood of summer. The palette may have iridescence and include soft, rainbow tints, or a gentle incandescence that seems to emit a quiet glow.

ENERGY

Movement is graceful and relaxed, swooping like a S-curve or a slow swirl. A fluid delicacy, refined and gentle, captures summer's energy.

DESIGN & STYLE

Summer style can be like a watercolor with soft, fluid forms and edges blending into one another, or a complex floral print dotted with color. The irresistible casual nature of summer comes across in lines and forms that cascade and swirl. Avoid tightly woven or fussy structures. Style is romantic and dainty, nothing shiny or clanky. Braided and twisted strands, filigree, draping fringe, and Victorian motifs are tailor-made for the summer palette.

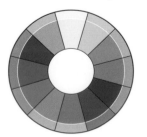

Summer Color Wheel

METALS

The cool undertones of silver and pewter, used delicately, are most resonant with summer tones. They combine beautifully with all the summer gemstones. Equally alluring is the gentle luster of soft rose gold. Avoid massive or chunky metals of any kind. This season does not abide the gypsy look of heavy costume jewelry.

STONES

Summer palettes showcase the more feminine stones, such as pale amethyst, rose quartz, aquamarine, fluorite, and tourmaline. Iridescent moonstone and abalone shells make lustrous additions. Turquoise, used in small quantities, is a lovely harmonizer. Pearls round off the palette perfectly.

In "Rhapsody in Flowers—Cascade" (far left), Margo Field creates summer's relaxed tone and style using complex and muted complementary colors. Pale magentas, pinks, and subdued violets contrast gently against warm olive greens. Peyote stitch and fringe.

In early summer, life has not yet come to its full repose, as spring still spills its blooms. Wendy Ellsworth captures this essence in all its iridescence and magic in "Summer Passion" (near left). Free-form gourd and herringbone stitch.

SURFACE FINISHES

Seek surface finishes that emit soft, almost hazy reflections. Aim for a gauzy look using pearl, ceylon, and opalescent finishes. Matte and semi-matte beads deliver pure chalky color reminiscent of many of summer's flowers; they are especially suited for the season in low-intensity colors. Evolve the palette with gold-luster and luster finishes that emanate a quiet glow. Use iridescent and AB finishes lavishly, as they embody that rarefied air of summertime twilight. Avoid the brilliant flash of silver-lined finishes, opting instead for semi-matte and matte silver-lined. Theirs is a dimmer, softer flash.

SUGGESTED PALETTES

1. DELICAS: DB-376, DB-377, DB-902
Two muted blues with a matte metallic finish, DB-376 and DB-377, bring to mind the feel of lazy, hazy summer air. A shimmering, low-intensity pink (DB-902) leaps off of the muted mattes, adding a sparkle of delicate color.

2. DELICAS: DB-629, DB-881, DB-135, DB-080
Four surface finishes comprise these colors that call to mind delphiniums on a summer day: DB-629 is a muted silver-lined lilac with an alabaster finish; a matte AB finish covers the periwinkle color of DB-881; DB-135 is a low-intensity metallic purple; and accents of a lined pale lavender AB (DB-080) finish with a flourish.

3. DELICAS: DB-374, DB-684, DB-067, DB-203
Creamy floral colors star against subtle, cool matte green (DB-374). DB-684, a semi-matte silver-lined begonia pink, pairs beautifully with a lined pale peach (DB-067). A ceylon cream (DB-203) crowns this gentle, retiring group of refined colors.

1

2

3

AUTUMN

Leaves twirl and dance, emblazoning the scenery with operatic colors. The sun's light slants, illuminating fields ready for reaping. A chill quickens the tempo of life, as this season of fruition and completion begins.

Filled with drama, autumn becomes a theatrical event of intoxicating sights, sounds, and smells. Autumn turns us back to the earth to gather the robust bounty of her harvest.

COLOR

Autumn's tones are burnished or darkened, and slightly lowered in intensity. They include the earth tones explored on page 32. With the exception of warm reds, they are never pure colors. The key is tone: mellow, rich, and warm.

Deliciously edible colors establish autumn's palettes: the golden oranges of butternut squash and pumpkin; the warm reds of apple and persimmon; the rich browns of coffee, pecan, walnut, and chocolate; the spicy tones of cocoa, cinnamon, and curry; and the cooler tones of plum and berry. Autumn greens come in shades of olive, forest, cypress, or fir—always toned down. Blues are limited to a slightly greenish blue such as a deep teal or a peacock blue.

ENERGY

Autumn is as forceful and determined as a gust of her chilly wind. There is a surety of movement in this season, nothing evasive or indecisive. Focus and direction are clear.

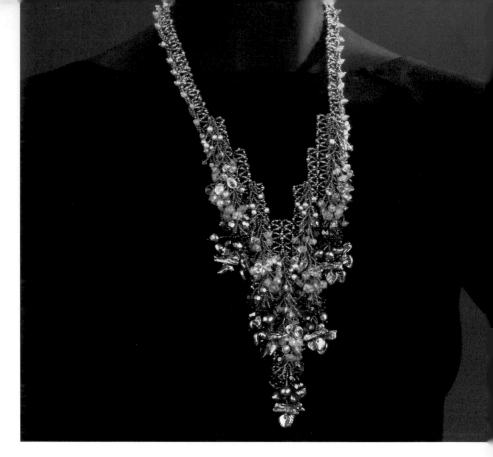

The flourish of early autumn is woven into "Chevron Elegance Necklace" (left) by Carol Wilcox Wells. Its myriad organic textures impart the ripe abundance of autumn.

DESIGN & STYLE

To reflect autumn's confidence, line and form is well delineated, with focus and a sense of drama. The style is robustly sensual, giving the impression that you can smell, taste, and hear the colors and textures. Jewelry jangles and clanks with such unusual artifacts as dZi beads, carved fetishes, scarabs, and coins. Texture and pattern abound. Planned textures of basketweaves, checkerboards, or geometrics capture the eye.

Mottled, or grainy textures of bark, leather, and pottery give an earthy substance. Autumn resonates with natural patterns and motifs, such as animal prints, snakeskin, and leaves (especially with points, such as maple leaves and pine needles). Flamboyance is a must. Achieve it with luxurious, exotic motifs inspired by the Middle East, such as Persian and Moorish geometrics, or Arabian and Byzantine ornamentation. And don't forget the Orient, especially China.

METALS

Metals are essential to this earth-based season. Autumn-inspired beadwork should give off a burnished glow, so weave radiant gold and/or warm bronze into every palette. The sheen of copper beautifully augments autumnal greens and blues.

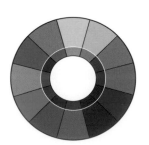

Autumn Color Wheel

Madelyn C. Ricks's "Autumn Splendor" kimono quietly radiates the warm and rich shades of the autumn palette. People inclined toward this palette often enjoy glowing metallic colors. Note the sophisticated balance of the near-complementary oranges and yellow-greens.

STONES

The autumn palette is the perfect setting for stones because, like metals, they are of the earth. Many stones embody autumn's essence. Most notable are tigereye, jasper, and agate, all of which feature requisite texture. Consider dramatic carnelian, the glowing yellows of amber and citrine, peridot's yellow-tinged green, and the low-intensity greens of aventurine and jade. Don't overlook smoky quartz and nuggets of turquoise in its dark, matrix-filled versions (avoid the clear, light, and bright versions). Autumn invites branched coral. It's not a stone, but oh, what texture!

SURFACE FINISHES

Metallics, gilt-lined beads, and gold lusters afford a palette the burnished autumn look. Avoid demure finishes such as pearlescent. Mix several surface finishes for a textural effect.

SUGGESTED PALETTES

1. DELICAS: DB-764, DB-913, DB-878
DB-764 is a chestnut brown matte transparent delivering the solid warmth necessary for the autumn palette. Shimmering salmon (DB-913) adds luminosity to an otherwise opaque palette, and accents of aqua AB (DB-878) give a cool, iridescent note to this unusual trio.

2. DELICAS: DB-116, DB-734, DB-651, DB-031
A background of an exotic transparent luster red (DB-116), reminiscent of Moroccan leather, begins this sultry autumn palette. Add dark chocolate opaque (DB-734) and goldenrod (DB-651), accented with 24-karat gold (DB-031) for spice and warmth.

3. DELICAS: DB-311, DB-280, DB-124, DB-272, DB-233
An autumn landscape in beads! Begin with a matte metallic olive green (DB-311), add deep garnet-lined crystal (DB-280) and the shimmering chartreuse transparent luster of DB-124. Golden, honeyed accents of DB-272 and DB-233 top off this most bountiful palette of the season.

1

2

3

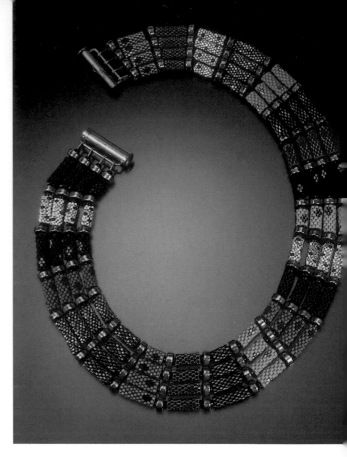

WINTER

The great wheel has made its final turn, ushering in a season distinct in extremes. Nature is at rest, replenishing and restoring, and the world around us is one of stark contrast.

Leafless branches stand black against pale gray skies. Days sparkle when sunlight skitters like diamonds across the snow, or draw out colorlessly in the tedium of winter overcast. We mark the culmination of the year by turning inward, to warmth.

Turn inward to the silence. Call upon your knowledge of beauty and your sense of style and sophistication to guide you in recreating the essence of winter.

COLOR

Intense, vivid, and pure hues convey the power and drama of the winter season: strong black against stark white, electric blue, stunning crimson, and regal violet—all with cool undertones. Pure colors can be darkened slightly with black. Intensity and contrast are the keys to this season's palette. For example, try accenting an expanse of pure cobalt violet with a flash of its complement, gold. Lighter colors are clear and crystalline in winter, appearing as if they were made of ice. Pearl tones are cool and icy because of their blue or purple undertones. Choose and arrange colors to convey striking beauty and regal dignity.

ENERGY

As nature hushes to a state of repose, movement is smooth, never jerky; natural, never forced; and graceful, never awkward. All motion is highly efficient, exerting the least amount of effort for the most impact. For example, one melodic, arching curve will reach its destination more quickly and more beautifully than many tightly packed loops heading in the same direction.

DESIGN & STYLE

Stylish, sophisticated drama is winter's mantra. Smooth undulating curves, graceful and distinct, echo the energy of winter. Accordingly, form is sculptural and well defined—often abstracted—like a Georgia O'Keeffe painting. Broad expanses of color are interrupted by one flaring accent, carefully weighed and placed. Several well-balanced jewel tones are juxtaposed with precision, creating shimmering drama (see "Pursuit of Beauty" on page 50). Patterns, if any, are pure and simple,

The vivid contrasts and saturated colors of the winter palette are dramatized in this unique beaded bead broadcollar by Valerie Hector.

usually organic. If geometry is introduced, it must be bold, unique, and unpredictable. Even in its boldest expressions, beauty, refinement, and polish pervade this coolest of seasons.

Imagine the awe-inspiring beauty of a stark, crystalline landscape blanketed in snow. The total effect is a magical, larger-than-life presence.

METALS

Metals in the winter palette are as smooth and polished as the surface of a frozen lake. Here silver, with its cool undertones, finds its zenith. Keep it highly polished, avoiding the textured, tarnished, ethnic look. Golden accents harmonize in winter when they are highly polished, brighter golds.

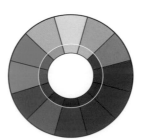

Winter Color Wheel

STONES

A winter palette loves gemstone beads that are either full of light, full of color, or both. Clear, cut, and faceted gemstone beads toss flashes of light like the sparkling stars. The clearest crystalline aquamarine, apatite, amethyst, and quartz are icy members of this palette. The more intense the color, the better. For contrast, combine these with smoky quartz, black onyx, and hematite. Mother-of-pearl and pearls make stunning additions, as long as they are used in either a classically simple, or stunningly unique fashion. For a more colorful, intense winter palette, the vivid hues of lapis lazuli, chrysoprase, green agate, turquoise (faceted or polished round beads, please), and clearer tourmalines are elegant palette members.

SURFACE FINISHES

In a winter palette, the purpose of surface finish is the same as that of gemstones—to provide intense saturated color, sparkle, or some combination of the two. Matte, matte metallic, opaque, and transparent finishes assure intense color. Sparkle is found in silver-lined finishes. Combined color and sparkle is achieved with luster, crystal-lined color-inside, and metallic finishes.

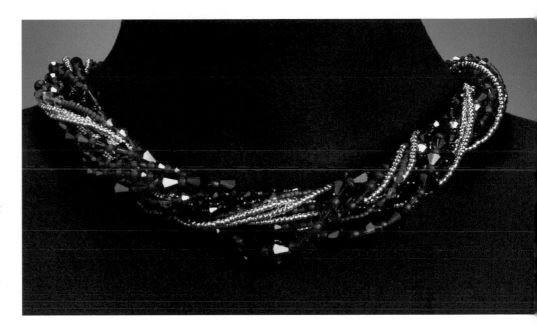

Strands of 24-karat gold and glass beads the colors of garnet and rubellite tourmaline accomplish a simple winter palette of striking contrast and vivid color. Twisted multi-strand necklace by SaraBeth Cullinan.

SUGGESTED PALETTES

1. DELICAS: DB-001, DB-748, DB-041
A shiny, cold gunmetal gray (DB-001) serves as a foundation for striking blue-violet matte transparent (DB-748), a color so intense it must be seen to be believed—ink cannot reproduce its rich saturation. Add icy silver-lined crystal silver (DB-041) and you have the cool, dramatic contrast of winter.

2. DELICAS: DB-757, DB-654, DB-1340, DB-310
Even though this is a warm palette, all the reds have a cool base, leaning more toward violet than orange. A carnival matte red (DB-757) and its darkened version in opaque (DB-654) set the stage for stunning silver-lined magenta (DB-1340) and a flat matte black (DB-310). Drama at its height!

3. DELICAS: DB-610, DB-249, DB-031
A sophisticated complementary palette begins on a field of silver-lined violet (DB-610). An icy tint of lavender (DB-249) provides a monochromatic midtone. 24-karat gold (DB-031) makes a stunningly elegant accent.

THEORY-BASED COLOR SCHEMES

The thirteen color schemes in this section are based on sound color theory. Your challenge will be to select colors within the bounds of a prescribed scheme that best suit your artistic aim. For instance, there are many ways to construct an analogous scheme. It can be predominantly warm or cool. Warm analogous schemes evoke images of the sun or fire, cool ones the experience of water. An analogous scheme can be bright, dull, or both. Bright analogous schemes are well suited to casual jewelry. Low-intensity schemes are mature and sophisticated.

Each project offered illustrates an application of the color scheme being described. Miniature color wheels demonstrate how the scheme is derived.

Get intimate with these basic color schemes and use them as foundations from which to develop your own melodious color harmonies.

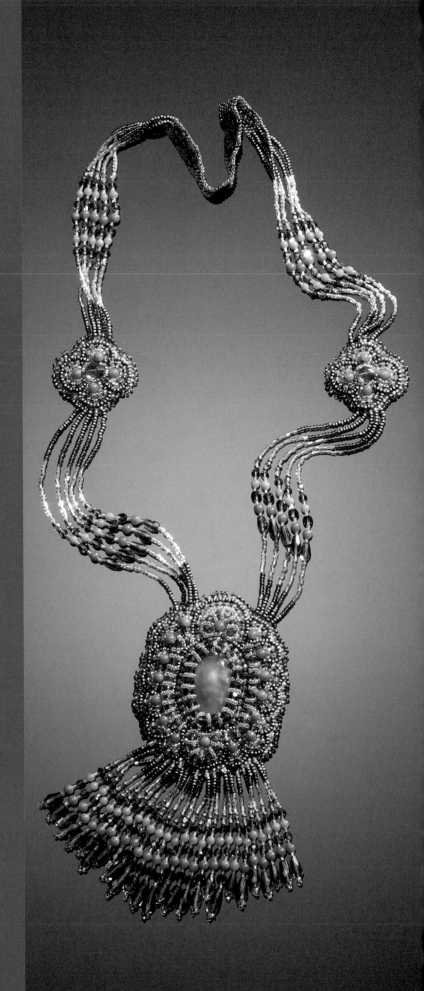

MONOCHROMATIC

Monochromatic schemes consist of a single color. Sound boring? Think again!
When different intensities, tones, shades, and tints of one color are combined,
gorgeous and evocative harmonies emerge.

In the medium of beads, monochromatic options expand to include different textures and finishes of the same color.

Because they feature one color, monochromatic schemes express emotions associated with that color. They are strong communicators of emotions and moods, eliciting palpable reactions. Look at the loneliness conveyed by the colors of "Evening," by Ann Tevepaugh Mitchell (see page 139). Even though quite a few colors are used, the overall scheme is monochromatic because blue dominates. "Lovely Lacey Lavender Lavalier," by Elizabeth Anne Scarborough, is a monochromatic scheme of lavenders, conveying an almost mystical aura (see page 69).

Want a challenge? Work with a monochromatic scheme based on your least favorite color!

SUGGESTED PALETTES

1. DELICAS: DB-919, DB-917, DB-131, DB-374
Four versions of low-intensity green create sophisticated monochromaticity. Note the four distinct values ranging from light to dark. Shimmering dragonfly (DB-919) and shimmering green tea (DB-917) start this palette. A rustle of Alpine green (DB-131) accented by an elegant shade reminiscent of the Palace of Versailles (DB-374) finish it off.

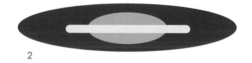

2. DELICAS: DB-012, DB-379, DB-052
A rich and sophisticated monochromatic palette based on low-intensity red. Most distinctive is the base of metallic Indian red (DB-012). Gorgeously subtle, matte metallic old rose (DB-379) and a pale, AB-finished cream tint (DB-052) add complexity, texture, and depth.

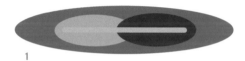

Each of Linda Breyer's meticulous peyote-stitched pinecones is an example of a monochromatic scheme. The colors radiate from light to dark from the inside to the outside of each scale.

ZEPHYR GLASS PENDANT

The shifting iridescent surface finishes of the beads chosen for this necklace create myriad nuances of blue and its analogous neighbors, green and purple.

FINISHED SIZE: 22" long

MATERIALS

- enough seed beads to make ten 18–21" strands (about 60 grams)
- 100 4mm peacock blue Swarovski (or comparable) crystal bicones
- vertical centerpiece bead
- flexible beading wire (.010 gauge)
- four-ring clasp

Cut a 24" piece of beading wire. String a silver crimp bead. Slide it down 1" and pass that inch through one of the loops on the clasp. Pass the wire tail back though the crimp bead and crimp it (see page 129).

String 7" of seed beads. Continue stringing, randomly spacing crystal bicones among the seed beads anywhere from 1" to 3" apart. When you have strung a total of 16", slide the centerpiece bead onto the strand, pulling the strand through so the last beads you strung are inside the bead. Don't string any crystal bicones onto the length of the strand inside the centerpiece bead.

Once a strand exits the centerpiece bead it becomes fringe. Continue stringing the fringe portion, alternating six seed beads and one crystal bicone, until the entire length of the strand (including fringe) is about 21" long. Add a crimp bead, a crystal bicone, and a seed bead. Pass the wire back up through the crystal bicone, the crimp bead, and as many of the seed beads as possible. Pull snugly with pliers. Crimp the crimp bead.

Create nine more strands in the same way, varying the lengths of the strands from 20" to 22" long. Alternate the spacing of crystal bicones on each fringe. On three strands alternate five seed beads and one crystal bicone; on four strands string six seed beads for every crystal bicone; on the last three strands alternate seven seed beads and one crystal bicone.

Place two strands on one loop of the clasp and one on each of the others, so there are five strands attached to each side of the clasp (photo below).

Pass as many of the ten strands of seed beads as possible through the centerpiece bead. The tightly bunched strands within the centerpiece bead will hold it in place. When there is no more room in the hole for strands of seed beads, string seed beads on the wire right up to the top of the centerpiece bead. Then slide the wire (without any beads) through the centerpiece bead. Continue stringing the

Using beads with iris and AB finishes energizes this single-color scheme, making it more lively and colorful than if I had adhered rigidly to a monochromatic blue palette. Necklace by Margie Deeb.

fringe. For extra safety, string a crystal bicone on a few strands at the point where the wire exits the centerpiece bead.

Gently twist each bunch of strands before wearing.

ANALOGOUS

Analogous schemes fill our world, from the iridescence of peacock feathers, to the changing blues and greens under the ocean, to the yellow-to-pink gradations of a lotus blossom.

Analogous schemes involve two or more colors adjacent to each other on the color wheel. On the ink wheel, for example, orange and cool red are analogous to warm red.

The analogous palette has a mellifluous quality. Its colors swirl and flow into one another, defying boundaries. Where does blue end and blue-green begin? The analogous palette seeks no answer. It just revels in the mystery of movement.

Because colors are grouped in a specific area of the wheel, the analogous scheme tends toward either warm or cool. Therefore mood and emotion can step forth.

Although it is possible to use many colors in an analogous scheme, you can maintain the temperature and overall mood by limiting your palette to four or fewer colors.

Because of their proximity on the color wheel, adjacent colors are intrinsically harmonious, making them easy to combine successfully.

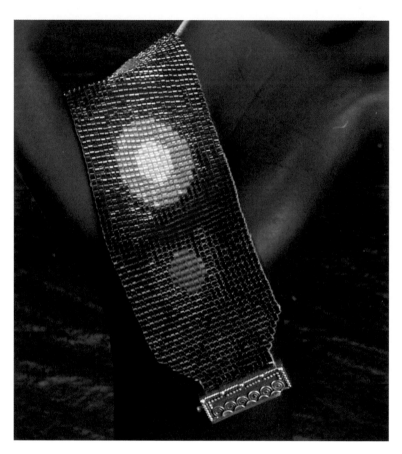

"Radiant Rings" features a rich analogous palette of violets, oranges, and reds (pattern on next page). Design by Margie Deeb; loomwork by Frieda Bates.

A warm analogous scheme that includes a range of oranges and warm and cool reds.

A cooler analogous palette incorporating a wide range of blues and greens.

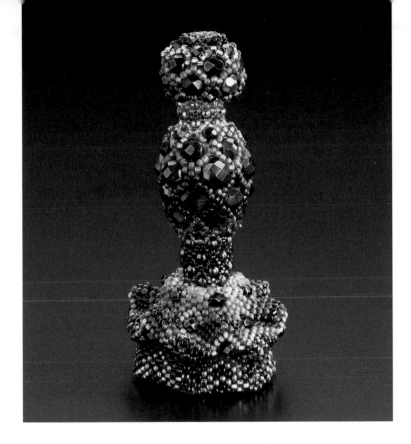

The colors of "Surreal Minaret" by Linda Breyer are the coolest on the wheel. There is an icy feel to this exquisite scheme in which the warmest color is purple. Peyote stitch.

SUGGESTED PALETTES

1. DELICAS: DB-1302, DB-622, DB-106, DB-233
Warm, gentle, and friendly, this analogous palette of lower intensity orange (DB-1302), dull pinks and peaches (DB-622 and DB-106), and lustrous buttercup (DB-233) yellow brings to mind Victorian floral wallpapers.

2. DELICAS: DB-651, DB-281, DB-378, DB-913, DB-012
The range of this palette, from goldenrod yellow-orange (DB-651) to a deep red-violet (DB-012), is so broad that it approaches a near-complementary harmony. Varying degrees of intensity create a gorgeous and complex array of tones.

3. DELICAS: DB-654, DB-694, DB-073, DB-248, DB-609
The passionate hues of a valentine begin with an intense deep red (DB-654), shimmy among lavender, purple, and pink, and end with accents of dark violet (DB-609). Each member of this ardent palette features a different surface finish.

4. DELICAS: DB-253, DB-923, DB-281, DB-240, DB-257
Romance and mystery are hinted at by these delicate tints poised against a rich dark violet. Royal fuchsia (DB-281) charges this otherwise cool palette with a brushstroke of passion.

5. DELICAS: DB-918, DB-083, DB-079, DB-218, DB-920
Mermaids and dolphins could swim through these cool, aqueous colors. The interplay of shimmering lined finishes and the range of lights and darks create a palette with liquid depth.

6. DELICAS: DB-053, DB-919, DB-917, DB-908
These fresh, warm colors sing the lustrous song of a sparkling spring day. The AB finish of the dominant pale yellow (DB-053) supplies the palette with more color than is visible in print.

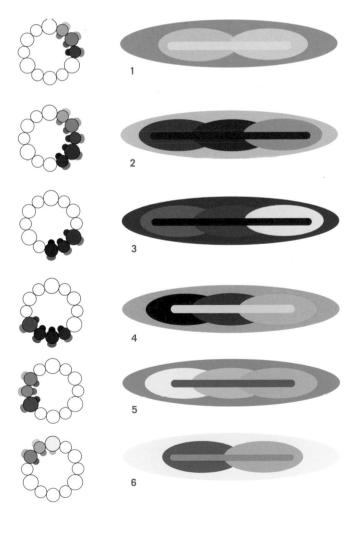

RADIANT RINGS BRACELET

This eight-color analogous palette ranges from a tint of orange to a shade of violet. Warm and rich, it surprises with a splash of bright orange smack-dab in the middle of violet.

PEYOTE: 27 beads wide (1 7/16")
80 beads high (5 3/8")

LOOM: 27 beads wide (1 7/16")
79 beads high (5 3/8")

QUANTITY OF BEADS	DELICA COLOR #		
1/2 gram Deep Vanilla	DB-205		
1/2 gram Sunset Orange	DB-855		
3 grams Carmine	DB-295		
1 gram Cameo Pink	DB-070		
4 grams Lined Tomato Red	DB-282		
4 grams Opera Red	DB-105		
4 grams Royal Fuchsia	DB-281		
3 grams Dark Shimmering Violet	DB-923		

Substitute similar analogous palettes from different areas of the wheel to study changes in the temperature, movement, and feel of the piece. For a more complex palette, vary the tints and shades. Lovely harmonies are almost effortless with analogous colors.

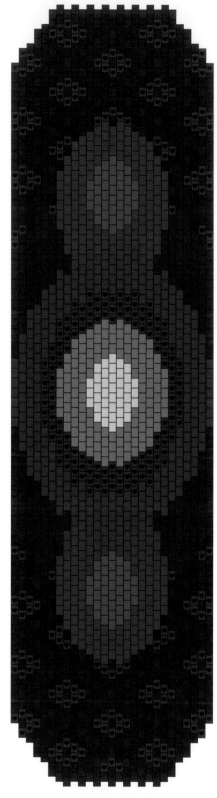

Peyote or Brick Stitch

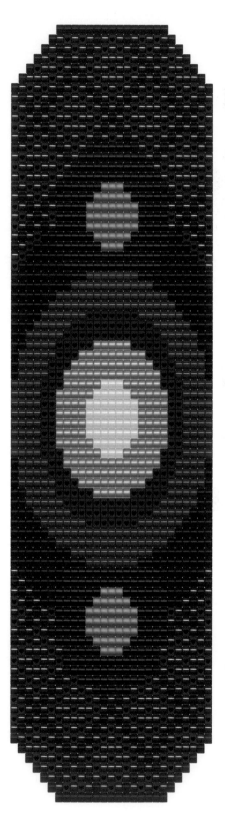

Loom or Square Stitch

COMPLEMENTARY

An exciting story of "opposites attract" underlies the complementary color scheme. Lured by their differences, complementary colors enhance one another because each contributes qualities the other lacks.

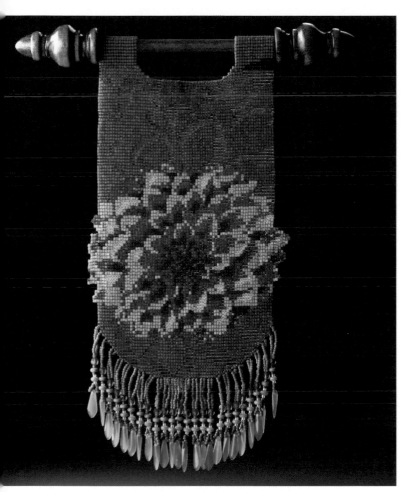

In the weaving project on the next page, a calm, frigid blue incites vigorous, blazing oranges to their most vivid brilliance. Other complementary pairs include red (or magenta on the ink color wheel) and green, and violet and yellow. See the description of "Complementary Relationships" (page 46) to learn more about complementary harmonies.

This "Blazing Dahlia" (top) glows bright against the receding, cool background. The temperature contrast is so intense that the whole tapestry seems to shimmer. Design by Margie Deeb; loomwork by Frieda Bates. (See pattern on next page.)

SUGGESTED PALETTES

1. DELICAS: DB-919, DB-729, DB-116, DB-098
Cool greens (DB-919 and DB-729) and cool reds (DB-116 and DB-098) form a complementary palette more reminiscent of crown jewels than Christmas decor. Imagine an emerald and garnet brooch, and finish it off with touches of gold.

2. DELICAS: DB-377, DB-240, DB-781, DB-099, DB-233
A palette loyal to Vermeer: the blues of DB-377 and DB-240 and the amberish yellows of DB-781 and DB-099, highlighted with buttercup (DB-233). The Dutch master carefully juxtaposed ultramarine blues against yellows to achieve exquisite harmony and balance in his home interior paintings.

3. DELICAS: DB-281, DB-274, DB-694
Rich fuchsia (DB-281) and yellow-green (DB-274) complement each other in stunning fashion. If you're a color doctrinaire, you'll insist on calling this triad "analogous-complementary," because of the accent of lavender (DB-694). Whatever its designation, it's a dazzling palette ready to enhance designs of intricate detail or bold masses of solid color.

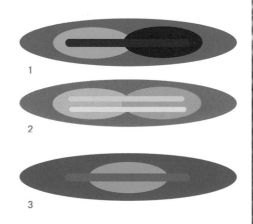

BLAZING DAHLIA TAPESTRY

PEYOTE: 69 beads wide (4¹/₄")
107+ beads high (7+")

LOOM: 69 beads wide (4¹/₄")
107+ beads high (7+")

QUANTITY OF BEADS	DELICA COLOR #	
7 grams Matte Transparent Turquoise (dyed)	DB-787	♥
17+ grams Shadowed Turquoise (dyed)	DB-798	
1 gram Buttercup	DB-233	
7¹/₂ grams Opaque Goldenrod	DB-651	
¹/₂ gram Matte Transparent Orange	DB-744	✳
4 grams Dark Pumpkin	DB-777	◯
4 grams Opaque Pure Orange	DB-722	⬇
2 grams Volcan Orange	DB-795	◻
1 gram Opaque Cayenne (dyed)	DB-653	⛾
1¹/₂ grams Matte Metallic Burnt Orange	DB-378	◥
¹/₂ gram Tuscany Red	DB-773	

Note: Quantity of beads does not include amount required for hanging tabs and fringe.

See instructions for making tabs on page 83.

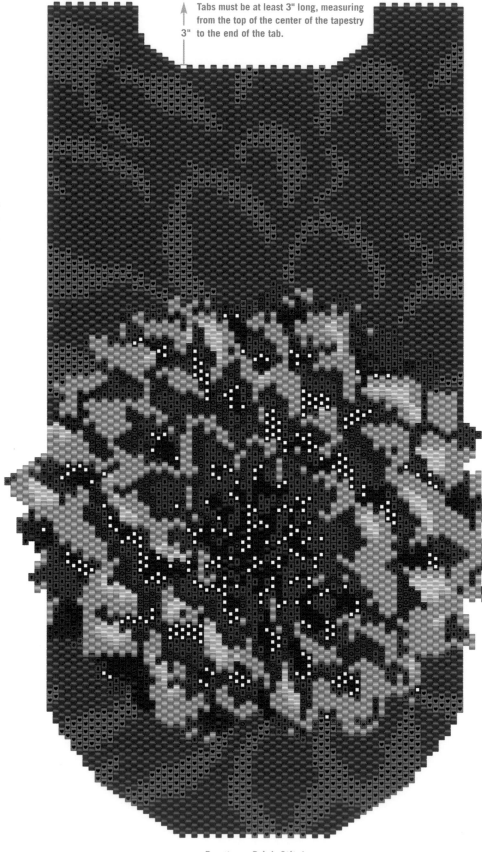

Tabs must be at least 3" long, measuring from the top of the center of the tapestry 3" to the end of the tab.

Peyote or Brick Stitch

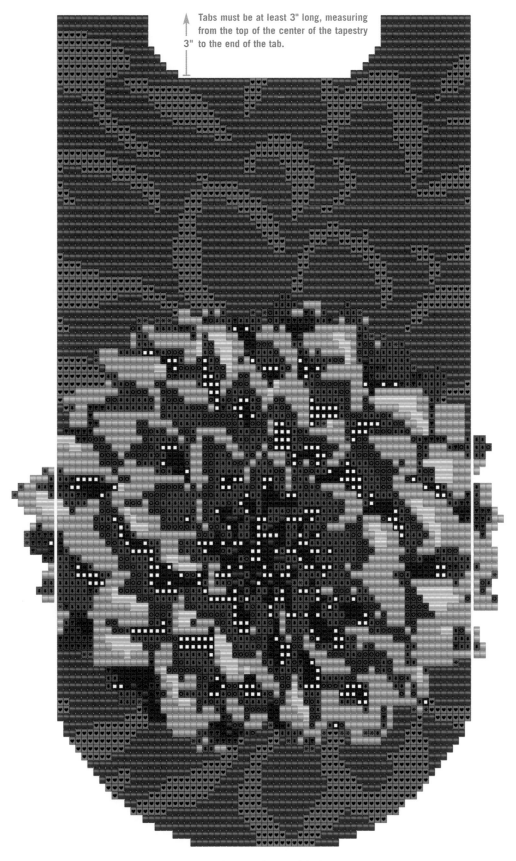

Tabs must be at least 3" long, measuring from the top of the center of the tapestry to the end of the tab.

3"

Loom or Square Stitch

SPLIT-COMPLEMENTARY

A split-complementary scheme is comprised of one color and the two colors on either side of the first color's direct complement.

Striking contrasts are made when you aim across the wheel, split your focus, and flank the complement. Orchestrating this abundance of contrast requires planning. Arrange your palette into dominant, secondary, and accent colors, and balance them accordingly. This will determine whether your split complements wreak havoc or sing harmoniously.

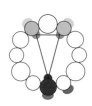

The uncluttered appeal of SaraBeth Cullinan's necklace "Ring of Hearts" stems from the careful balance of the three major colors. Yellow-green serves as a dominant, with yellow-orange as the secondary color. Minimal accents of violet and purple enrich the overall scheme.

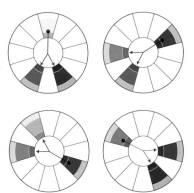

Find a split-complementary scheme by first choosing one color, then adding the two colors on either side of its complement. Those two colors are the near complements of the first color.

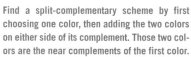

You can easily locate split-complementary colors by inscribing an isosceles triangle on the color wheel.

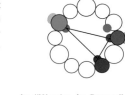

In "Wonder in Borneo" a wide range of greens forms a backdrop for the near complements orange and red-violet. The forests of Borneo and Indonesia are the last habitats for the endangered orangutan, an extraordinarily intelligent and peaceful great ape. Design by Margie Deeb; loomwork by Frieda Bates.

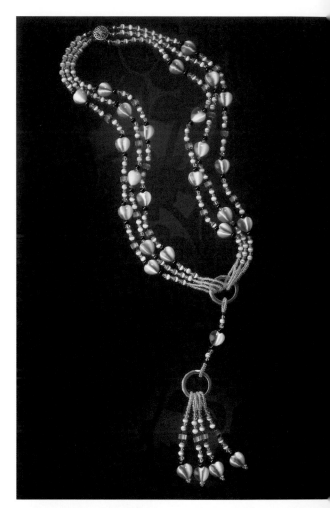

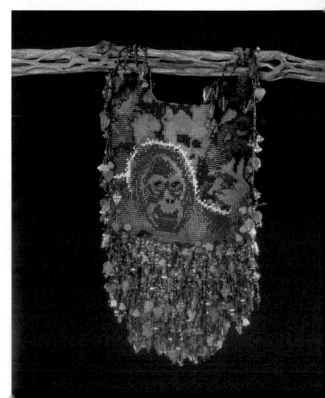

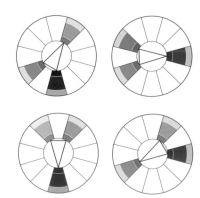

RING OF HEARTS NECKLACE

FINISHED SIZE: 34" long

MATERIALS
- three-strand clasp
- six bead tips
- size D Nymo thread
- glue for knots
- medium twisted wire needle

MAIN COLOR (MC)
- Twenty-one 12mm fiber-optic glass hearts
- Two 20–22mm glass rings
- 118 4mm rounds
- Ninety-six 3mm rounds
- Thirty-eight 4mm crystal bicones
- Fifty-two 3mm crystal bicones
- Twenty 5- x 4mm fire-polished spacers
- 4 grams of 11o seed beads

SECONDARY COLOR (SC)
- Six 12mm fiber-optic glass hearts
- Forty-two 4mm rounds

FIRST ACCENT COLOR (A1)
- Fifty 4mm rounds

SECOND ACCENT COLOR (A2)
- Forty-two 3mm crystal bicones

OUTER STRANDS

Using approximately 40" of thread, string one seed bead and slide it toward the end of the thread, leaving a 3–4" tail. Knot around the seed bead and then slide a knot cover down over it. Add on beads in the following order.

Start with a 3mm round MC and alternate with a 4mm round MC for a total of nine 3mm rounds and eight 4mm rounds. Continue stringing in the following order:

> 4mm round A1
> heart MC
> 4mm round A1
> 4mm crystal MC
> 4mm round MC
> 3mm crystal MC
> 4mm round SC

> 3mm crystal A2
> spacer MC
> 3mm crystal A2
> 4mm round SC
> 3mm crystal MC
> 4mm round MC
> 4mm crystal MC

Repeat this stringing combination for a total of two sections, then string on the following:

> 4mm round A1
> heart MC
> 4mm round A1
> 4mm crystal MC
> 4mm round MC
> 3mm crystal MC
> 4mm round SC
> 3mm crystal A2
> spacer MC
> 3mm crystal A2
> 4mm round SC
> 3mm crystal MC
> 4mm round MC
> 4mm round A1
> heart MC
> 4mm round A1

Starting with a 3mm round MC, alternate with a 4mm round MC for a total of four 3mm rounds and three 4mm rounds.

String on thirty seed beads MC.

FINISHING OUTER STRANDS

Skipping all thirty seed beads, run needle back through the entire strand, into the knot cover and the seed bead inside it. Tie working thread to tail, glue knot, close knot cover and trim excess threads. Attach strand to clasp.

MIDDLE STRANDS

Begin stringing in the same way as for outer strands. Start with a 3mm round MC and alternate with a 4mm round MC for a total of thirteen 3mm rounds and twelve 4mm rounds. Continue stringing in the following order:

> 4mm round A1
> 3mm crystal MC
> heart SC
> 3mm crystal MC
> 4mm round A1
> 4mm crystal MC
> 4mm round MC
> 3mm crystal MC
> 4mm round SC
> 3mm crystal A2
> spacer MC
> 3mm crystal A2
> 4mm round SC
> 3mm crystal MC
> 4mm round MC
> 4mm crystal MC

Repeat this stringing combination for two sections, then string on the following:

> 4mm round A1
> 3mm crystal MC
> heart SC
> 3mm crystal MC
> 4mm round A1

Start with a 3mm round MC and alternate with a 4mm round MC for a total of six 3mm rounds and five 4mm rounds.

MAKING FRINGE

Tie a stopper bead onto a 16–18" length of thread, leaving a 3–4" tail. String on beads in the following combination:

> ten seed beads MC
> 3mm round MC
> 4mm crystal MC
> 4mm round MC
> 3mm crystal MC
> 4mm round SC
> 3mm crystal A2
> spacer MC
> 3mm crystal A2
> 4mm round SC
> 3mm crystal MC
> 4mm round MC
> 4mm crystal MC
> 4mm round A1
> heart MC
> three seed beads MC

Skip the three seed beads and run the needle back through the entire strand, exiting the 3mm round. Remove stopper bead, add on ten seed beads, and needle through the glass ring. Tie threads together; needle through four seed beads, make a half-hitch (page 104), and repeat. Run down and up through the entire strand to reinforce. Needle through four seed beads, half-hitch, repeat, and cut thread. Bury tail by running through a few seed beads and half-hitching, repeat and cut thread.

Repeat above steps to make four lengths of fringe.

CONNECTING RINGS

Tie a stopper seed bead onto a 12" length of thread, leaving a 3–4" tail. String on beads in the following order:

> eight seed beads MC
> 3mm crystal A2
> 3mm round MC
> 4mm round SC
> 4mm crystal MC
> 4mm round A1
> heart MC
> 4mm round A1
> 4mm crystal MC
> 4mm round SC
> 3mm round MC
> 3mm crystal A2
> sixteen seed beads MC

Needle through the ring with the fringe, skip the seed beads, and run up through the strand, exiting the 3mm crystal. Add on eight seed beads, needle through the neck strap ring, and finish off in the same manner as with the fringe.

ANALOGOUS-COMPLEMENTARY

Something happens when you pair the enchantment of adjacent colors with the gusto of complements…something rousing and vigorous, coursing with life.

This "something" is technically called the analogous-complementary scheme. But what really happens is magic.

Begin the magic with a group of two or three colors adjacent to each other on the wheel. This group becomes the dominant color force.

For the complementary part of this alchemy, select the color directly across from the middle color of the analogous group. This direct complement becomes the accent color. Or, choose a near complement (one on either side of the direct complement).

You have now created a dominant color grouping of three similar colors accented with the direct complement (or the near complement) of one of them.

Got it? Good! That was "Analogous-Complementary Magic 101."

To graduate to "202," use the complement, rather than the analogous colors, as the dominant color. Look at the necklace and accompanying color wheel to the right. The blue sits directly across the wheel from the orange of the yellow-orange analogous group. It could have been used as an accent color, with startling results. But instead, blue was used as the main color. The results are equally stunning.

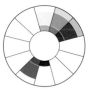

A show-stopping combination of brilliant, irresistible colors comprise this startling analogous-complementary scheme. Necklace by Margie Deeb, based on a technique by Diane Fitzgerald. Fused glass centerpiece bead by Vilma Dallas.

An extended, complex interpretation of the analogous-complementary scheme. "Chanin Study" was inspired by the abstract Art Deco ornamentation on the Chanin Building in New York City. Design by Margie Deeb; execution by Frieda Bates.

To practice "Analogous-Complementary Magic 303," extend the palette. Rather than using just one complementary color, put two or three to work. See "Chanin Study" on the previous page. To avoid a random mishmash of colors, logical relationships have been established. The analogous members are grouped together: Violet, purple, and red serve as a background; greens and yellows swirl and flow in front.

An extended analogous-complementary scheme is as complex to work with as it is to say aloud. Juggling these many colors, especially complements, requires planning.

But it is worth every effort. What happens when you harmonize and balance this lively array of color? Pure magic!

"Waning Crescent" exemplifies the analogous-complementary scheme. Design by Margie Deeb; tapestry executed by Frieda Bates in peyote stitch. (See pattern on next page.)

Accents of magenta among the green-to-yellow analogous group are an unexpected surprise, pulsing this scheme to life. Necklace by Margie Deeb.

WANING CRESCENT TAPESTRY

Tranquil blues play the dominant role in this design, emphasizing the meditative reverie of the night-drenched dreamer. Complementary pale yellow and sparkling daffodil command our attention.

PEYOTE: 74 beads wide (3^{3}/$_{4}$")
74 beads wide (3^{3}/$_{4}$")
98 beads high (6^{1}/$_{2}$")

LOOM: 74 beads wide (3^{7}/$_{8}$")
98 beads high (6^{1}/$_{2}$")

QUANTITY OF BEADS	DELICA COLOR #	
7 beads Pale Yellow Pearl	D-232	♥
1/$_{2}$ gram Sparkling Daffodil	D-160	
2 grams Pale Sapphire Pearl	D-257	
2 grams Periwinkle Matte Opaque AB	D-881	✳
2 grams Windsor Blue	D-361	
4 grams Union Jack Blue	D-377	◉
18 grams Matte Transparent Dark Violet (dyed)	D-785	
5 grams Midnight Purple	D-135	
10 grams Cobalt Luster	D-277	⬇

Note: Height does not include tabs. Quantity of beads does not include amount required for hanging tabs and fringe.

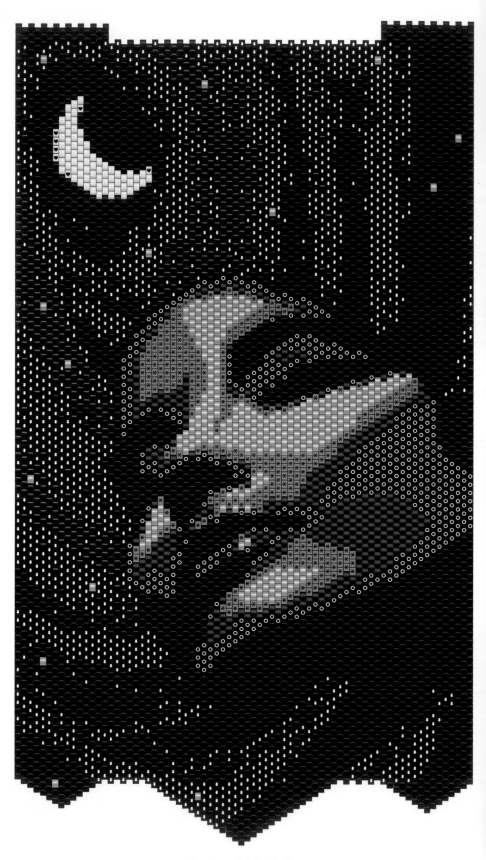

Peyote or Brick Stitch

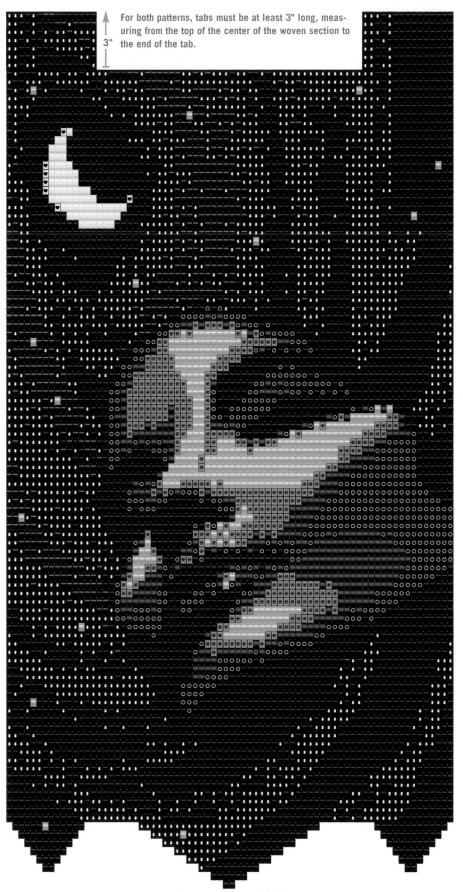

For both patterns, tabs must be at least 3" long, measuring from the top of the center of the woven section to the end of the tab.

3"

MAKE TABS

The tabs will make loops for a hanging rod. Weave the tabs so they are at least 3" long, measuring from the top of the center of the woven section to the end of the tab. A 3" length will make them long enough to slide through rods up to $\frac{1}{2}$" in diameter. When you are finished with all the weaving, fold the tabs over toward the backside of the tapestry. Align the edge of the tab with the top edge of the tapestry. Sew the edge of each tab to the back of the tapestry.

Loom or Square Stitch

BASIC TRIADS

Basic triads are composed of three colors equidistant from each other on the color wheel. They can be primary, secondary, or tertiary colors, as long as they form an equilateral triangle on the wheel.

Triadic combinations exhibit bold, energetic, and striking contrasts because the members of the group, spaced as they are on the wheel, are neither analogous nor complementary. Basic triads contrast strongly in both temperature (warm and cool colors) and value (light and dark colors). Because of its bold directness, the primary triad of the traditional artist's color wheel—yellow-red-blue—is often used in children's toys and graphic design.

Secondary triads are more unusual, and they form distinctive, sometimes surprising, combinations. Tertiary triads can produce a contemporary stylishness.

In "Cha Cha Cha," Kim Price exploits the brilliance of the ink wheel's basic primary triad: cyan, magenta, and yellow. Spikey fringe around a flexible core. Bracelet collection of Renee Long, Ontario, Canada.

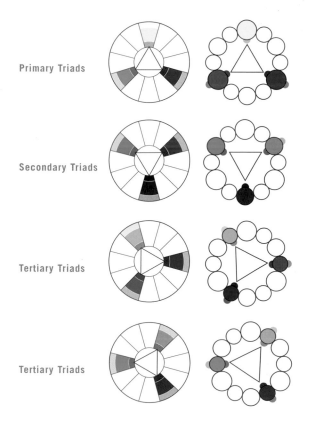

Primary Triads

Secondary Triads

Tertiary Triads

Tertiary Triads

The four basic harmonious triads are created by using equally spaced colors, every fourth one on the wheel, to form an equilateral triangle.

The warm, spicy palette of "Phulkari" is based on a secondary triad. Design by Margie Deeb; loomwork by Frieda Bates.

BASIC TRIADS PROJECT

PHULKARI BRACELET

Considered the finest of all rural-based handicrafts from the Punjab region of India and Pakistan, *phulkari* means "flower working." It describes the extraordinary floral motifs embroidered on handspun cotton to embellish head cloths, shawls, and bedcoverings.

In this beaded version, the slightly muted colors of a secondary triad are lifted by a bright note of yellow-orange (DB-651), reminiscent of curry.

PEYOTE: 27 beads wide (1⁵⁄₈")
80 beads long (5¹⁄₂")

LOOM: 31 beads wide (1⁵⁄₈")
82 beads long (5¹⁄₂")

Note: Length does not include length of clasp and findings.

QUANTITY OF BEADS	DELICA COLOR #	
1 gram Sorrento Gold	DB-065	♥
10 beads Pale Topaz	DB-742	✳
4 grams Opaque Goldenrod	DB-651	
4 grams Dark Pumpkin	DB-777	
2 grams Royal Fuchsia	DB-281	
2 grams Pale Aubergine	DB-660	
10 beads Grasshopper	DB-372	○
1 gram Verdigris	DB-373	↓
3 grams Dragon Scale Green	DB-327	

Peyote or Brick Stitch

Loom or Square Stitch

COMPLEMENTARY & MODIFIED TRIADS

Basic triads are composed of three colors equidistant from each other on the color wheel, or every fourth color.

Complementary triads are formed by combining any two complements with one of the two available colors midway between them on the wheel. The addition of the third color can bring the sparkle and flourish of an ambitious diva.

Because these two available accent colors are opposites on the wheel, one will always be warmer than the other. Changing the third color can bring a dramatically different temperature to a piece.

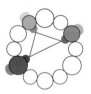 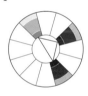

Modified triads are created by choosing three colors on the wheel, each with only one space separating them instead of the two spaces used to create complementary triads. Because their colors are closer together on the wheel, modified triads are more subdued than complementary triads.

Modified triads are similar to analogous schemes, but show slightly more contrast. The contrast occurs because the colors at either end of the arc are farther apart than the outer colors of a three-color analogous arc.

 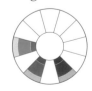

SUGGESTED PALETTES

1. DELICAS: DB-377, DB-372, DB-797, DB-795
This complementary triadic scheme uses a subdued blue (DB-377) background. The muted greens (DB-372 and DB-797) tonally match the blue, and provide a complement for the lively accent of intense orange-red (DB-795).

2. DELICAS: DB-660, DB-913, DB-654
This modified triadic scheme uses elegant, mid-depth purple (DB-660) as a backdrop for a low-intensity, shimmering salmon (DB-913). The most intense color, a dark red (DB-654), is used sparingly as an accent.

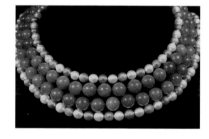 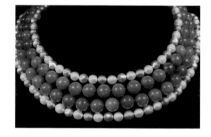

In this necklace, cool blue and sea green bring a calm elegance (left). By changing the third color to spicy orange, the same necklace grows strikingly warmer (right).

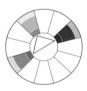

The unexpected colors of the "Kona" sea form (near left) by Wendy Ellsworth are those of a high-key (page 96) complementary triad. Its bright, reddish-orange ruffled edge contributes intrigue. This improbable color adds warmth and verve to the cooler, liquid tints.

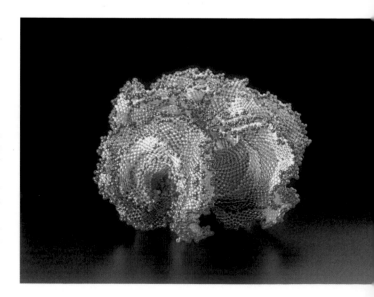

MULTI-STRAND TWISTED NECKLACE

This simple yet stunning multi-strand necklace is made by stringing three groups of three strands each.

FINISHED SIZE: 17 1/2" long

MATERIALS
- assorted seed beads and accent beads (crystals, pearls, bicones, fire-polished, pressed glass, etc.) in three colors (see list below)
- medium-fine twisted wire needle
- size D Nymo thread
- six bead tips
- one clasp
- jeweler's cement
- three shallow dishes or trays

MAIN COLOR: magenta (50 grams)
SECONDARY COLOR: red (20 grams)
ACCENT COLOR: gold (5 grams)

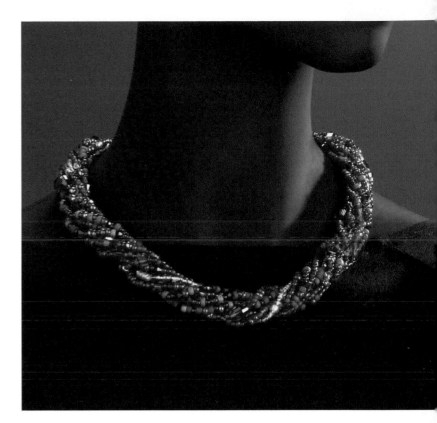

SaraBeth Cullinan weaves together strands of "bead soup" in the carefully measured colors of a modified triad: yellow, warm red, and magenta. Magenta is the main color, and on its own would have made a frivolous statement. As it is, warm red brings depth and richness; one strand of gold adds elegance.

In each dish make a random mixture or "bead soup" of each color. Determine the overall length of the necklace. Multiply that length by 3, and add an additional 4–6". This is how much thread will be needed for each stringing sequence.

Use the "bead soup and scoop" method to string each group of strands: Scoop the needle into the bead soup and allow the beads to be randomly picked up. String in the following order:

GROUP 1: two strands main color
one strand secondary color

GROUP 2: two strands main color
one strand accent color

GROUP 3: two strands main color
one strand secondary color

When each strand is finished, cover the ends with a small piece of tape to keep the beads from sliding off.

Refer to page 128 for instructions on attaching strands to bead tips. You will be attaching three strands, rather than one, to each bead tip. Pass the ends of the three strands through the tip and knot them as if they were one strand.

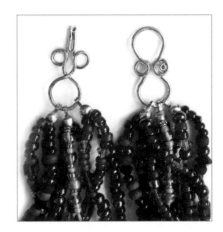

Attach each of the three groups of strands to the ends of the clasps.

Twist necklace gently before wearing.

TETRADS

A tetrad consists of four colors on the color wheel. Tetrads can be created in several configurations, based upon four-sided geometrics. Though the structures are similar, each type of tetrad is unique.

The most demanding tetrad is created by inscribing a square on the color wheel; its four corners form the tetrad. Because a square tetrad is comprised of two pairs of complementary colors, it is also known as a double-complementary scheme.

Tetrads based on the square deliver powerful contrasts. Value, temperature, and hue each emphasize and augment the other. A double-dose of complements packs quite a punch, so use finesse!

A second type of tetrad is created by inscribing a rectangle. This brawny tetrad pulsates with slightly less contrast than the double-complementary tetrad because each pair of its members are closer to each other on the color wheel.

A third scheme consists of two adjacent colors and their two direct complements. In this case, the rectangular structure is narrowed. This complex color scheme offers a relaxed, analogous harmony and a striking, complementary harmony.

Yet another tetrad is formed by inscribing a trapezoid. Begin by choosing two adjacent colors. Aim across the wheel, and, rather than the direct complements of these two colors, choose their near complements. This tetrad juxtaposes tranquil analogous harmony and invigorating near-complementary harmony.

SUGGESTED PALETTE

DELICAS: DB-281, DB-296, DB-919, DB-374
A rich tetradic scheme: Deep fuchsia (DB-281) weaves a seductive background for accents of deep cranberry AB (DB-296), reminiscent of a robust Beaujolais; shimmering, serene green-blue (DB-919); and tranquil, clay-like, matte green (DB-374). Florals and ornate designs will flourish within this luxurious palette.

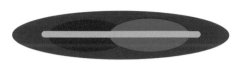

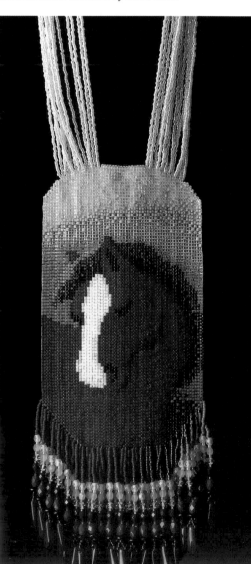

"Horse for Franz" by Margie Deeb illustrates the vibrant complexity of a well-planned tetradic scheme. Loomwork by Frieda Bates.

Tetrads based on a square.

 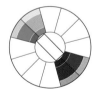

Tetrads based on a rectangle.

Tetrads based on a narrow rectangle.

 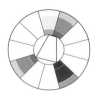

Tetrads based on a trapezoid.

HORSE FOR FRANZ NECKLACE

The colors of this tetrad were located by inscribing a trapezoid in which the top two colors are not analogous. This scheme is inspired by the bold, dazzling palettes of German artist Franz Marc (1880–1916), who portrayed animals and nature in intense, bright colors.

PEYOTE: 61 beads wide (3¹⁄₈")
90 beads high (6")

LOOM: 60 beads wide (3¹⁄₈")
89 beads high (6")

QUANTITY OF BEADS	DELICA COLOR #	
½ gram Cream Matte Opaque	DB-883	
1 gram Vanilla Ceylon	DB-204	♥
5+ grams Buttercup	DB-233	
2 grams Opaque Goldenrod	DB-651	
½ gram Dark Chocolate	DB-734	
6 grams Carnival Red Matte	DB-757	
7 grams Crimson Red Matte	DB-753	
2½ grams Dark Red Opaque (dyed)	DB-654	✳

QUANTITY OF BEADS	DELICA COLOR #	
½ gram Hydrangea Blue	DB-730	
2 grams Windsor Blue	DB-361	
2 grams Cobalt Matte Transparent	DB-748	
3 grams Light Neon Lime AB	DB-174	
1 gram Lime Zest	DB-274	
2 grams Dark Kelly Green	DB-656	○
½ gram Olive Metallic	DB-011	

Note: Quantity of beads does not include amount required for straps and fringe.

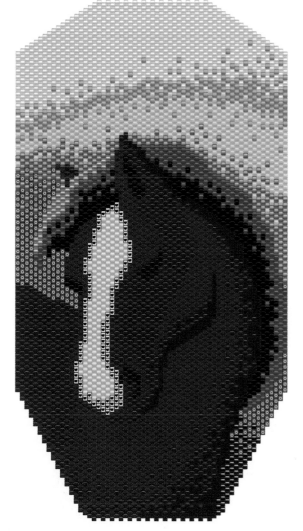

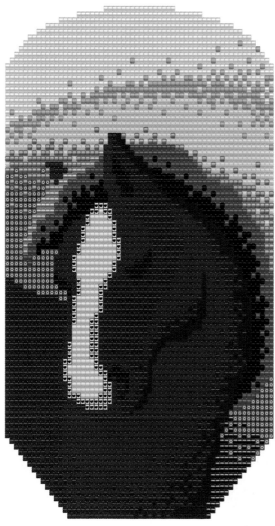

Peyote or Brick Stitch

Loom or Square Stitch

PURE COLORS

Pure colors excite and energize. These are the sit-up-and-pay-attention palettes. Reactions to a pure-color palette are often near the extremes of love or hate.

Pure hues are completely saturated. With no white, black, or gray to alter their purity, they radiate like vibrant spectral jewels.

Some consider pure-color schemes gaudy and unsophisticated. When flung together with no regard for balance, they can appear primitive, even juvenile. But the palette itself is not to blame.

Nature brims and bursts with pure colors. Think of the blooms of a lush garden, or the plumes of a tropical parrot. Butterflies, reptiles, insects, and saltwater fish all display this fervent palette.

Choose pure colors according to what you want to convey, as they are charged with emotion. Vibrant red proclaims an entirely different message than bright blue.

If you are new to this vivacious palette, start with two adjacent colors and a simple, bold design. Use the color wheel to make theory-based color decisions when combining more than three non-adjacent pure hues.

Pay attention to the distribution and balance of colors. Focus on featuring a dominant color, and carefully distribute values. Pure schemes can have very strong value contrast, especially if they involve color groupings from the top and bottom of the wheel.

As you become more confident in working with pure colors, try creating vivid schemes with only your eye and intuition.

White and black find perfect companions in pure colors, because they too are pure. Light pure colors—yellows and oranges—shine brightest when surrounded by black. Dark pure colors—blues and violets—look most colorful against white, but seem dulled when surrounded by black. The brilliance of pure colors is subdued on neutral and gray backgrounds.

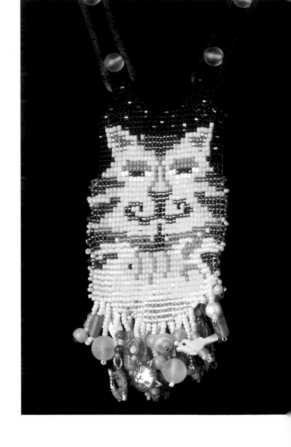

"Butterscotch, King of Cats" by Margie Deeb illustrates the playful mood that pure yellow and pure violet create.

The pure-color palette works well with simplified shapes and minimal detail, as in the sculptural "Garden Crab" by Liz Manfredini. Lively tension is created by the competing forces of abundant red and minimal green. Blue, right in the middle, balances the whole piece.

BUTTERSCOTCH, KING OF CATS NECKLACE

The King of Cats demands the boldest of palettes; this one is based on the principle of complementary relationships. Violet and yellow form the foundation that enables other vivid hues to shine.

PEYOTE: 35 beads wide (1⁷⁄₈")
45 beads high (3³⁄₄")

LOOM: 35 beads wide (1⁷⁄₈")
45 beads high (3³⁄₄")

QUANTITY OF BEADS	DELICA COLOR #		QUANTITY OF BEADS	DELICA COLOR #	
4 grams Matte Transparent Yellow	DB-743		3+ grams Silver-lined Violet	DB-610	
1 gram Sorrento Gold	DB-065		1 bead Cobalt Matte Transparent	DB-748	
2 grams Matte Transparent Orange	DB-744		4 beads Opaque Capri Blue (dyed)	DB-659	
¹⁄₂ gram Opaque Pure Orange	DB-722		¹⁄₂ gram Neon Green Opaque	DB-733	
¹⁄₂ gram Chestnut Brown Matte Transparent	DB-764		¹⁄₂ gram Summer Leaf Green	DB-688	
¹⁄₂ gram Matte Old Rose	DB-800		25 beads Pearl White	DB-201	
¹⁄₂ gram Silver-lined Red-Violet	DB-1345		4 beads Opaque Black	DB-010	

Note: Height does not include tabs. Quantity of beads does not include amount required for straps or fringe.

Tabs must be at least 2" long, measuring from the top of the center of the woven section to the end of the tab.

Peyote or Brick Stitch

Loom or Square Stitch

TINTS

If you are new to combining many colors, begin with the easiest range of colors to work with: tints. You would be hard-pressed to choose two or more tints that do not readily harmonize with each other.

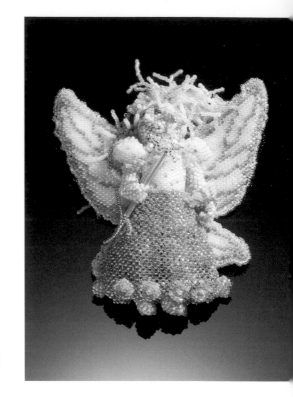

Tints, also called pastel colors, are pure colors to which white has been added. They are feminine and delicate, with a soft, clean quality. Think of infants' sleepwear, decorated pastries, Easter eggs, fine porcelain, and rococo interiors. Pastel palettes do their best work in floral and curvilinear designs, misty landscapes, and feminine portraits.

After the drab, sober, war years of olive greens and grays, the 1950s palettes of maize, soft turquoise, lilac, mint green, and candy pink expressed the hope and optimism of Americans. These pastels adorned furniture, appliances, vinyl upholstery, textiles, and even automobiles.

Pastel colors harmonize beautifully with white because white is what creates them. The addition of white, pearl, or ivory beads to a palette of tints adds a note of higher value, thus more contrast.

There's nothing like a naturally harmonious palette of tints to convey soothing, unhurried clarity and understated elegance. If attention is paid to value, it is the easiest, most graceful palette with which to achieve lovely color combinations.

With gently hued tints of varying values, Kimberley Price weaves a playful energy into this fairy. Peyote and right-angle weave.

"Pastel Swirl" uses a wide range of values within a pastel palette to enhance the concentric movement of the design. Design and execution by Margie Deeb.

A pastel palette with all colors of the same value will inevitably be bland and easily overlooked because too much similarity bores the viewer.

Aim for a more distinctive, interesting palette by varying the values of the colors.

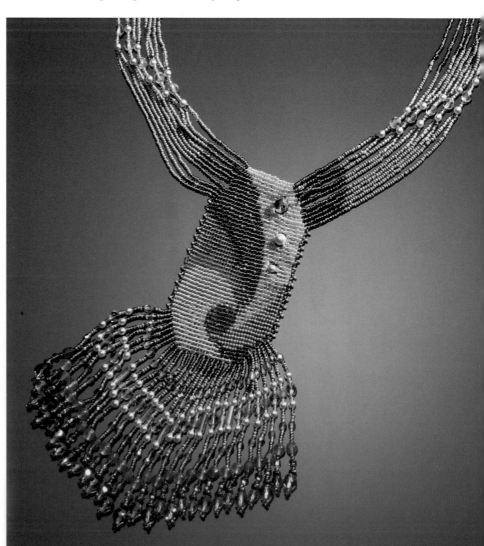

PASTEL SWIRL NECKLACE

Strong pink is the center of a swirling vortex of color dominated by elegant peach and lavender tints. Darker blue and green add depth to a primarily pastel palette.

Weave openings for the three larger beads and add them last; 6mm and 8mm pearls or fire-polished faceted glass are recommended.

PEYOTE: 41 beads wide (2 1/8")
 51 beads high (3 1/2")

LOOM: 41 beads wide (2 1/8")
 51 beads high (3 1/2")

QUANTITY OF BEADS	DELICA COLOR #	
4 grams Peach Luster	DB-207	
1/2 gram Shimmering Pink	DB-914	
2 grams Lavender	DB-694	♥
2 grams Periwinkle Matte Opaque AB	DB-881	✱
2 grams Windsor Blue	DB-361	
2 grams Transparent Dark Aquamarine AB	DB-177	○
2 1/2 grams Opaque Aqua Green	DB-729	↓
1/2 gram Shimmering Teal	DB-918	

Note: Quantity of beads does not include amount required for straps and fringe.

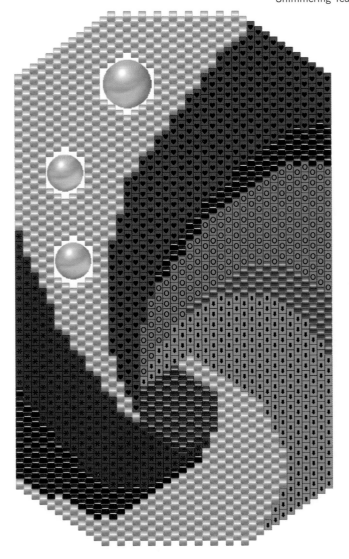

Peyote or Brick Stitch

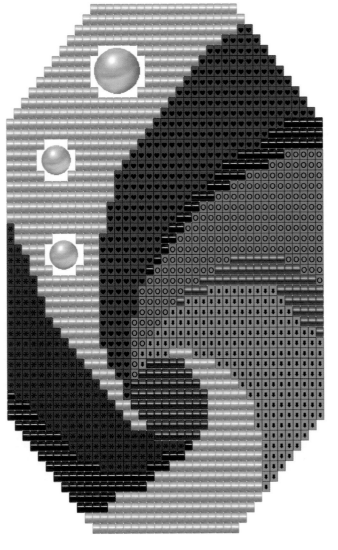

Loom or Square Stitch

LOW-KEY

The least frivolous of all color schemes, the low-key scheme, employs colors of middle and low value, low intensity, and low contrast. The overall tone is dignified, possibly even conservative. It is well-suited to formal and evening jewelry, displaying an air of sophistication and refinement.

Note the emotional differences between low- and high-key (page 96) schemes: Value and intensity completely transform the mood. Low-key colors are like a quiet, moonlit night. High-key colors are lively, sun-drenched afternoons.

To keep low-key schemes from becoming depressing, use low-key colors, not just blacks and grays. Many metallic beads, especially those with an iris finish, fall in the low-key range and display rich, sumptuous hues. Low-key gemstone beads include mahogany obsidian, garnet, lapis lazuli, dark tourmaline, and labradorite.

If your palette strains under the load of too many dense dark shades, add mid-value tones, highlights, or accents of lighter colors to buoy it up.

Use texture to coax some contrast into this scheme. Go for sparkle and facets, and vary the finishes of your beads. Use unexpected accents. A stunning palette arranges gold accents against mid- and low-value matte metallics.

SUGGESTED PALETTES

1. DELICAS: DB-277, DB-301, DB-379
A retiring low-key scheme with moderate contrast: a cobalt luster (DB-277) background, matte gargoyle gray (DB-301) as a secondary color, and accents of a very muted matte metallic rose (DB-379).

2. DELICAS: DB-116, DB-022, DB-919, DB-377
A transparent luster metallic red background (DB-116) is host to earthy metallic bronze (DB-022) and shimmering dragonfly green (DB-919). A foggy, low-intensity matte blue (DB-377) finishes this well-rounded palette.

1

2

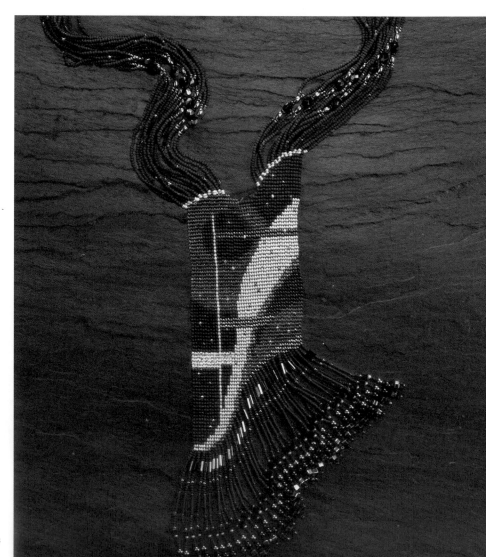

"Doreen" displays low-intensity colors in a flourish of geometrics. Design by Margie Deeb and Doreen Tunnell; loomwork by Margie Deeb.

LOW-KEY PROJECT

DOREEN NECKLACE

A richness of textures—metallics, matte metallics, silver-lined, and flat matte finishes—add depth to this low-key scheme.

Notice in the photo that gray beads are strung on the warps at the top of the medallion to distinguish it from the straps.

PEYOTE: 50 beads wide (2½")
 95 beads high (6½")

LOOM: 50 beads wide (2¾")
 95 beads high (6½")

SUGGESTED STRAP WIDTH: Eleven strands

QUANTITY OF BEADS	DELICA COLOR #		QUANTITY OF BEADS	DELICA COLOR #	
½ gram Transparent Crystal	DB-141		1½ grams Opaque Black	DB-010	♥
4½ grams 22-karat Matte White Gold	DB-336		8+ grams Matte Black	DB-310	✳
½ gram Silver-lined Gray	DB-048		½ gram Metallic Bronze	DB-022	
1½ grams Matte Metallic Silver Gray	DB-321		½ gram Dark Brown Iris	DB-007	
4 grams Matte Metallic Dark Gray	DB-307		½ gram Matte Metallic Fog Blue	DB-376	
½ gram Gunmetal Gray	DB-001		1 gram Lined Luster Tartan Green	DB-275	

Note: Quantity of beads does not include amount required for straps or fringe.

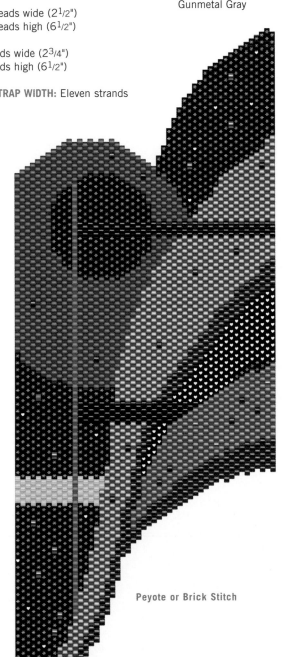

Peyote or Brick Stitch

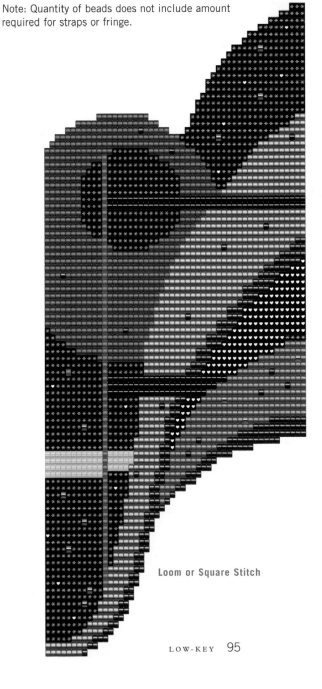

Loom or Square Stitch

HIGH-KEY

Tints and pure, light colors comprise high-key schemes. They are cheerful and optimistic.

High-key palettes are those of early spring, with a fresh wetness to them, like new blossoms in the morning dew. Keep the palette clean by avoiding muted or grayed-down shades.

Glass beads skitter light in all directions, and are a perfect medium for high-key colors. Different surface finishes create varying degrees of transparency, refraction, and reflection. Select light colors with the following finishes: semi-matte, frosted, color-lined, luster, transparent, and transparent luster. The shimmering, shifting colors of AB and dichroic finishes (micro-thin layers of metal on glass that give it a "two-color" effect) on a base of clear glass embody the jubilation of a high-key palette.

High-key gemstone beads include citrine, tanzanite, blue lace agate, fluorite, aquamarine, apatite, and frosted and crackle quartz.

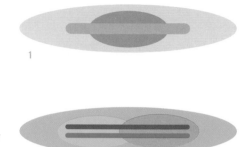

"Trellis" by Frieda Bates derives its sparkle from high-key colors with finishes that reflect a lot of light. Even the browns of the edging and latticework fall in the high-key range because of their light and clarity.

SPRING CANDY BRACELET

Pearls, silver, and lampworked beads tinged with dichroic glass coalesce into the visually edible "Spring Candy" bracelet by Kristy Nijenkamp.

MATERIALS

- six 3/4–1" long lampworked beads
- six 6mm pearls
- fourteen 6mm silver spacers
- one medium toggle clasp
- two long crimp beads (silver)
- heavy flexible beading wire (.024 gauge)
- crimp pliers
- wire cutters

Cut 11" of beading wire with wire cutters. Use a heavy gauge wire for two reasons: The slightly abrasive surface of the holes in lampworked beads can wear down the wire, and lampworked beads are quite heavy; a bracelet with this many of them requires heavy stringing material. Glass bead artist Kristy Nijenkamp creates a buffer between the lampworked bead and the wire by lodging a clear seed bead in the hole of the lampworked bead.

String a silver spacer, a crimp bead, and another silver spacer. Pass the wire through one half of the toggle clasp and back through the two spacers and crimp bead. Pull snug the loop around the clasp and crimp the crimp bead (see page 129). Leave a tail long enough for two or more beads

to slide over. Test the hold of the crimp bead by holding the toggle in one hand, and pulling the wire tail away from the toggle with the other hand.

String beads according to the photo or a pattern of your own design. Slide the first few beads over the tail and right up against the spacer.

String enough beads to fit around your wrist comfortably. Test the length by wrapping it around your wrist.

Finish the other end as you did the first end: String a spacer, a crimp, and another spacer. Make a loop through the toggle and pass the wire back through the spacers, the crimp, and another two or three beads. Pull the tail snug, but not so tight that the bracelet is inflexible. Crimp the crimp bead. Test the hold. When you are sure it will hold, clip the tail as close to the hole of the exit bead as possible.

EMOTIONAL & SYMBOLIC COLOR SCHEMES

Just as color is used to evoke emotion, color symbology uses specific colors to represent themes.

In the following nine color schemes, emotionalism and symbolism overlap, augmenting each other. Often a symbolic scheme stems from an emotional color. For example, the basis for the friendly color scheme is orange, a cheerful, affable hue.

Symbolic meanings of colors differ from culture to culture. According to color expert Leatrice Eiseman, "Our cultural backgrounds and traditions influence our learned response and reaction to color... Each culture has its own unique heritage of color symbolism and each of us is a product of our early environment..." The palettes in this section represent western culture's color interpretations.

Use the suggested palettes as they are, or as a starting point to convey your own message.

DYNAMIC

Black. Bottom of the well, pitch of night black. Spill upon it sizzling red as a focal point, then spill a little more. Lace it with sunburst yellow, or tangerine.

The dynamic palette captures attention wherever it appears: sportswear, billboards, national flags, and pop art.

Black plus one or two pure, warm colors are the foundation of a dynamic palette. An exuberant red is always a sure bet. Neutrals (whites or grays) can be added sparingly.

To warm the palette, add yellow and orange, colors analogous to red. Warm yellows, leaning toward orange, are stronger than lemon yellow.

To increase vibrancy, throw in a splash of green or blue-green.

SUGGESTED PALETTES

1. DELICAS: DB-310, DB-757, DB-274
A daring palette, not for the meek! Start with a field of matte black (DB-310). DB-757, an opaque matte, is a hot, completely saturated red. The smallest touch of a yellow-green (DB-274) electrifies the entire palette. Use it sparingly!

2. DELICAS: DB-613, DB-757, DB-752, DB-200
Stray from matte black to a silver-lined dark gray like DB-613. Its sheen adds depth to the palette of otherwise flat matte colors. A small accent of white prevents the connotation of Halloween.

1

2

The most potent red available rivets our attention. In these two pieces from the "Ship of Transition" series, Valerie Hector, a master of strong contrasts, juxtaposes sharp angles and sensual curves, hard metals and soft fringe, shiny silvers and matte black.

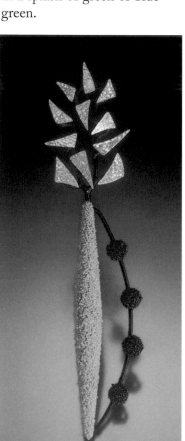

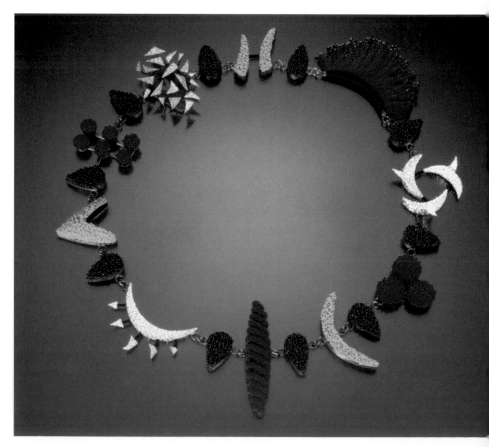

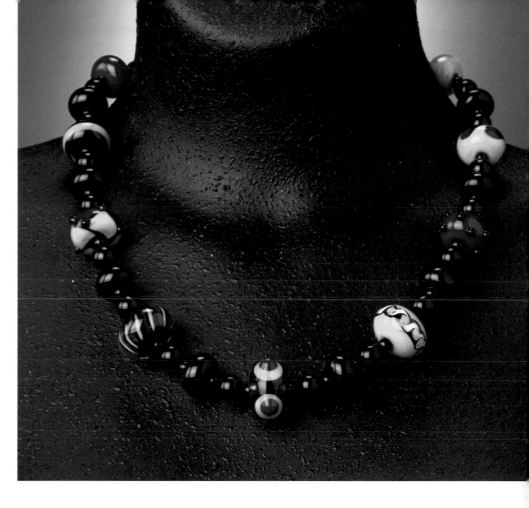

DYNAMIC PROJECT

DYNAMIC SINGLE-STRAND NECKLACE

Lampworked beads display dynamic colors beautifully because of their shiny surface finish and ability to hold fully saturated color. Notice how black allows the reds and yellows to jump forth.

FINISHED SIZE: 16" long

MATERIALS
- nine large colored lampworked beads
- twelve medium black lampworked beads
- twenty 8mm black onyx beads
- forty-four 4mm black onyx beads
- one medium toggle or lobster clasp
- two long crimp beads (silver)
- heavy flexible beading wire (.024 gauge)
- crimp pliers
- wire cutters

Arrange the lampworked beads in the order you will string them, placing the most interesting bead in the very center.

Cut a 24" piece of beading wire with wire cutters. Use a heavy gauge wire for two reasons: The slightly abrasive surface of the holes in lampworked beads can wear down the wire, and lampworked beads are quite heavy; a necklace with this many of them requires heavy stringing material. Glass bead artist Kristy Nijenkamp creates a buffer between the lampworked bead and the wire by lodging a clear seed bead in the hole of the lampworked bead.

String four 4mm onyx beads and a crimp bead. Pass the wire through one half of the clasp and back through the crimp bead and the four 4mm onyx beads. Pull the loop snugly around the clasp and crimp the crimp bead (see page 129). Leave a tail long enough for a few more beads to slide over.

String beads according to the photo or a pattern of your own design. Slide the first few beads over the tail and right up against the crimp bead.

String enough beads to fill the desired length of the necklace.

Finish the other end as you did the first end: After the last four 4mm onyx beads, string a crimp bead, loop through the clasp, and pass the wire back through the crimp and four or more beads. Pull the tail snug, but not so tight that the necklace is inflexible. Crimp the crimp bead. Test the hold. When you are sure it will hold, clip the tail as close to the hole of the exit bead as possible. Stain the crimp bead and the wire with a permanent black marker.

NATURAL

A natural color palette is made up of complex colors that are somewhat subdued. Unlike pure, saturated jewel tones, natural tones are comprised of mixtures of several hues.

The shadings of plants, flowers, sea, and sky, and natural colors of almost any shade, tint, or tone capture the feel of the natural palette. Natural color schemes are not limited to earth tones—they can and do encompass all of nature. For example, in the painted desert of the American Southwest, a natural scheme of subdued pinks, oranges, yellows, greens, and grays dominates the landscape.

Examples of color schemes of colored minerals and earth pigments date as far back as the Paleolithic period and have been used throughout human history. Their complex subtleties are seen in Greek pots, Egyptian wall paintings, William Morris's decoratives, and the muted primaries and grays of Colonial America.

Natural color schemes feel comfortable, stable, and at times rustic. Use them to achieve a classic, conservative, well-groomed look. Beads of natural materials, such as bone, shell, wood, seeds, and gemstones, are perfect in this color palette.

If your natural scheme begins nodding off to sleep, wake it up with a bright color. But beware. A natural scheme is easily overwhelmed. Try shades of grass green or turquoise, which will invigorate and balance natural colors.

SUGGESTED PALETTES

1. DELICAS: DB-312, DB-311, DB-253, DB-372
Matte metallic umber (DB-312) creates a background for DB-311, a velvety matte metallic the color of chive stalks. The only highly reflective bead in this palette is a luster-finish DB-253. Accents of grasshopper green (DB-372) balance this scheme.

2. DELICAS: DB-377, DB-240, DB-702, DB-254, DB-271
An unusual and masculine color scheme begins with a grayed blue (DB-377). DB-240 is the clearest, brightest member of this palette. Use it sparingly or with gusto, depending on the effect you are trying to achieve.

1

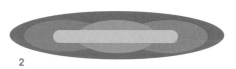

2

An amalgamation of natural earth tones and textures by Beadazzles' Alice Walker includes amber, onyx, and Chinese turquoise.

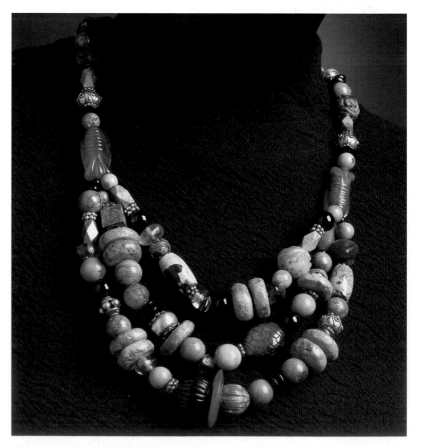

NATURAL SCHEME PROJECT

FETISH & TASSEL PENDANT

MATERIALS

- enough beads to make three 26" strands and eight 4" tassels (the example in the photo uses turquoise, trade beads, jasper, brass, horn, heishi, coral, and coal jade)
- carved stone Zuni fetish bead with an attached offering bundle
- one substantial trade bead with smooth hole and edges (to support the center-piece beads)
- one double-drilled horn hairpipe toggle
- 2 drilled horn rings
- size D Nymo thread
- stringing cord (medium weight)

MAKE TASSEL

String enough Nymo D thread with heishi to wrap around the fetish (a). Tie securely under fetish. Fuse knots with jeweler's cement, leaving a 10" tail.

Loop the tail thread around the arrowhead bundle several times and tie it off above the arrowhead and underneath the fetish (b). (These loops provide an attachment point for the tassel.) Cement the knot and trim excess thread.

Construct tassel by passing a new thread (about 36" long) through the loops on the underside of the arrowhead. Tie and cement a knot, leav-ing a tail. String on three beads with holes large enough to accommodate all the fringe threads (c).

Thread enough beads for the length of the first fringe of tassel. Loop thread around the last bead (d) and run it back up through all beads (including the three large beads) and over the loops under the arrowhead. Bring thread back down through large beads and make seven more fringe strands, for a total of eight. Tie the excess thread to the original tail at the top.

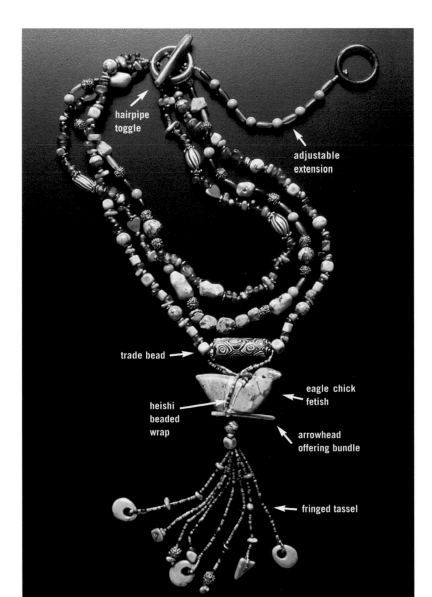

hairpipe toggle

adjustable extension

trade bead

heishi beaded wrap

eagle chick fetish

arrowhead offering bundle

fringed tassel

Mary Hicklin's "Fetish & Tassel Pendant" epitomizes the natural palette in color, texture, and material. Glass trade beads introduce the polish of human handiwork to this raw menagerie of earth-wrought stones and beads. Eagle chick fetish by Lena Boone.

Above the fetish, loop a thread under the heishi strand wrapped around the fetish. String enough heishi to fill the length between the end of the trade bead and the heishi strand wrapped around the fetish. Thread through trade bead, and the same amount of heishi (e). Again, thread under the heishi strand on the fetish. Go through all beads at least twice, being sure to leave enough space in the hole of the trade bead for one pass of necklace cord. Tie off, cement knot, and trim excess thread.

MAKE STRANDS

On beading cord string beads onto three separate strands of the following lengths: 24", 25", and 26". In the center of the longest strand, string the trade bead holding the fetish.

MAKE TOGGLE CLOSURE

Attach one end of each beaded strand to the hairpipe as shown in figure 1. Pass thread of each beaded strand up through three large joining beads, the hairpipe, and three turn beads. (Make sure these turn beads are smooth seed beads. Sharp seed beads like vintage cut beads often have sharp edges.) Pass thread back down through hairpipe, three large joining beads, and back into the strand. Knot thread onto itself with a half-hitch knot with a twist (see figure 3) at several points and cement the knots.

Attach loose ends of beaded strands to the ring as shown in figure 2.

If desired, make and attach an extension to the ring (figure 3). This will enable the wearer to adjust the length of the necklace.

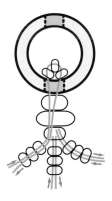

The holes of these three turn beads must accommodate three strands of bead cord.

The holes of the three joining beads (beneath the hairpipe toggle) and the hairpipe toggle must accommodate six strands of bead cord (three beaded strands, each one passing through twice).

Figure 1

Unless you find a piece of hairpipe drilled through the width, you'll have to drill it yourself using a Dremel. Make a hole large enough to accommodate six strands of the cord you'll be using (three beaded strands passing through twice).

Figure 2

Connect the other ends of the three beaded strands to the ring just as you connected them to the hairpipe toggle.

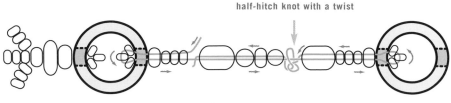

half-hitch knot with a twist

Figure 3

Construct an extension about 4" long attached to the closure ring. Knot thread onto itself in several places, between larger beads. Knot and trim excess thread tails of both ends. Be sure to fuse all knots with jeweler's cement.

LUXURIOUS

The luxurious palette is an unfettered voluptuary. It revels in sensuous delights: swooning color, scintillating light, and tantalizing texture.

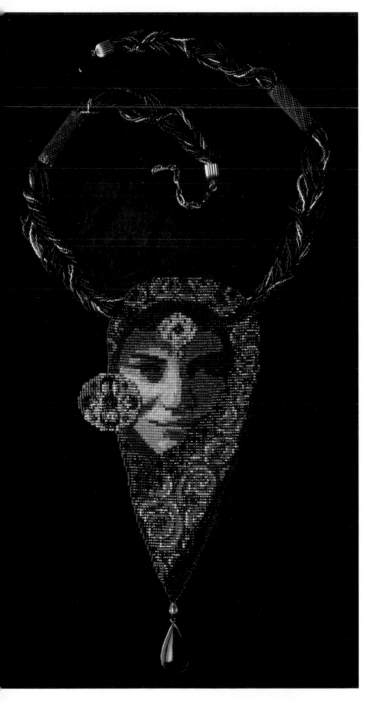

"Mandira" by Margie Deeb wears sumptuous texture, exotic ornamentation, and flamboyant colors laced with rich, sparkling gold—all the textures and hues of the luxurious palette. Loomwork, peyote-stitched beaded beads, and braided strands by Frieda Bates.

All members of the luxurious palette recline on shades of deep magenta or maroon. Purple, in its guises from plum to eggplant, is always invited. Other colors are welcome, provided they offer up their richest, most sultry side.

An effusive golden sparkle veils the palette like spicy perfume. Charlottes and true-cut seed beads are perfect luxurious bedfellows. The small, flat facets ground onto their surfaces become mirrors tossing shards of light in every direction.

Texture must never be spiked or sharp, but rather smooth, curved, or undulating, and always irresistible to the touch.

When color, light, and texture coalesce into quivering pleasure, the splendor of the luxurious palette is born.

SUGGESTED PALETTES

1. DELICAS: DB-281, DB-073, DB-610, DB-331
A luxurious mystique emanates from this palette with its background of royal fuchsia (DB-281). A magenta-purple (DB-073) and violet (DB-610) add definition and depth, while accents of matte metallic gold (DB-331) offer their radiance.

2. DELICAS: DB-296, DB-281, DB-923, DB-361, DB-034
A deep cranberry with an AB finish (DB-296) offers the lap of luxury for royal fuchsia (DB-281) and violet (DB-923) to cast their spell. A porcelain-like quality is introduced with accents of matte blue (DB-361). 22-karat light gold (DB-034) lends glorious splendor to the mix.

1

2

LUXURIOUS PROJECT

MANDIRA NECKLACE OR MINI-TAPESTRY

A luxurious mood is reflected in the colors, patterns, and smile worn by the beguiling Mandira. Frieda Bates executed the loomed version on the previous page with braided straps, matching beaded beads, and a teardrop-shaped amethyst at the bottom.

PEYOTE: 79 beads wide (4")
120 beads high (8")

LOOM: 79 beads wide (4")
120 beads high (8")

QUANTITY OF BEADS	DELICA COLOR #	
2 1/2 grams Matte Old Rose	DB-800	
6 grams Silver-lined Gold	DB-042	
9 grams Royal Fuchsia	DB-281	
3 grams Lined Deep Emerald Luster	DB-275	
2 1/2 grams Matte Metallic Chive Green	DB-311	
1 1/2 grams Opaque African Violet	DB-661	
3 grams Silver-lined Violet	DB-610	
1 1/2 grams Vanilla Ceylon	DB-204	
2 grams Opaque Tan	DB-208	
4 grams Shimmering Copper	DB-915	
4 1/2 grams Matte Metallic Umber	DB-312	

Note: Quantity of beads does not include amount required for hanging straps or fringe.

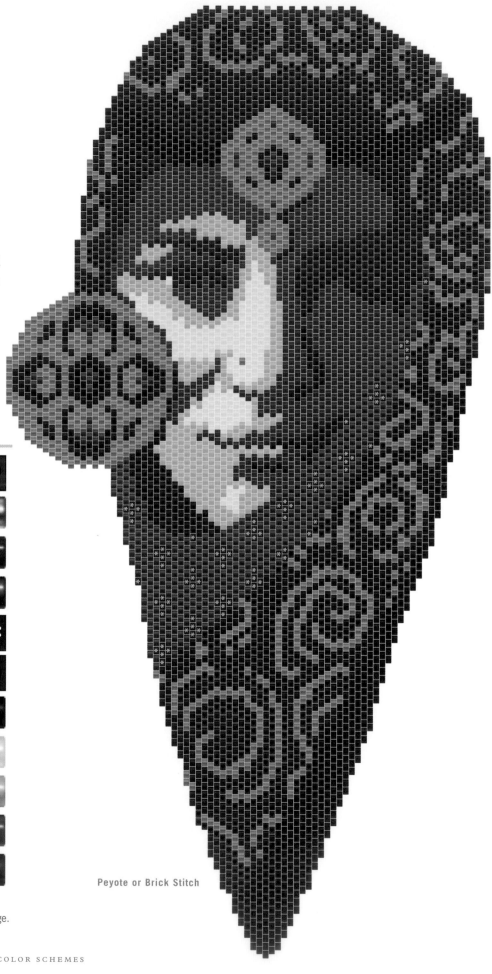

Peyote or Brick Stitch

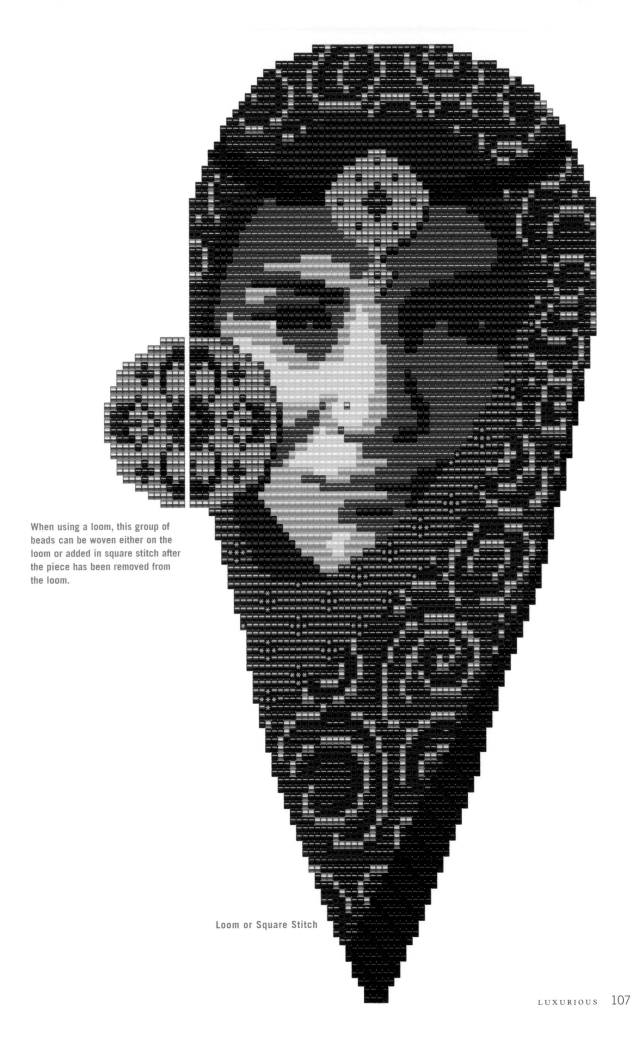

When using a loom, this group of beads can be woven either on the loom or added in square stitch after the piece has been removed from the loom.

Loom or Square Stitch

TROPICAL

Begin with fresh, Caribbean blue-greens. Combine lavishly with other luminous, clear colors, and you have the tropical palette.

This vibrant panoply of colors includes smooth banana yellows, rich mango oranges, bird-of-paradise reds and purples, ginger pinks, rain-forest greens, and the blues of primordial lagoons. Tropical color schemes are at once serene and teeming with life.

The finish of the beads in a tropical scheme will include transparent, shimmering pearl, and crystal-lined beads that sparkle with dancing light. Be sure to include iridescent and AB finishes, reminiscent of the shimmer of abalone shells and mother-of-pearl.

SUGGESTED PALETTES

1. DELICAS: DB-918, DB-233, DB-905, DB-914
Reflected light is as important to the tropical palette as color. The dominant shimmering teal (DB-918) is more green than blue. DB-233 is a yellow-lined crystal luster finish. The blue (DB-905) and pink (DB-914) are lined crystal with a shimmering finish. Flat ink representations do not begin to approximate the sparkling quality of these tropical palettes.

2. DELICAS: DB-166, DB-074, DB-078, DB-237, DB-249
The AB finish of the dominant aqua color (DB-166) reflects silvery lime green and light fuchsia. These are echoed by two more colors: DB-074, a light magenta, and DB-237, a lighter lime green. Aqua mist (DB-078) and sumptuous lavender (DB-249) provides rich accents.

1

2

The element of water is personified in "Dance of the Undines" by Margie Deeb. Its color palette is tropical blues and greens with golds and gently muted amethyst and peach. Loomwork by Frieda Bates and Margie Deeb.

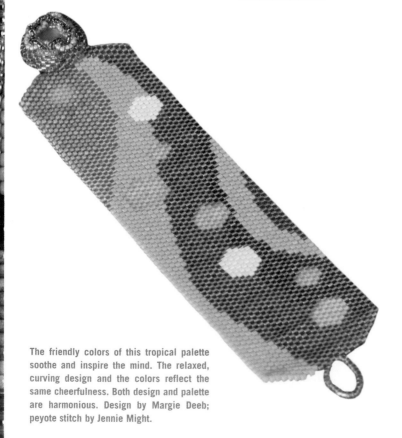

The friendly colors of this tropical palette soothe and inspire the mind. The relaxed, curving design and the colors reflect the same cheerfulness. Both design and palette are harmonious. Design by Margie Deeb; peyote stitch by Jennie Might.

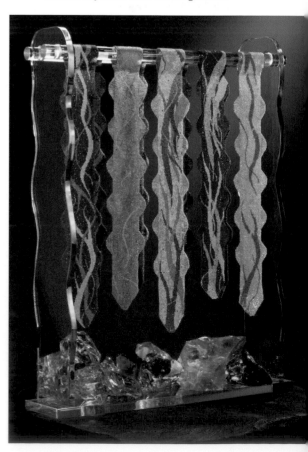

BARBADOS BAJAN BRACELET

If you live in Barbados, you are called a "Barbadian." If you live in Barbados and are a friend, you are considered a "bajan." Friendly, clear, light colors make up this lively palette. Reflective and shimmering beads make sunlight dance and sparkle off "Barbados Bajan." The "bubbles" or spheres drifting among the undulating waves are opaque and solid. With the suggestion of flower petals or leaves, they harmonize land and sea.

PEYOTE: 27 beads wide (1⁷/₁₆")
 81 beads high (5³/₈")

LOOM: 27 beads wide (1⁷/₁₆")
 81 beads high (5³/₈")

Note: Measurements do not include length of clasp and findings.

QUANTITY OF BEADS	DELICA COLOR #		
1/2 gram Sparkling Daffodil	DB-160		♥
1 1/2 grams Cameo Pink	DB-070		✳
Fifty beads Shimmering Pink	DB-914		◯
1 1/2 grams Shimmering Violet	DB-906		◒
4 1/2 grams Shimmering Cerulean	DB-920		▼
1 gram Aqua Green	DB-904		♥
4 1/2 grams Aqua Green AB	DB-878		↓
1 gram Chartreuse AB	DB-860		←

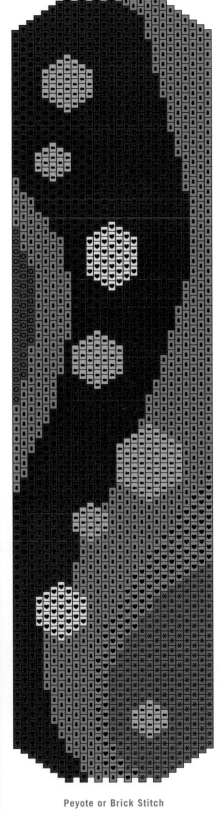

Peyote or Brick Stitch

Loom or Square Stitch

OPULENT

Like a fine, aged Burgundy wine, the piquant aroma of the opulent palette is velvety, full-bodied, and richly textured. These are not chic or trendy tones. Mature and enduring, they convey long-standing affluence.

Begin with deep, jewel-toned garnet and ruby colors. These resplendent reds find a perfect complement in the gorgeous greens of emerald, peridot, and aventurine. Mellow tones of purple and violet (found in tanzanite and amethyst) add their own sumptuous bouquet. To finish off the palette, remember that opulence often exhibits a high note of gold accents, perhaps infused with hints of such burnished metallics as bronze or antique silver.

Ordered texture enriches the opulent palette. Imbue it with different bead shapes, sizes, and finishes to develop a tapestry of textures. Braid or twist together strands of smooth, nugget, and faceted gemstones interlaced with tiny seed beads.

And don't be skimpy with materials! The opulent palette requires those beads you've been hoarding because they were so expensive. Adorn this palette with the finest you have, and lots of them!

Like that fine Burgundy wine, the cachet of beaded art steeped in the opulent palette will only improve with age.

SUGGESTED PALETTES

DELICAS: DB-116, DB-001, DB-923, DB-919

A metallic muted red (DB-116) begins the dance of opulence. Highly reflective, dark, gunmetal gray (DB-001) steps in and whirls shimmering violet (DB-923) around the palette. An accent of dragonfly green (DB-919) takes the final bow. All partners in this palette have lustrous, reflective finishes.

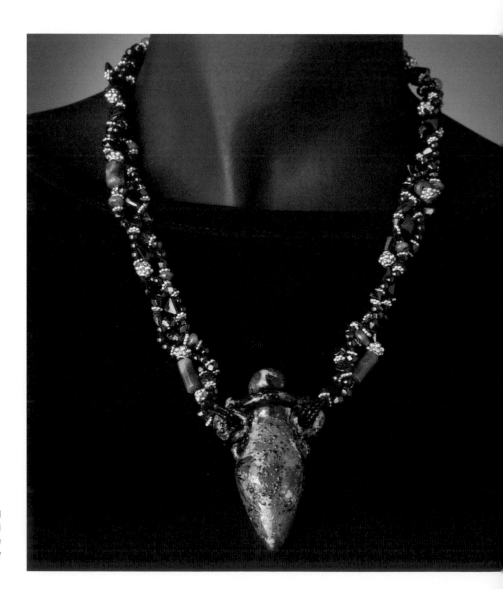

Braided strands of luxurious opulence hold a miniature glass amphora crafted by Stevi Belle. Gold gives a glorious sparkle to the rich garnet and zoisite scheme. Necklace by Mary Hicklin.

VESSEL WITH BRAIDED STRANDS

This intermediate-level stringing project requires the finest materials befitting the opulent palette. Don't skimp. Use gemstones and gold or vermeil.

FINISHED SIZE: 24" long

MATERIALS:
- enough beads to make six 10–12" strands (the assembly in the photo uses red garnet, ruby in zoisite, and vermeil beads and spacers)
- garnet-colored seed beads to attach strands to vessel
- centerpiece vessel bead
- stringing cord (medium weight)
- flexible beading needle
- two head pins (or wire) for wire loops
- two cones
- soldered jump rings
- clasp

Unique to this design is a centerpiece bead requiring two sets of strands on either side looping around it, rather than one group of strands strung through it. The method Mary Hicklin uses to hold the vessel bead can be used for donut bead lariats, too.

Cut beading cord to more than 2½ times the length of the finished necklace. Thread cord onto a flexible beading needle. Tie a stop bead (or guard bead) onto the thread, leaving a tail about 4" long (a). (You will remove this later.)

Begin stringing beads (see page 128 for stringing tips) in a pattern of your choice about 3–4" inches from the handles of the centerpiece bead.

When you are about 1/8" from the centerpiece bead, string enough seed beads to make a comfortable loop around the centerpiece handle (b). These seed beads will protect the cord from being frayed by the centerpiece.

After completing the loop of seed beads, pass thread back through the 3–4" inches of the strand. Tie one over-hand knot before and after each larger gemstone bead. (These knots will prevent beads from slipping off if the strand should break.) String the rest of the strand.

Remove the stop bead. If you are not knotting between the gemstone beads, thread the tail on a needle, and pass it through several beads. Tie it to the strand with a half-hitch twist knot as shown at the bottom of page 104. Thread it through several more beads and repeat. Secure knot with a dab of jeweler's cement.

Make two more strands the exact same length using a different pattern of beads. Attach these strands to the centerpiece bead and jump rings the same way.

Repeat the procedure for the other side of the center-piece bead. Once all strands are complete, make wire loops (see page 130) to tie the strands to. Finish off with cones and a clasp as shown on page 130.

After the necklace is attached to the cones, braid each side. Begin loosely braiding at the vessel end. As you braid, allow the cone end to naturally flip through the strands. The braid can be unbraided easily if necessary.

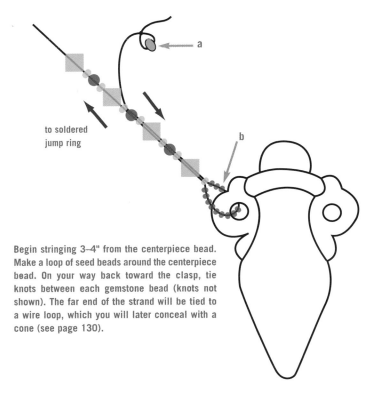

to soldered jump ring

a

b

Begin stringing 3–4" from the centerpiece bead. Make a loop of seed beads around the centerpiece bead. On your way back toward the clasp, tie knots between each gemstone bead (knots not shown). The far end of the strand will be tied to a wire loop, which you will later conceal with a cone (see page 130).

FRIENDLY

What could be more friendly than the earth herself? Orange tones speak of earth and warmth, and form the basis of a friendly palette.

Marigolds, pumpkins, tangerines, and glowing fires wear these colors. True oranges are invitingly warm, embracing, sociable, even uplifting. Add yellows and reds to heat them up, or near-complementary greens and complementary blues for harmonious vitality.

SUGGESTED PALETTES

1. DELICAS: DB-872, DB-073, DB-274
Brilliant day-glo orange beads (DB-872) with tints of hot pink are the basis for a vivid, friendly palette. Sparkling lilac (DB-073) and a grassy green (DB-274) make a slightly skewed split-complementary scheme. Consider altering this palette by making lilac the dominant and orange the secondary color.

2. DELICAS: DB-1302, DB-233, DB-622, DB-106
This analogous palette of lower intensity oranges (DB-1302 and DB-622), pink (DB-106), and a lustrous buttercup yellow (DB-233) is friendly in a quiet, gentle way. A very feminine palette with a Victorian feel.

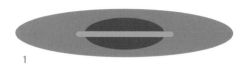

1

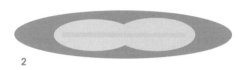

2

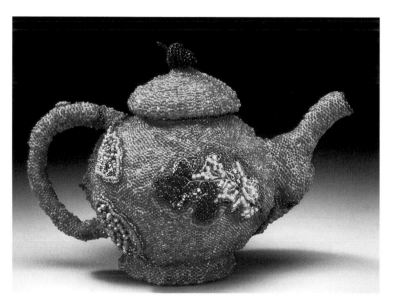

"Tea Leaves," by Ann Tevepaugh Mitchell, radiates a sunny orange warmth, brightened with a hint of yellow (above). This bright, effusive color becomes a friendly invitation to afternoon tea. Self-supporting peyote stitch worked dimensionally.

With the help of brilliant orange, a simple, folded design is transformed into a striking piece (right). Gold-beaded edging and gold foil make an elegant addition to "Fire Dragon Purse" by Margie Deeb. Loom-woven seed beads and blown glass beads.

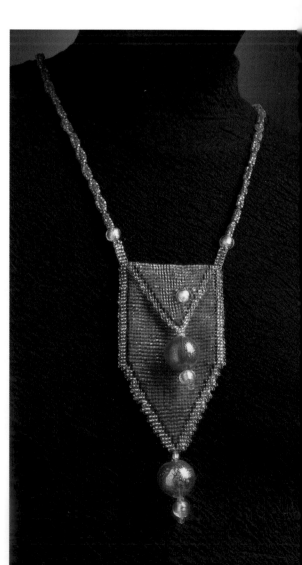

FIRE DRAGON PURSE

In warm and cheerful shades of bright orange, this simple purse wants to be touched and worn. Just inside the elegant gold border is a darker shade of orange, which adds substance and the illusion of depth. The dragon-like design continues onto the back.

Large, decorative lampworked or blown glass beads hung from the bottom and the point of the flap finish the purse in a grand way.

PEYOTE: 35 beads wide (1³/₄")
 131 beads high (8³/₄")

LOOM: 35 beads wide (1⁷/₈")
 131 beads high (8³/₄")

Note: Measurements do not include length of clasp and findings.

QUANTITY OF BEADS	DELICA COLOR #		
5 grams Gold	DB-031		
11 grams Orange	DB-151		
1¹/₂ grams Dark Pumpkin	DB-777		

Note: Quantity of beads does not include amount required for straps.

For the loomed version, the purse is folded and each warp is pulled, automatically securing the bottom (the diagonal sides) of the purse. Be careful not to pierce any of the warps with your needle while weaving. If you do, pulling the warps will no longer be an option. You'll have to snip and tie off each one individually.

Peyote or Brick Stitch Loom or Square Stitch

CLASHING

Clashing schemes are unexpected combinations of colors that collide, vibrate, stimulate, and excite. Carnivals, festivals, and clowns cash in on clashing colors.

Traditionally, "clash" has been used to describe a negative or unpleasant combination of colors, but that need not be the case. Today, almost any combination is permissible, thanks to the influence of the psychedelic sixties and its far-out, shocking color combinations. Peter Max and Andy Warhol shattered traditions—and color wheels—in a frenzy of shocking, acidic, unrestrained color. The intense, fluorescent palettes of that time attempted to express the visual sensations induced by psychedelic drugs. These palettes broke all the rules and opened the door for clashing combinations.

Schemes that clash use mostly saturated brights in unrestrained and often equal proportions. No subtlety here! Splashes of complementary and near-complementary harmonies create the main frisson of the clashing scheme.

Bead finishes that hold a lot of color—opaques, matte opaques, semi-mattes, and silver-lined—make the best clashing schemes.

Expand your sense of what is possible. Take risks! Experiment with clashing schemes in smaller creations, such as earrings and bracelets, until you feel comfortable with their mind-altering, eye-popping possibilities.

SUGGESTED PALETTES

1. DELICAS: DB-751, DB-1347, DB-1340, DB-733
Violet (DB-1347) on yellow (DB-751) vibrates like a washing machine on spin. Toss in magenta (DB-1340) and neon lime green (DB-733) in less than refined proportions and you've got an eye-popping, bead-rattling color palette.

2. DELICAS: DB-757, DB-610, DB-169
Carnival red matte (DB-757) makes a background on which silver-lined violet (DB-610) and iridescent lime (DB-169) simmer. This clashing palette yearns to become a multi-strand necklace with oddly shaped and sized beads.

3. DELICAS: DB-161, DB-073, DB-920
Hot orange with glints of pink in the finish (DB-161) is host to the palpitations of shimmering magenta-purple (DB-073) and cerulean blue (DB-920). This fresh, bold palette doesn't scream, but it definitely gets noticed.

4. DELICAS: DB-751, DB-1345, DB-688
A palette fit for a clown! Or maybe a summer bracelet of cane glass and lampworked beads. Either way, a bright matte yellow (DB-751) is the stomping ground for red-violet (DB-1345) and leaf green (DB-688).

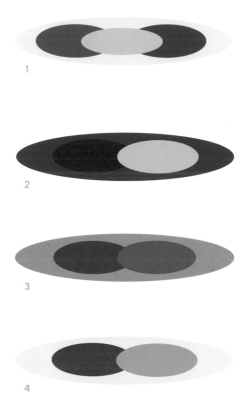

Earrings are just the right-size project for venturing into the wild world of clash. Each one of these is a stop-you-in-your-tracks explosion of color fired by the irrepressible excitement of complementary and near-complementary harmonies. Earrings by Margie Deeb.

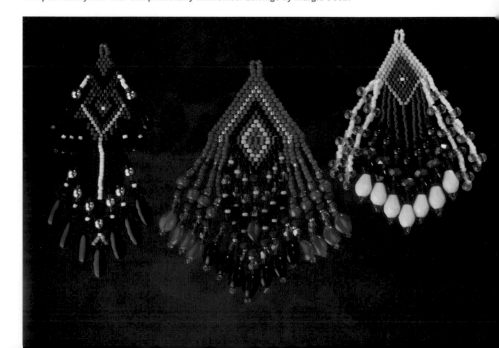

CLASH OF THE EARRINGS

Clashing combinations of vibrant, high-intensity colors make these three pairs of brick-stitched earrings stunning. Notice how complementary and near-complementary harmonies add to the sense of movement. Try them with the palettes on the previous page.

Two to three grams of each color will be more than enough beads to create these traditional brick-stitched earrings and their accompanying fringe.

Begin the tops of the earrings by making a "ladder" of beads stitched side by side. The ladder row of each earring is indicated with an arrow. Using brick stitch, add rows onto the ladder. Add a loop of six beads at the top to attach your finding. Make fringe as short or as long as you like.

DELICA COLOR #

DB-160
Sparkling Daffodil

DB-661
Opaque African Violet

DB-165
Blue Violet AB

DB-748
Cobalt Matte Transparent

DB-651
Goldenrod Opaque

DELICA COLOR #

DB-752
Matte Opaque Orange

DB-151
Orange AB

DB-681
Spanish Orange

DB-756
Royal Blue

DB-787
Matte Transparent Turquoise (dyed)

DB-658
Opaque Lagoon Green (dyed)

DB-744
Matte Transparent Orange

DELICA COLOR #

DB-860
Chartreuse AB

DB-274
Grass Green

DB-281
Amaranth

DB-1340
Silver-lined Magenta

DB-295
Carmine

DB-160
Sparkling Daffodil

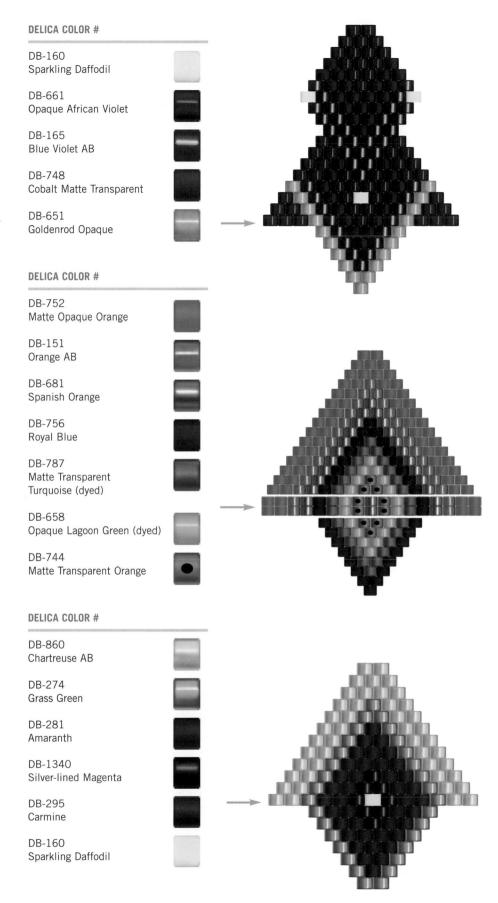

PENSIVE

Low-intensity lavenders and mauves with muted, slightly grayed tones reflect a pensive mood.

Begin with a grayed lavender, which imparts a sense of meditative reflection or nostalgic longing. Keep the contrast restrained; no jarring darks or glaring lights. In the pensive palette, lavender finds natural companions in subtle pink and mauve (a pale, faintly grayed magenta). Grays and blues add a hint of wistful melancholy, reminiscent of a quiet rainy day. Rather than yellows, which would pep up the mood, use cream or ivory colors. These soft, retiring colors work well in landscapes and florals.

SUGGESTED PALETTES

1. DELICAS: DB-629, DB-080, DB-695, DB-081
These mauve to lavender tones include lilac alabaster (DB-629), lined pale lavender-gray AB (DB-080), and silky mauve (DB-695). Accents of lined medium gray AB (DB-081) deepen the otherwise monochromatic palette. Iridescent AB finishes hint of glimmer within the foggy mist.

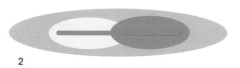

2. DELICAS: DB-210, DB-353, DB-376, DB-913
Begin with mauve luster (DB-210) and pale, porcelain, bisque-like peach (DB-353). Add matte metallic fog blue (DB-376) and shimmering salmon (DB-913) for an unusual, yet gentle palette.

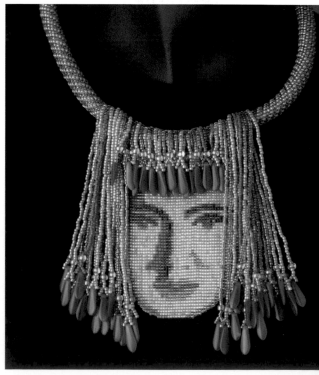

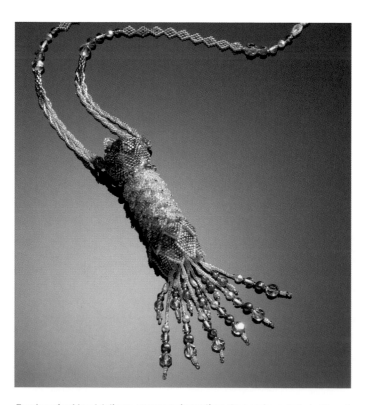

Touches of gold and delicate ornamentation enliven the pensive palette in "Desert Journey" by Margo Field. Peyote-stitched with braided strands.

The steady gaze of "Kiyoshi" reflects the subdued, muted colors of the pensive palette. Design by Margie Deeb; loom-work, peyote strap, and fringe execution by Frieda Bates.

PENSIVE PROJECT
KIYOSHI

PEYOTE: 56 beads wide (3 1/8")
 4" high

LOOM: 56 beads wide (3 1/4")
 4" high

Note: Dimensions are for woven section only.

QUANTITY OF BEADS	DELICA COLOR #	
10+ grams Light Pink Pearl	DB-248	♥
4 grams Shimmering Muted Pink	DB-902	✳
4 grams Pale Aubergine (dyed)	DB-660	■
1 1/2 grams Dark Shimmering Violet	DB-923	🍷

Note: Quantity of beads does not include amount required for straps and fringe.

Using tubular peyote, stitch around a 1/4"-diameter rope, creating a 16–18" strap from which to hang the woven section. Finish the ends of the strap with end caps linked to a clasp.

When attaching the woven section to the strap, the strap must be fastened together to create a circle similar to the shape it will take when being worn. Do not work with the strap straight, or the final piece will not curve and hang properly.

Lay both pieces on a table and center the woven section just below the strap. Weave thread into several strap beads so your needle is firmly attached to the strap. Bringing your thread out of a strap bead, string on five beads and pass needle through the topmost bead on the left side of the woven section. Pass needle back through the five beads and back into the same strap bead from which you began. Repeat in a straight line all the way across the top of the woven piece, using as many beads as necessary each time you drop down from the strap to the woven piece. You will need a length of more than five beads as you are attaching the center part of the woven section to the strap.

Drop fringe from the strap so that it hangs in front and to the side of Kiyoshi's face like hair.

Peyote or Brick Stitch

Loom or Square Stitch

TRANQUIL

Whisper-soft blue sky on a summer's day. Pristine mountain lake, clear blue to its spring-fed bottom. Lazy Aegean-blue waters, stretching endlessly. The tranquil palette is composed of just such clear blues.

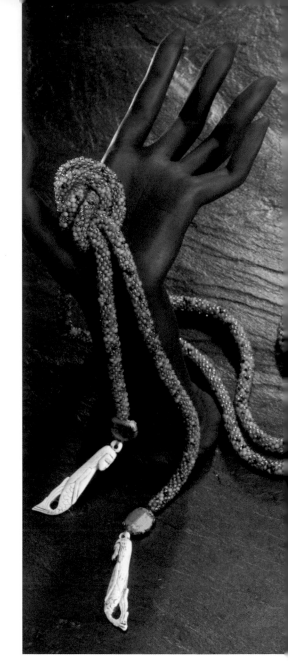

This palette retains its serenity when each of its colors has similar intensity. To remain clear and light, the colors should never contain gray or black, which would make them more opaque.

This palette also remains serene when value contrast is minimal. Striking contrasts would make the palette dynamic rather than relaxing. Make sure the dominant hue is always a tranquil blue; all other colors should be accents.

What keeps the tranquil palette from having a tranquilizing effect? Movement and depth! Use luminous bead finishes that encourage the movement of light. Excellent choices are beads that allow light to pass through them, like transparent and color-lined finishes, or beads that gently reflect light, such as pearlescent and luster finishes. While an opaque or matte bead may have the perfect

tranquil blue hue, its finish lacks depth and absorbs light, leaving the palette stagnant and flat. When choosing bead finishes, think of the movement of light through the bead. Think of the depth of water and sky.

"Tranquil" is not synonymous with lifeless. The tranquil palette can uplift and refresh even as it calms. The key is in its overall tonality. Choose clear, light colors with mild contrast, and bead finishes that allow both movement and depth.

Jennie Might began this crocheted lariat with a palette of blues both tranquil and tropical. As if plumbing the briny deep, she flowed into it the greens of oceanic flora and fauna, then finished it off with a pair of antique bone mermaids.

SUGGESTED PALETTES

1. DELICAS: DB-057, DB-076, DB-109, DB-904
Sparkling, clear blue (DB-057) forms the background. A darker blue (DB-076) and a whisper of transparent pale yellow (DB-109) provide balance for an enchanting emerald green (DB-904) accent.

2. DELICAS: DB-240, DB-694, DB-257, DB-285
An analogous palette based on pearlescent finishes: Medium blue (DB-240) is the dominant, accented by a tint of the same hue (DB-257) and a semi-matte lavender (DB-694). Use the strongest blue (DB-285) sparingly!

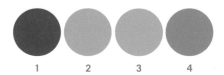

| 1 | 2 | 3 | 4 |

#1 is a true blue with no white added. Notice how the addition of white makes #2 and #3 calmer. Because #4 is darkened with black, it is more opaque and appears "muddier." Because it lacks clarity, #4 should not be included in a tranquil palette.

1

2

ANGEL WHEELS NECKLACE

MATERIALS
- single-strand clasp
- bead tips (knot covers)
- size D Nymo thread
- needle
- jeweler's cement

MAIN COLOR (MC): LIGHT BLUE
- 188 4mm crystal bicones
- twelve 4mm round crystals
- sixty 3mm crystal bicones
- 5 grams of Delicas or size 15o seed beads

SECONDARY COLOR (SC): CAPRI BLUE
- 129 4mm crystal bicones

FIRST ACCENT (A1): GREEN
- sixteen 4mm crystal bicones

SECOND ACCENT (A2): AMETHYST
- twenty 5mm crystals

THIRD ACCENT (A3): PEACH
- twenty-four 4mm crystal bicones

Make all the wheels separately, then string them together and attach the clasps.

CONSTRUCT SMALL WHEELS

Make seven small wheels with MC crystal bicones and two small wheels with SC crystal bicones.

Using a length of thread from 18–26" long, string a stop bead. Loop thread around it once and slide toward end of thread, leaving a 3–4" tail.

Starting with a Delica and alternating with a 4mm crystal bicone, string a total of nine Delicas and nine crystals.

net

Figure 1

Tie into a ring and reinforce the entire circle by passing needle through all beads again and exiting a Delica. Add on five Delicas and pass needle through next Delica, creating a tiny "net" (figure 1). Continue all the way around ring.

After adding the last Delica net, pass needle up through the first three Delicas of the next net. Add on one Delica, one crystal, and one Delica. Pass needle through the third bead of the adjacent net (figure 2).

Figure 2

Continue all the way around the ring, then reinforce entire circle. Pass thread through two or three beads and make a half-hitch (see page 104). Repeat two or three times, then bury thread within beads. Trim excess.

CONSTRUCT LARGE WHEEL

Start by making a small wheel. Using crystal bicones make the first ring MC, second ring SC, third ring MC.

Figure 3

When adding the final net, pass needle through two Delicas. Add on five Delicas and pass needle through the Delica that is just on the other side of the crystal (figure 3). Pass needle through the next two Delicas. Continue all the way around the ring.

Pass needle through the first three Delicas of the net and add on two Delicas, one crystal, and two Delicas; then run through the third Delica of the adjacent net (figure 4). Continue around ring. Reinforce entire circle, knot off, and bury thread.

Figure 4

Figure 5

BEAD SEQUENCES

SEQUENCE #1
3mm MC
4mm SC
3mm MC
4mm A3
5mm A2
4mm A3
3mm MC
4mm SC
3mm MC

SEQUENCE #2
3mm MC
4mm SC
3mm MC
4mm A1
5mm A2
4mm A1
3mm MC
4mm SC
3mm MC

SEQUENCE #3
3mm MC
4mm SC
4mm round MC
4mm SC
3mm MC
4mm A3
5mm A2
4mm A3
3mm MC
4mm SC
4mm round MC
4mm SC
3mm MC

MAKE CONNECTING STRANDS

Using a length of thread 22–26" long, string a stop bead. Loop thread around it once and slide toward end of thread, leaving a 3–4" tail.

String on twenty-five MC crystal bicones. Attach to one MC wheel by passing needle through one crystal, three Delicas, one crystal, three Delicas, one crystal (figure 5).

String the following:

sequence #1 (see chart at left)
SC wheel
sequence #2
MC wheel
sequence #2
SC wheel
sequence #1
MC wheel
twenty-five MC crystal bicones

Add on a bead tip (see page 128) and a seed bead. Skip seed bead and pass needle back through twenty crystals. String on seven MC crystals and pass needle through the second crystal below the crystal attached to the neck strap. Pass needle through the next three crystals (figure 6).

String the following:

sequence #1
MC wheel
sequence #3
MC wheel
sequence #2
large wheel
sequence #2
MC wheel
sequence #3
MC wheel
sequence #1

Attach string to the small MC wheel of the top strand. Add on seven MC crystals. Counting down from bead tip attach the seven-crystal swag by passing needle between the twentieth and twenty-first crystals.

Run the thread up through the remaining strand, into the bead tip and the seed bead. Knot off and seal with jeweler's cement. When dry, close bead tip and trim thread.

Figure 6

ATTACH BOTTOM SWAGS TO TOP ROW

Attach an 18" length of thread to an MC wheel on either side of the top row and string the following:

sequence #1
(pass through SC wheel)
sequence #2
(pass through MC wheel)
sequence #2
(pass through SC wheel)
sequence #1

Pass thread into MC wheel, knot off, and bury thread within beads.

ATTACH BOTTOM SWAGS TO BOTTOM ROW

Attach a 20" length of thread to a small MC wheel on either side of the bottom row and string on:

sequence #1
(pass through MC wheel)
sequence #3
(pass through MC wheel)
sequence #2
(pass through large wheel)
sequence #2
(pass through MC wheel)
sequence #3
(pass through MC wheel)
sequence #1

Pass thread into MC wheel, knot off, and bury thread within beads.

SaraBeth Cullinan gently warms this tranquil palette with peach tones, while allowing clear, cool blues to remain dominant. This piece was inspired by a necklace worn at Napoleon's coronation by Empress Josephine's lady-in-waiting. The "sparkly wheel" technique was created by Nikia Angel.

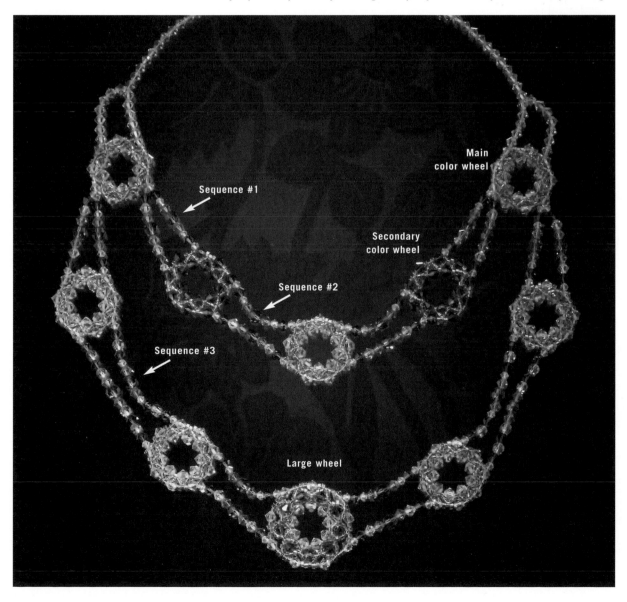

INSPIRATION
&
TECHNIQUE

Extraordinary use of color emerges from both knowledge and a depth of personal expression. No matter how often the muse gifts you, you must have the ability to rise to her bequest. You need ability to express inspiration. Many artists study color their entire lives. Their knowledge expands their mastery so that intuition and expression may come into play.

But artistry is more complex and profound than mastery. Finding your voice, through color or any other medium, is a lifelong process. There are no guaranteed paths, as the process is a personal journey, and ultimately, a spiritual one. It requires that you allow all your senses to find the beauty, movement, light and life of color, wherever it exists. It requires passion.

Use the techniques in this section to expand your mastery, and let the artwork inspire your artistry.

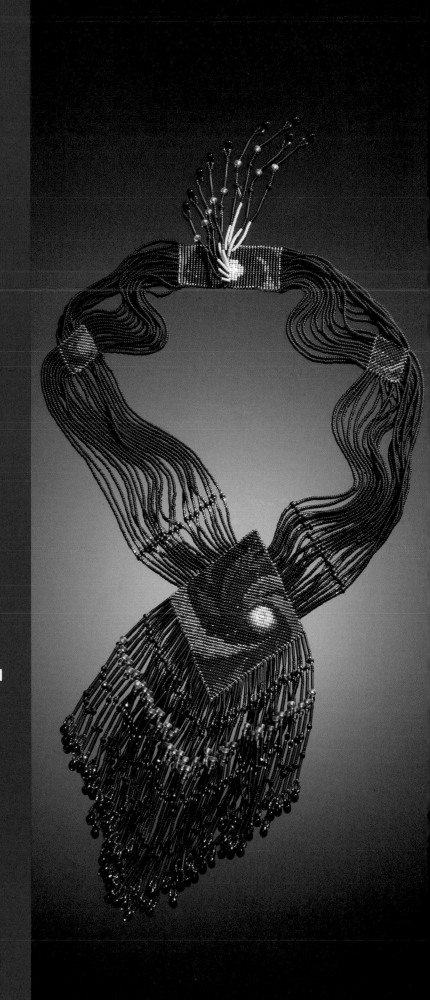

INSPIRATION

Add now passion to your artistry and mastery. Take all three into the realm of imagination. Let them brew and steep and rumble. From there you'll emerge with new vision, and your colors will be uniquely yours, singing your unique voice.

For centuries, the Aurora Borealis has astounded observers. This breathtaking phenomenon of color has inspired those who opened their hearts, minds, and senses. Rather than mentally noting the shades of color, they lingered in the mystery of it all.

When colors set your imagination on fire, allow yourself to do more than note them for later use. Linger in the mystery of your inspiration. If it is the Aurora that inspires you, think about how the colors move. Are they quick and pulsating, or sweeping and majestic? What is the quality of their light: luminous and sparkling, or dense and opaque? What are the nuances of color fluctuation? Do they change in intensity, value, or luminosity?

Allow your experience of color to move beyond your senses, into the realm of the imagination. If you could hear colors sing, what would they sound like? What of their texture? What would it feel like to trace your fingertips across them? If you could taste them, what would you taste? And how would they smell? How far into the colors can you go? What is it about these colors, their movement and life, that cause your soul to stir? What sparks your passion?

Imagination can infuse your work, making it more than a pretty combination of hues or a mere record of colors. With imagination, your work becomes expressive of you.

On the path of imaginative artistry, the journey is as valuable as the work that arises from it. A passion for living life in all its colors is an exhilarating one, and may just turn out to be your path.

A passion for color and movement is the driving force in all of Margie Deeb's creations. In "That Silver Ribbon of Road," three independent panels of color represent the past, present, and future, as well as the subconscious, unconscious, and conscious mind. That silver ribbon of road connects them all. Design by Margie Deeb; loomwork by Margie Deeb and Frieda Bates.

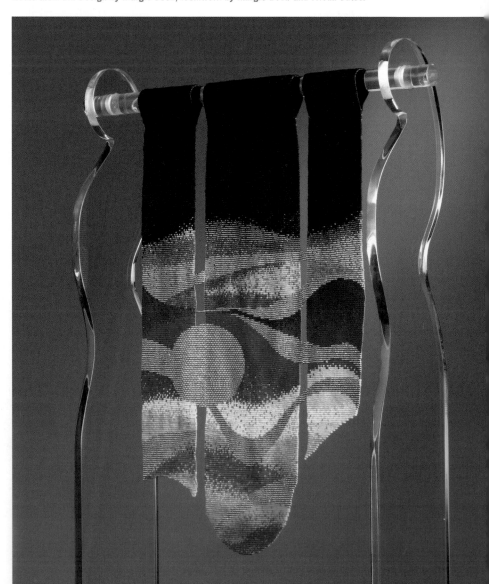

"Refugees" by Ann Tevepaugh Mitchell. Mitchell uses glass beads to create representational sculptures of visual brilliance and emotional intensity. Her concept of the figure includes the culture surrounding it as symbolized by landscape, clothing, and possessions. Peyote stitch worked dimensionally over forms.

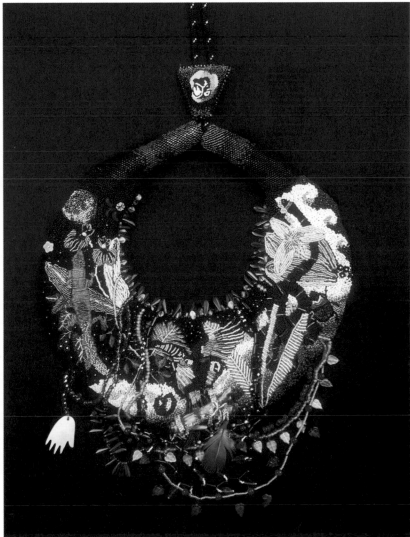

Rebecca Brown-Thompson's background in horticulture and scientific illustration are evident in her bead art, which often features living creatures. She is inspired by the life and beauty of the natural world. "Rainforest" began as an experiment in bead embroidery. A trip to Costa Rica inspired its finished color and design. A painting by Raymond Harris Ching, a prominent New Zealand wildlife artist, inspired the parrot on the trapezoid at the back of the neck. Necklace embroidered with antique glass beads.

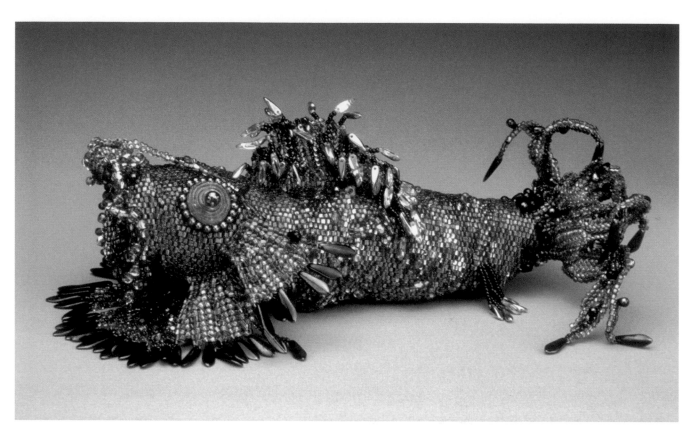

"Livyatan II" by Ina Golub. Ina Golub has devoted her art to the traditions of her Jewish faith. She works in many fiber mediums creating Torah mantles, prayer shawls, Ark curtains, tapestries, masks for Purim, and wrappers for ceremonial objects. Her work must function in a religious communal environment, so she chooses colors and designs for specific emotional purposes.

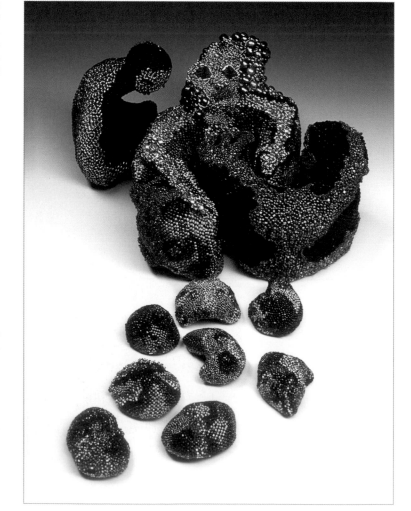

NanC Meinhardt created "Between a Rock and a Hard Place" as a tribute to a dear friend who died. Tender affection is woven into the gentle curves and undulating contours. The dark, hollow, and bent figure conveys the emptiness of loss. The friend was an artist, and the colors symbolically represent the spirit of her life and work. The colors of the central figures are those used exclusively in her friend's beadwork: gold, silver, and black tones. The other colors come from the art with which her friend surrounded herself. Off-loom bead weaving, freeform right-angle weave, applied beads.

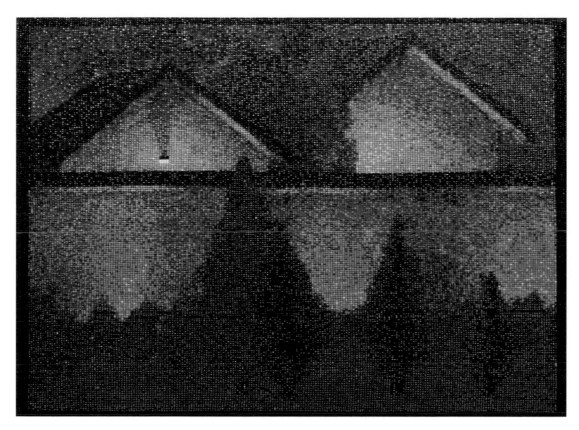

Laura Willits is fascinated by the magic of the world at night, and her imagery comes partly from frequent night wanderings. "At night logic seems less important than vision and sensation. Places and things illuminated by natural or man-made light are isolated from each other by the rich darkness between them. Colors and contrasts are intensified by that dark void. Night makes things seem possible that in the day are improbable." "Perimeter" was loom-woven with glass beads.

Karen Paust has funneled her botany, painting, sewing, knitting, and sculpting skills into her beadwork. Believing that beadwork can reflect how plant cells connect, she frequents gardens for inspiration. She used variations on peyote stitch to create "Lily and Lacewing."

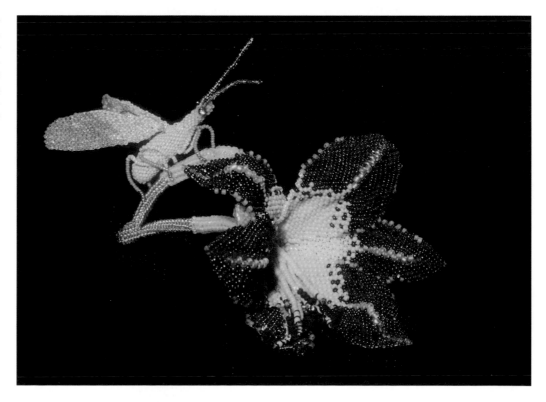

BEADING BASICS

The basics of stringing, finishing, and on- and off-loom weaving are offered to get you started on the projects in this book.

STRINGING

STRINGING WITH CORD

Stringing beads on cord makes luxurious, supple strands that are strong. Beading cord is made of either nylon or silk (best for pearls) and consists of several strands of finer cord twisted together.

Use flexible twisted wire needles with beading cord. Twisted needles have large eyes that collapse as you pull the cord through beads. They are available in several gauges, from light (for 2- to 3mm beads) to heavy (for 8mm and larger beads).

You can also create a self-needle on thicker cord by coating an inch of the end with instant glue.

You may double the cord or keep it as a single cord. If dou-

bling, begin with a piece about five times the length of the final necklace. If you are stringing with a single cord, use a length two and a half times longer. String the cord on the needle and pull it halfway through, so the needle is in the very center of the length of cord.

To attach clasps and finish strands, beading cord is knotted two or more times. The knots must be glued because cord is slippery and the knots may eventually untie. Unsightly knots must be hidden by using one of two kinds of knot covers: double-cup (clamshell) bead tips or single-cup bead tips. The technique for both is similar. Bead tips work best for light necklaces. Heavier necklaces are strongest when finished with cones (page 130).

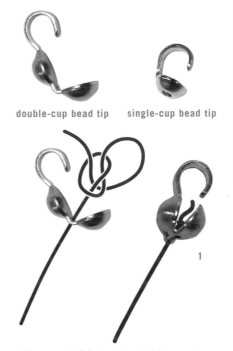

double-cup bead tip single-cup bead tip

1. To securely finish each end of the strand you'll need to cover your knots with a bead tip.

Slide the bead tip onto the cord and tie a knot. Slide the knot into the base of the cup. Tie a second knot and clip the end. Tie as many knots as needed, one on top of the other, to make a bundle of knots too large to be pulled through the bead tip.

Apply jeweler's cement to the knot to keep it secure.

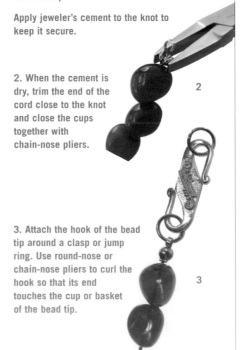

2. When the cement is dry, trim the end of the cord close to the knot and close the cups together with chain-nose pliers.

3. Attach the hook of the bead tip around a clasp or jump ring. Use round-nose or chain-nose pliers to curl the hook so that its end touches the cup or basket of the bead tip.

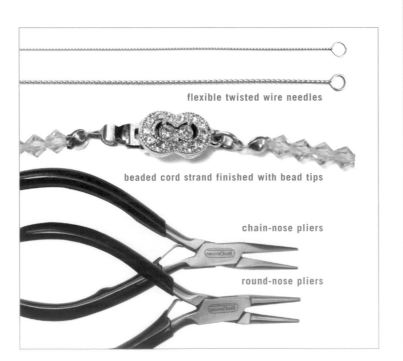

flexible twisted wire needles

beaded cord strand finished with bead tips

chain-nose pliers

round-nose pliers

STRINGING WITH WIRE

Stringing beads on wire ensures that beads with sharp-edged holes will not cut the strands. Beading wire has become so flexible that beautifully draping strands are possible.

Flexible beading wire is composed of several braided or twisted cables covered with smooth material, like plastic or nylon. It is very strong and is available in many weights. Soft Flex, Acculon, and Beadalon are reliable brands offering a range of colors.

Needles with large eyes can be used with the thinnest wire (.010 gauge), but needles are not necessary with most beading wire.

Because beading wire is often too thick to be knotted, crimp beads are used to attach clasps and finish jewelry. Crimp beads have large holes and are made of thin metal designed to be flattened over the beading wire to secure it.

For a professional look, crimp beads must closely match the wire size used for the strand, and should be sterling silver or gold (not base metal, which will eventually discolor).

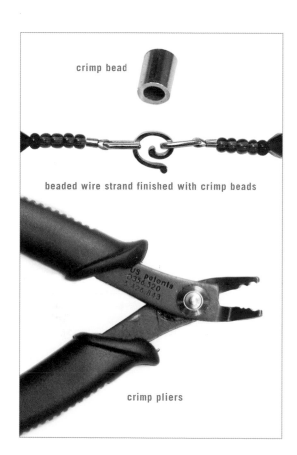

crimp bead

beaded wire strand finished with crimp beads

crimp pliers

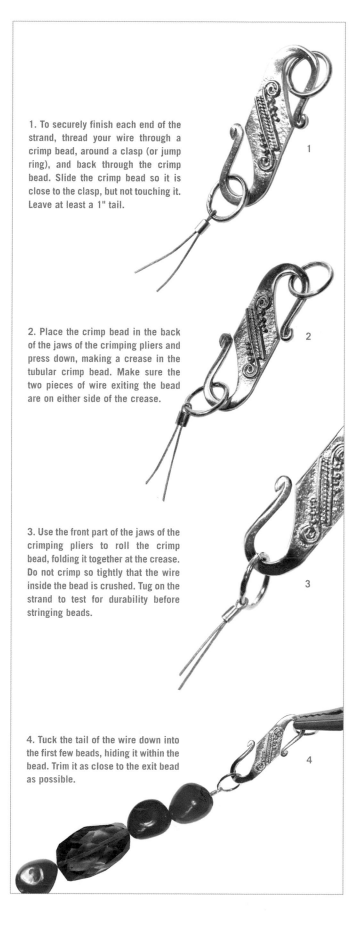

1. To securely finish each end of the strand, thread your wire through a crimp bead, around a clasp (or jump ring), and back through the crimp bead. Slide the crimp bead so it is close to the clasp, but not touching it. Leave at least a 1" tail.

2. Place the crimp bead in the back of the jaws of the crimping pliers and press down, making a crease in the tubular crimp bead. Make sure the two pieces of wire exiting the bead are on either side of the crease.

3. Use the front part of the jaws of the crimping pliers to roll the crimp bead, folding it together at the crease. Do not crimp so tightly that the wire inside the bead is crushed. Tug on the strand to test for durability before stringing beads.

4. Tuck the tail of the wire down into the first few beads, hiding it within the bead. Trim it as close to the exit bead as possible.

FINISHING WITH CONES

Cones are used to hide knots and make attractive clasp connections. Finish multi-strands and strands of large, chunky beads with cones. They add an elegant taper to the ends of the strands.

various types of cones

1. You'll need to make a looped structure upon which to secure the strands. Cut a 4" piece of 0.018- or 0.020-gauge round wire. Grasp it about 1" from the top with a pair of chain-nose pliers. Bend the top down at a right angle.

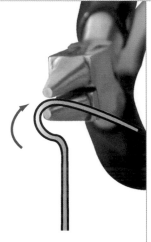

2. Just above the bend, grasp the wire with round-nose pliers. Wrap the wire in the direction opposite the bend, making a loop. Round-nose pliers enable you to form a round loop.

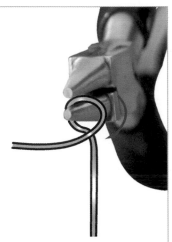

3. Pull the end of the wire in the same direction as the first bend.

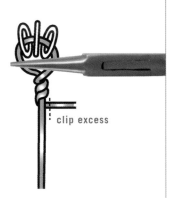

clip excess

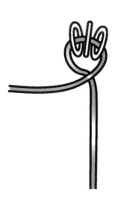

4. If you wish to use jump rings, split rings, or chains, they can be added while the loop is still open. In this example, three soldered jump rings have been added. Strands will later be attached to each jump ring.

5. Close the loop by wrapping the wire around itself (underneath the loop). Clamp flat across the loop with the round-nose pliers, while using the chain-nose pliers to wrap. Make sure your first wrap is as close to the loop as possible, and each subsequent wrap butts right up against the previous one. Two wraps are sufficient. Clip the excess wire as close to the wraps as possible.

Note: Before attaching strands, test the size of the loop and wraps. Slide the cone onto the wire, covering the loop and rings to make sure it fits properly. You may have to adjust the size of the loop or the number of wraps to make it fit properly.

6. If you are stringing with cord, as required in the "Vessel with Braided Strands" project (page 111), for example, this is the time to tie the bundle of cord tails to the wire loop.

Before you attach the bundle to the loop, tie all the cord tails together with two overhand knots.

Separate the tails in half so you have two bunches of cord. Take one bunch of cord and thread it through the loop from right to left. Take the other bunch and thread it through the loop from left to right.

Tie them together using two square knots. Seal the knots with jeweler's cement. Trim the cord ends 1/4" from the knot when the cement is dry.

7. If you are attaching your strands to jump rings, do so at this time.

8. Slide the cone over the wire loop to conceal everything but the strands.

9. Attach the finding to the wire by making another loop, repeating steps 1 through 5. Make the right-angle bend in the wire a distance of three wraps away from the top of the cone.

10. Be sure to snug the wraps tightly against both the wire and the top of the cone, so no parts slide around. Do the same thing for the other end of the strands.

multi-strands finished with cones

OFF-LOOM WEAVING

Peyote and brick stitch are the most popular of all off-loom stitches. They both position the beads in brick formation, that is, staggered rather than aligned straight (like loom weaving).

Weaving is best done with multifilament nylon thread. It is available either twisted or untwisted and comes in sizes 00 (the finest) to 0, A, B, D, and F, the heaviest. Beading needles are available in several sizes, with 10 being the largest and 16 the smallest.

PEYOTE STITCH (EVEN-COUNT)

1. Loop thread around bead 1 twice to keep it in place and use the "tail" to adjust tension as you work the first few rows. (For simplicity, the illustration shows only one loop.) Later you will remove this loop and weave its tail into the beadwork. Thread an even amount of beads onto the thread to begin your first two rows.

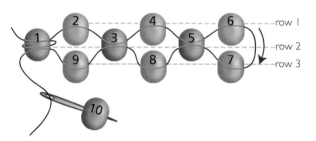

2. After picking up bead 7, pass needle through 5. Continue picking up a bead and passing the needle through a bead until you pass back through the first bead. Pull thread snug, so the beads touch each other.

You now have three rows and are ready to begin the fourth row.

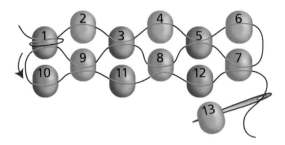

3. Continue each row as described in step 2. If your first two rows are loose or uneven, pull the tail of the thread you looped around bead 1 to tighten the tension.

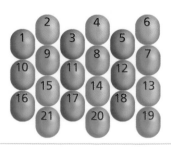

4. When all the weaving is complete, tie off your thread tails by weaving them into the beadwork in a circular path, hidden within the beads.

Your final weaving should look like this.

PEYOTE STITCH (ODD-COUNT)

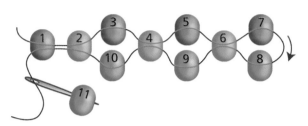

1. Begin with the loop as shown in step 1 of the even-count peyote. (For simplicity, the loop around the first bead is not shown in this diagram.)

Place an odd number of beads onto the thread to begin your first two rows. Thread all but the last bead of row 3 into place. Pass thread through beads 1 and 2. Put bead 11 on the thread.

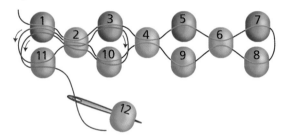

2. After you've passed back through beads 1 and 2 and picked up bead 11, you are going to make a figure-eight path with the thread to begin the fourth row. Pass thread through beads 2, 3, 10, 2, and 1, and then back through 11.

If your needle's final exit bead is number 11, and the beads on the left end are fit snugly together, you'll know your figure-eight path was successful. You won't have to do this fancy move again until you start a new project using the odd-count peyote.

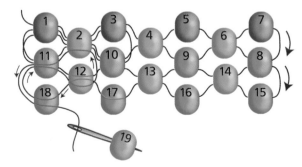

3. From here on out, each row that begins on the left has a more complex turn than the row beginning on the right. After picking up bead 18, pass the thread through beads 11, 12, 2, and 11, and back through 18 to begin the next row.

BRICK STITCH

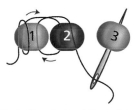

1. Notice how the beads in the brick stitch are rotated 90 degrees from their position in the peyote stitch. Begin with the loop as described in step 1 of the even-count peyote. Your first row will be a ladder of beads stitched side by side. The thread between the beads are the rungs to which you will stitch more beads.

From the top of bead 1, go down into bead 2, back up through 1, and back down into 2. For added security, circle up through 1 and down into 2 again before adding bead 3. (For simplicity, this is not shown in the illustration.)

4. Position beads 6 and 7 side by side atop the ladder. Pass the needle under the rung that is on top and between the last two beads of the first row, beads 4 and 5. Immediately pass the needle back up through bead 7. The outer bead of this row, bead 6, will not be hooked onto any ladder rungs.

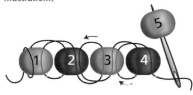

2. Following the thread path in the diagram, continue circling through the beads and stitching them together. After the needle passes through each bead, it goes backward through the previous bead, and then forward again. You are making a series of loops with your thread. Every other loop starts at the top, and every other loop starts at the bottom.

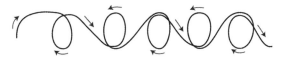

This diagram shows the pattern of movement you make with your thread. Make your first row as long as desired. (In these instructions the first row—the ladder—is five beads wide.)

5. Continue attaching beads to the ladder, looping your thread under the rungs. Begin a new row the same way you did in step 4. Notice that the outer bead of the second row, bead 11, is not hooked onto a rung, just like bead 6. The outer bead of every row will not be hooked onto a rung.

You may find it easier to flip your piece of beadwork over vertically each time you being a new row. If you do this, you'll be stitching each row in the same direction.

3. Add two beads to the thread to begin your second row. In this diagram, beads 6 and 7 have been added, and the needle will be passed under the top rung between beads 4 and 5. Beads 6 and 7 are the beginning of the second row.

6. When all the weaving is complete, tie off your thread tails by weaving them into the beadwork in a circular path, hidden within the beads.

Your final weaving should look like this. See how it resembles the peyote stitch rotated 90 degrees? Notice how every other row sticks half a bead width out to the left or the right, like rows of stacked bricks.

LOOM WEAVING

Loom weaving sandwiches warp threads with a weft thread. Warps, those long vertical threads attached to the loom, separate each column of beads.

BUILDING A LOOM

Looms can be purchased from bead and craft stores or on the Internet, or you can easily construct one yourself. A loom that can handle warps at least 36" long will be required to make split-loom neckpieces. Warps are the anchoring threads that run the length of the loom. The weft is the thread you string a needle and beads onto.

Construct the loom with two end boards nailed to a center board (1" by 8" stock works fine). Fasten a spring across the top as a warp separator.

String the warp threads onto your loom using nylon or silk thread. Some people prefer to use a slightly heavier warp thread than weft, though this is not necessary. Remember that the width of the finished piece will change depending on the size of thread used for warps.

For projects in which you will be taking the warps off and re-tying them back onto the loom, like some split-loom necklaces, use eyehooks on the end boards (figure 1). Make the warp threads at least 42" for split-loom necklaces. Tie groups of four to ten warp threads onto the hooks with two overhand knots (figure 2).

For projects that do not require taking off and re-tying warps, a cleat, which is available at hardware stores, can be used (figure 3).

This method uses one continuous warp thread rather than many single threads. Wrap your warp threads around the cleat on each end of the loom (figure 4). For bracelets and tapestries, a continuous warp thread is recommended. A continuous warp can be used just as easily with eyehooks (figure 5). String your warp threads onto the loom taut enough so there is a small but definite springy bounce when you push gently on them. They should not sag at all, nor should they be tightly pluckable. Take care to ensure that the tension is consistent among all the warps.

Depending on where your eyehooks or cleat are located, you may tighten the warps by sliding bead tube containers between the board and the warps, above where they are tied onto the loom (figure 6).

1. Eyehooks used to hold warp threads

3. Cleat used to hold warp threads

5. Continuous warp wrapped onto eyehooks

2. Single warps being tied in groups

4. Continuous warp wrapped onto cleat

6. Warps tightened with bead tubes

BASIC LOOM WEAVING

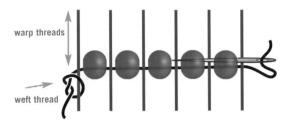

warp threads

weft thread

1. In these illustrations, the warp threads are orange, and the weft thread is black. Begin by tying your weft onto the leftmost warp with an overhand knot that you will eventually remove. Leave a tail at least 5" long to weave in and tie off later.

Position your weft thread under all the warps and upon it string enough beads for one row. Push the beads up in between the warps, so that each bead has a warp thread on its left and its right side. Weave back through each bead, passing your needle above the warps. The weft will sandwich the warp threads.

If you are left-handed, it may be easier to tie your thread on the rightmost warp, and work right to left.

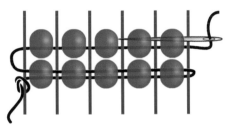

2. Working from bottom to top, your second row will be placed above the first. Before beginning your second row, be sure your weft thread is behind the warps. String your next row, push the beads up in between the warps and continue as you did in step 1. The hard part is over!

3. Tie off excess thread by wrapping it around warps, passing it through beads, and hiding it within beads. (The black weft has been changed to yellow so you can follow the tying off path.)

When you have finished weaving, use the method shown here to remove warps and tie them off. Follow the yellow thread path. When a path of at least one full "circle" has been made with the thread (two circles is more secure), clip the excess thread as close to the right side of the last bead as possible. The end of the excess thread will be hidden inside the bead.

If you are making fringe out of the warp thread (as on the bottom of split-loom necklaces), string your fringe beads onto your warp, add a stop bead, bring your needle back up through the fringe beads, and work the end of that warp into the beadwork as shown above.

DECREASING ROW WIDTH ON LEFT SIDE

When decreasing the width of your loomwork on the left side, the weft thread must find its way to the left of the bead that begins each row. In other words, it must be in the same left-side position it is for non-decreasing rows. A yellow bead begins each decreased row.

Follow the path of the weft thread, wrapping it around the warp to the left of the bead that begins each row.

INCREASING ROW WIDTH ON LEFT SIDE

To increase the width of your loomwork on the left, the weft thread must find its way to the left of the bead that begins each row. In other words, the weft thread must be in the same left-side position it is for non-increasing rows. A yellow bead begins each increased row.

Follow the path of the weft thread, wrapping it around the warp to the left of the bead that begins each row.

Decreasing and increasing on the right side is no different from straight weaving.

CONTRIBUTING ARTISTS

Jeanette Ahlgren, who began beading in 1976, is inspired by the tactile quality of the beads themselves and the challenge of pushing color to the limit. Jeanette was the featured artist in *Fiber Arts* magazine in February 1995, and the 2003 Victor Jacoby award recipient. Her wire-woven structures are in private and permanent museum collections nationally.

Frieda Bates is best known for her split-loom necklaces, namely the pottery designs featured in *The New Beadwork* (Harry N. Abrams, 1992). She lives her life surrounded by the beauty of New Mexico and an enormous bead and bead art collection. She began beading in 1963, and has a driving passion for making gorgeous art out of specks of color. Her work has appeared in numerous magazines, books, and galleries. *www.pvtnetworks.net/~fbates*

Janet Baty started creating doll clothes at age five, later making her own wardrobe and producing stuffed animals. Janet has been beading since 1997 and teaches locally. Her work has been published in *Beadwork* magazine and *Myths & Folktales: Selections from the 2nd International Miyuki Delica Challenge* (Caravan Beads, 2000).

Linda Breyer lives in London, England. Previously a graphic and display artist, she has been working exclusively with beads since 1994, moving further into sculptural bead art. Color, texture, shape, and organic forms have a great influence on her designs. Her work has been published in several UK magazines. *www.geocities.com/mortsbeads*

Rebecca Brown-Thompson's beadwork is influenced by her background in horticulture and scientific illustration. She received Best in Show in *Bead & Button's* 2001 exhibition. She currently lives in New Zealand, where she teaches and exhibits her work. *www.rbrown.co.nz*

Peter Ciesla emigrated from Poland to America in 1991. He launched Creative Apparel Design, now known as Bazyli Studio, in 1993. Peter offers custom couture, art-to-wear jewelry, and accessories. He is the recipient of numerous awards, most recently a finalist in the 2003 Saul Bell Design Award competition.

Cheryl Cobern-Browne gave up a nursing career in 1990 to move into the field of beadwork. She has since explored its many facets: designing, teaching, lecturing, owning a bead shop, directorship of the Bead Museum in Arizona. Cheryl now leads international BEADVENTURE workshops. *www.beadventure.info*

Jeannette Cook has worked in the medium since 1968 and is a nationally recognized bead artist and instructor. She has lectured and taught techniques at bead stores, societies, and national shows. She co-wrote and self-published six popular beading books. Her work has been featured in leading bead magazines. *www.BeadyEyedWomen.com*

Suzanne Cooper began beading in 1984 and has authored many bead and stained glass books. The Southwest is a constant source of inspiration in her art. She teaches privately, at bead stores, and at bead shows. Her art background includes painting and jewelry fabrication. *www.suzannecooper.com*

SaraBeth Cullinan has always been obsessed with color. With a degree in Veternarian Technology and an extensive background in dance, SaraBeth combines her love of color, nature, and movement in her art. She has authored several articles for both *Beadwork* and *Bead & Button* magazines.

Wendy Ellsworth is a seed bead artist living in Bucks County, Pennsylvania. Beading since 1970, her signature "SeaForms" can be found in numerous private collections and museums. Her beadwork has also been featured in many books and periodicals as well as in select gallery exhibitions. She teaches nationally and internationally and received a 2003 Fellowship from the Pennsylvania Council on the Arts. *www.ellsworthstudios.com*

Margie Deeb is an illustrator and designer for print and the Web. She is also a talented painter, author, musician, and bead artist. Her work has appeared in magazines and books. She has self-published a loom technique book, *Out On A Loom*. She teaches color workshops across the country. *www.margiedeeb.com*

Jennifer Fain began beading as a teenager. Inspired by a pair of earrings she could not afford to buy, she bought a loom and made them herself. Her work has appeared in *Myths & Folktales: Selections from the 2nd International Miyuki Delica Challenge*. She teaches locally and her work is featured in various stores and boutiques.

Margo C. Field retired from a career in pharmacy and opened Poppy Field Bead Company in Albuquerque, New Mexico. Her work has been featured in *BeadWork* magazine, and she has received numerous awards. Margo's work is inspired by nature and her passion for flowers and foliage. She teaches workshops across the U.S. *www.poppyfield.com*

Diane Fitzgerald is best known for her award-winning "Ginkgo Leaf Necklace," which incorporates smooth gradations of color within a fan-shaped form. Her use of color is based on formal study as well as experimentation and observation. She is the author of

several books and articles about beadwork and teaches internationally. *www.dianefitzgerald.com*

Ina Golub began developing a series of beaded ceremonial forms after visiting the Israel Museum in 1994. Fascinated with the way beads capture light, she devotes more and more time to sculptural beadwork. In 1998, she won the Spertus Judaica Prize for a beaded spice container. Her beadwork is owned by the Jewish Museum, New York, Yeshiva University Museum, and many private collectors. *www.inagolub.com*

Barbara L. Grainger, an internationally recognized bead artist, instructor, and designer, has authored three beadwork books and several magazine articles. Her work appears in national shows, exhibits, and publications. She specializes in innovative beadwork techniques and travels the country teaching workshops and giving lectures.

Anne Hawley comes from a family of artists and she selected beads as her medium in 1990. Her Hillsinger Fine Hand Beadwork Web site, dating to 1995, is a pioneer of Internet beadwork. Anne specializes in peyote-stitched cylinders and portrait handbags. Her world travels and spiritual pursuits provide inspiration for her designs. *rogue.northwest.com/~ahawley/home.html*

Valerie Hector is a beadwork jeweler who has been exhibiting at juried shows since 1988. Her work has been widely published. For inspiration Valerie looks to the beading traditions of other cultures, such as those of Asia and Africa. Valerie is the author of *The Art of Beadwork* (Watson-Guptill).

Mary Hicklin, a lifelong beader, started Virgo Moon in 1991 as a service to those who, like herself, believe you can't wear too many beads. Awards include recognition by the San Diego Reader as "Best Jewelry Designer, 2003." She opened her Web store in 2001. *www.virgomoon.com*

Mel Jonassen always knew she would be an artist, but experiments with traditional media proved unsatisfying. In 1988, Mel discovered beads; jewelry ensued, art followed. Her beadwork has been featured in the book *Beaded Embellishments* (Interweave Press, 2002) and beading magazines, and accepted in national juried exhibitions. *www.beadmeistermel.com*

Karen Lewis discovered the medium of polymer clay in the late 1980s and her life hasn't been the same since. She has produced five instructional videos and her work appears in trade magazines, books, museum collections, and is shown around the world. She was a featured guest artist on The Learning Channel's program *Simply Style* and on the Smithsonian's Artrain in 1998. *www.klewexpressions.com*

Liz Manfredini is an internationally recognized bead artist who has exhibited in several traveling shows, major galleries, and museums. Liz has always been in love with color. Her work is characterized by repeating patterns, defined shapes, and whimsical subjects. Two pieces of her work have been included in the Corning Museum of Glass. *www.manfredinidesign.com*

NanC Meinhardt, an accomplished artist, exhibits her work and teaches internationally. She has been published in eighteen books and magazines, including *The Art & Elegance of Beadweaving* (Lark Books, 2002) and *The Art of Beadwork*. NanC uses beads as her chosen medium to make art and as a vehicle to help others explore the creative process. NanC resides in Highland Park, Illinois. *www.nancmeinhardt.com*

Jennie Might lives in central Texas has been beading since 1997. She likes to explore many styles of beading and needlework and enjoys combining mediums. Her love of beading also emerges in her business of beadwork design and self-published beading pattern books. *www.blackgiraffe.com*

Ann Tevepaugh Mitchell is a classically trained artist and learned dimensional off-loom beadweaving from Joyce Scott. Her work has been shown in many exhibitions, magazines, and books, including *The Best in Contemporary Beadwork* (Interweave Press, 2000).

Kristy Nijenkamp has been fascinated with melting glass since her childhood glimpse of glassblowing in Venice. She sells her work at private and artisan shows. She is on the board of the Atlanta Southern Flames, a chapter of the International Society of Glass Beadmakers. *gezellig@prodigy.net*

Jacque' Owens began beading as a hobby and it soon became a full-time career. She now teaches beading all over the country and in her native city of Atlanta. Her work has been published in the first two Caravan challenge books. She has self-published two books, *The Art of Beadweaving* and *The Art of Beaded Beads*. *www.jacqueowensbeadart.com*

Karen Paust has been fascinated by the spectacular interaction of light with tiny glass beads since 1988. Completely self taught, she creates wearable art, sculptures, and mobiles using the smallest beads she can obtain.

Don Pierce first started beadweaving in 1987. His work has appeared in several books and publications, including *Ornament, American Craft, Beadwork* and *Bead & Button* magazines. A nationally recognized teacher, he has authored two books, *Beading on a Loom* (Interweave Press, 1999) and the self-published

Designs for Beading on a Loom. He designed, and now manufactures and markets, Larry the Loom Mark IV, The Master Loom. *www.donpierce.com*

Kimberley Price was inspired by the work of Joyce Scott in the early 1990s. Since 1997, her jewelry design turned primarily to beadwork with her passion being beaded sculptures. Kim's style has been influenced by the whimsy of her parents' extensive folk art collection, and life with her young children. *www.kimberleyprice.com*

Madelyn Ricks had been a full-time artist making large ceramic pieces since 1980. In 1997 she decided she needed to scale down. She discovered beadwork and became fascinated with the possibilities of peyote stitch. Although the medium has changed, there is still a love of color and Art Deco–inspired patterns in her contemporary beadwork. *madelyn@gulfaccess.net*

Elizabeth Ann Scarborough has been beading off and on since she was a child. Scarborough draws her inspiration from folk art and from the colors and textures of the materials themselves. She had a one-woman show at Wynwoods Gallery and Bead Studio. She is the author of the self-published *Beadtime Stories,* a pattern book. *www.olympus.net/personal/scarboro*

Mary Tafoya's first art experiences involved the weavers, whittlers, and potters of Kentucky. She moved to New Mexico in 1977 and received her B.A. in Fine Arts there in 1983. Mary has been a frequent contributor to *Beadwork* magazine since 1999. Her artwork has appeared in numerous books and national exhibitions. Mary is a member of the New Mexico Bead Society and Rainbow Artists, a New Mexico–based women's art collective. *www.flash.net/~mjtafoya*

Nancy Tobey has been working in glass since 1996. She is known for her experimentation with borosili- cate colors. She uses layering techniques and the reduction process inherently found in colored boro to create beads with a sculptural quality, depth, and luminosity. Nancy shares her love of handmade glass through teaching and exhibiting her work in galleries in the Northeast. *www.nancytobey.com*

Alice Walker has owned Beadazzles, a beadstore in Atlanta, for 19 years. She explores countless designs and color combinations on a daily basis with her customers. Two hints she gives her customers: add an unusual color for shock value, and, when designing a piece, try the opposite of what you think will work. These tips can lead to exciting discoveries and interesting jewelry.

Carol Wilcox Wells is an artist, teacher, and author. Her two books *Creative Bead Weaving* (Lark Books, 1996) and *The Art & Elegance of Beadweaving* (Lark Books, 2002) are among the top sellers in the field. Her work has been published in *Ornament, Lapidary Journal, Beadwork,* and *Bead & Button* magazines and numerous books. Carol travels across the country teaching others the off-loom weaving techniques she loves. She lives in North Carolina.

Laura Willits earned degrees in printmaking, but since the early 1990s, her main medium has been glass seed beads. Her imagery comes partly from frequent night wanderings, and partly from inside her head. *www.laurawillits.com.*

Carol Zilliacus is a fine artist with an unusual slant on polymer clay. Her original "Tapestry Techniques," which take clay into the realm of fine art, allow her to design sheets of polymer clay with many blended colors that have a variety of value and hue. An award-winning Maryland artist whose work is exhibited nationally in American Craft Council shows as well as Washington, D.C., area galleries, she has been featured in newspaper articles, art books, videos, and TV programs. *www.studiogallerydc.com*

Peyote-stitched vessel by Cheryl Cobern-Browne.

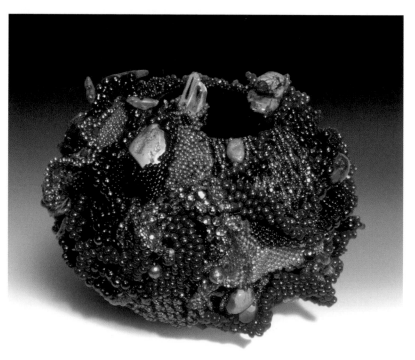

PHOTO CREDITS

Jeanette Ahlgren: 16, 40, 48 (top), 58 (top)

Jerry Anthony: 49 (top), 51 (bottom), 65

Philip Arny: 57, 127 (top)

Pat Berrett: 58 (bottom)

T. E. Crowley: 68, 127 (bottom)

Margie Deeb: 80 (bottom), 97

David Ellsworth: 45 (bottom), 52 (top), 63, 86 (bottom)

Diane Fitzgerald: 42 (top)

Ralph Gabriner: 20 (top), 66, 100 (left and right)

Steve Gyurina: 32

John Haigwood: 2, 10, 17, 19, 22, 27, 30, 34, 45 (top), 54, 64, 67, 71, 72, 75, 78 (top and bottom), 80 (top), 81 (top and bottom), 84 (bottom), 87, 88, 90 (top), 93, 94, 98, 101, 105, 108 (left and right), 110, 114, 116 (right), 118, 121, 124

Melinda Holcen: 103

Martin D. Kilmer: 8 (top)

Joe Manfredini: 18, 21, 23, 90 (bottom)

Neil Moore: (all beaded strips throughout book), front cover, 5, 8 (bottom), 11, 20 (bottom), 24, 25, 26, 28, 29, 31, 33, 36, 37, 38, 39 (top and bottom), 46, 47 (top and bottom), 48 (bottom), 49 (bottom), 50 (top and bottom), 51 (top), 52 (bottom), 53 (top), 60, 61, 62, 69, 70, 73, 84 (top), 92 (top and bottom), 96, 99, 102, 112 (right), 116 (left), 122, 123, 141

Lloyd Parks: 55, 125 (bottom)

Dean Powell: 112 (left), 125 (top), 139

Hap Sakwa: 9

Larry Sanders: 44 (top and bottom)

Taylor Photo: 126 (top)

Jeff Tippett: 1, 53 (bottom)

Don Vallereux: 35

Tom Van Eyende: 126 (bottom)

"Evening" by Ann Tevepaugh Mitchell.

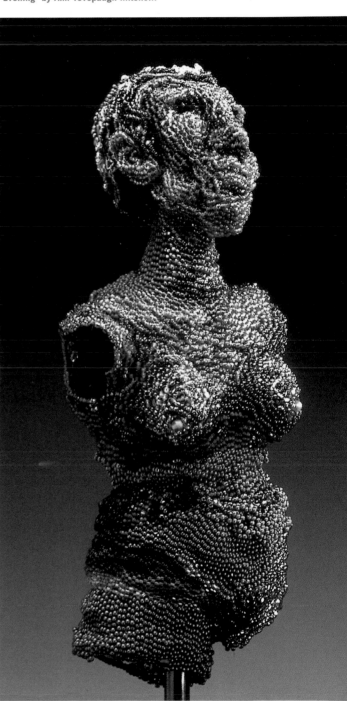

SUPPLIES & RESOURCES

PROJECT SUPPLIES

**Fused glass pendants
(pages 20 and 80)**
Dallas Designs
3357 W. 97th Ave. #26
Westminster, CO 80031-7947
vilmadallas@wmconnect.com

Zephyr Glass Pendant (page 71)
11o Semi-matte metallic irides-
cent Blueberry seed beads
(F460LJM11): Stormcloud
Trading (see below)
4mm Peacock Blue Swarovski
crystal bicones: Beyond
Beadery (see below)
For this project I used a beautiful
centerpiece bead made by John
and Mary Curtis of Elkhart
Lake, Wisconsin. Comparable
handmade vertical centerpiece
beads are available from:
Nancy Tobey
(www.nancytobey.com)
Ghostcow Glassworks
(www.ghostcow.com)
Heirlooms in Glass
(www.heirloomsinglass.com)
Heart Bead Art Glass
(www.heartbead.com)
Kennebunkport Bead Art
(www.kportbeadart.com)
4-ring silver clasp and Softflex
beading wire: Rio Grande (see
below)

Ring of Hearts Necklace (page 79)
Fiber-optic glass hearts and 4mm
rounds:
Out On A Whim (see below)
Shipwreck Beads (see below)
Crystal bicones, fire-polished
spacers, 3- and 4mm rounds:
Beyond Beadery (see below)
20—22mm glass rings: Ghostcow
Glassworks
(www.ghostcow.com)

Multi-Strand Twisted Necklace (page 87)
11o 22kt-gold-plated seed beads:
Out On A Whim (see below)
Vermeil clasp: Rishashy (see
below)

Spring Candy Bracelet (page 97)
Comparable dichroic lampworked
beads are available from:
Paula Radke
(www.paularadke.com)
Sara Creekmore Glass, Inc.
(www.creekmore-glass.com)

Dynamic Single-Strand Necklace (page 101)
Comparable lampworked beads are
available from beading stores
and from:
Fire Mountain Gems (see
below)
Susan Barnes's Fire Goddess
Beads (www.firegoddess.com)
Mother Beads (www.mother-
beads.com)
Kennebunkport Bead Art
(www.kportbeadart.com)

Fetish & Tassel Pendant (page 103)
Carved stone fetish with offering
bundle: Sedonawolf
(www.sedonawolf.com)
Heishi beads: Mystique Beads
(www.mystiquebeads.com)
Heishi beads, horn rings, and hair-
pipe: Fire Mountain Gems (see
below)

Mandira Necklace or Mini-tapestry (page 106)
Fluted bell caps: Fire Mountain
Gems (see below)

Vessel with Braided Strands (page 111)
Centerpiece vessel bead: Stevi Belle
(www.belleisimoglass.com)
Ruby in zoisite: Fire Mountain
Gems (see below)

Fire Dragon Purse (page 113)
Gold foil beads: Alexander-Lee
(www.venetianbeads.com)
Blown-glass bubble beads: The
Lady in Venice
(www.patiwalton.com)

Angel Wheels Necklace (page 119)
Nikia Angel's Sparkly Wheel kits:
Buy the Kit
(www.buythekit.com)
Swarovski crystals:
Beyond Beadery (see below)
Copper Coyote Beads (see below)
Arizona Bead Company
(www.arizonabeadcompany.com)

ONLINE & MAIL ORDER SOURCES

Astral Beads
www.astralbeads.com
*Assorted beads and findings, semi-
precious stone beads*

Beadbox, Inc.
800-BEADBOX
www.beadbox.com
*Delicas and seed beads, various-
sized beads and findings, semi-
precious stone beads, beading tools,
books and videos*

Beadcats
www.beadcats.com
*Delicas and seed beads, various-
sized beads and findings*

Beyond Beadery
www.beyondbeadery.com
*Delicas and seed beads, various-
sized beads and findings, beading
tools, books and videos*

Caravan Beads
800-230-8941
www.caravanbeads.com
*Delicas and seed beads, various-
sized beads and findings*

Copper Coyote Beads
www.coppercoyote.com
Books and videos

Fire Mountain Gems
800-355-2137
www.firemountaingems.com
*Wide variety of beads, including
Delicas and seed beads, findings,
beading tools, books and videos*

General Bead
415-621-8187
www.genbead.com
*Delicas and seed beads, semi-precious
stone beads*

Out On A Whim
www.whimbeads.com
*Delicas and seed beads, various-
sized beads and findings, beading
tools, books and videos*

Pacific Silverworks
www.pacificsilverworks.com/
Unusual findings and clasps

Rio Grande
800-545-6566
www.riogrande.com
Wide variety of beads, including Delicas and seed beads, findings, beading tools, books and videos

Rishashy
800-517-3311
www.rishashay.com
Silver and vermeil findings and clasps

Scottsdale Bead Supply
www.scottsdalebead.com
Unusual findings and clasps

Shipwreck Beads
360-754-2323
www.shipwreck-beads.com
Wide variety of beads, including Delicas and seed beads, beading tools, books and videos

Star's Clasps
www.starsclasps.com
Unusual findings and clasps

Stormcloud Trading
www.beadstorm.com
Delicas and seed beads

Thai Gem
www.thaigem.com
Semi-precious stone beads

MAGAZINES & PERIODICALS

Bead & Button and BeadStyle
Kalmbach Publishing Co.
P.O. Box 1612
Waukesha, WI 53187
www.beadandbutton.com
www.beadstylemag.com

Beadwork
Interweave Press, Inc.
210 E. Fourth St.
Loveland, CO 80537-5655
970-669-7672
www.interweave.com

Belle Armoire Magazine
22992 Mill Creek, Suite B
Laguna Hills, CA 92653
www.bellearmoire.com

Fiber Arts Magazine
67 Broadway
Asheville, NC 28801
www.fiberartsmagazine.com

Lapidary Journal and Step by Step Beads
Primedia Magazines
60 Chestnut Ave., Suite 201
Devon, PA 19333-1312
www.lapidaryjournal.com

Ornament
Ornament, Inc.
P.O. Box 2349
San Marcos, CA 92079-2349

The Surface Design Journal
Surface Design Association
P.O. Box 360
Sebastopool, CA 95473-0360
www.surfacedesign.org

ONLINE RESOURCES

About.com Beadwork
www.beadwork.about.com

Bead Bugle
www.nfobase.com/index.htm

FiberArts Online
www.fiberartsonline.com

Southern Flames Beadmakers
www.southernflames.org

The Bead Site
www.thebeadsite.com

Frog necklace by Jacque' Owens.

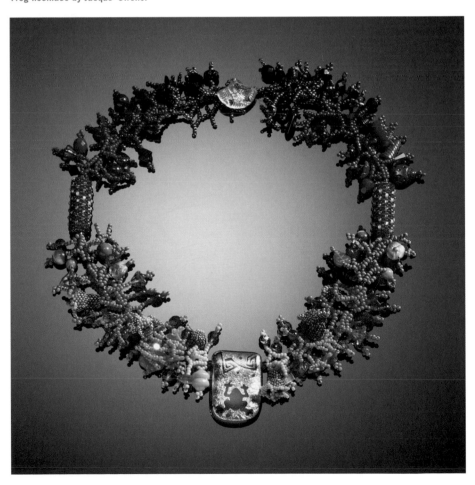

NOTES & SOURCES

Color Wheels (pages 12—14)
"Color theory has progressed throughout history...seven dominant bands of color."
Cary Wolinsky, "The Quest for Color," *National Geographic,* July 1999, p.74 (hereafter cited as "Quest for Color").

"In the late 1700s...white light."
Hillary Page, *Color Right from the Start* (New York: Watson-Guptill Publications, 1994), p. 15 (hereafter cited as *Color Right from the Start*).

"The mixing of cyan...the artist's wheel."
Herbert E. Ives was the first on record to suggest a twelve-color system based on cyan, magenta, and yellow as primaries. Artist and author Nita Leland in *Exploring Color* (Cincinnati, Ohio: North Light Books, 1998) refers to this as an alternate palette for painters. Jim Ames provides a thorough exploration of these primaries from a painter's vantage point in *Color Theory Made Easy* (New York: Watson-Guptill, 1996). Faber Birren was a staunch supporter of the cyan, magenta, yellow primaries as being capable of forming "a tolerably good spectrum of pure hues, but not an ideal one by any means." *Principles of Color* (Atglen, Pennsylvania: Schiffer Publishing, 1987), p. 26 (hereafter cited as *Principles of Color*).

"As art historian Faber Birren wrote, 'The facility...his fancy.'"
Faber Birren, *Creative Color* (Atglen, Pennsylvania: Schiffer Publishing, 1987), p. 10.

Yellow (page 16)
"In nearly all cultures...divine power."
Augustine Hope and Margaret Walch, *The Color Compendium* (New York: Van Nostrand Reinhold, 1990), p. 282 (hereafter cited as *Color Compendium*).

"In ancient China...yellow."
Ibid., p. 57.

"Yellow and gold...light."
Ibid., p. 282.

"Yellow is the brightest and most visible color, and the first the human eye notices."
Ibid., p. 318.
Color Right from the Start, p. 64.

"In its full saturation...more clearly."
Suzy Chiazzari, *The Complete Book of Color* (Great Britain: Element Books Limited, 1998), p. 45 (hereafter cited as *Complete Book of Color*).

"Vincent van Gogh felt that yellow was 'capable of charming God.'"
Leatrice Eiseman, *Colors for Your Every Mood* (Sterling, Virginia: Capital Books, Inc., 1998), p. 45. (herefter cited as *Colors for Your Every Mood*).

"Duller tones...yellow robes."
Ibid., p. 46.
Color Compendium, p. 282.

Orange (page 18)
"Psychotherapist and author Ambika Wauters describes it as 'a laughing color...fun.'"
Ambika Wauters, *Homeopathic Color Remedies* (Freedom, California: The Crossing Press, 1999), p. 87 (hereafter cited as *Homeopathic Color Remedies*).

"Orange is a food color...digestion."
Colors for Your Every Mood, p. 53.

"Earthy orange...desire."
Complete Book of Color, p. 16.

"Featured in erotic art...sexual slang."
Colors for Your Every Mood, p. 52.

"Orange's vigor...orange."
Homeopathic Color Remedies, p. 88.

"In ancient China orange symbolized life's joys..."
Rhonda Kennedy, "Feng Shui: The Ancient Art of Design and Placement," *Alternatives Magazine* (Issue #2, Summer 1997).

"It is used today...antidepressant."
Homeopathic Color Remedies, p. 87.
Charles Klotsche, *Color Medicine* (Sedona, Arizona: Light Technology Publishing), p. 53.

"In her book *Color Harmony 2,* Bride Whelan writes, 'Orange...price.'"
Bride M. Whelan, *Color Harmony 2* (Cincinnati, Ohio: Rockport Publishers, Inc., 1994), p. 46.
Dr. Morton Walker, *The Power of Color* (New York: Avery Publishing Group, 1991), p. 51. Walker explains that one of the physiologic effects of orange is that of an... increased appetite.

Red (page 20)
"Ruby, garnet...tissue."
Complete Book of Color, p. 242.

Magenta (page 22)
"The Victorians reveled...fuchsia."
François Delamare and Bernard Guineau, *Colors: The Story of Dyes and Pigments (New York:* Harry N. Abrams, Inc., 2000), p. 98 (hereafter cited as *Story of Dyes and Pigments*).

"In their book...'was associated...Persia.' The texts tell us of its 'irresistible...death.'"
Story of Dyes and Pigments, p. 35.

Blue & Cyan (page 26)
"The color of the heavens...most cultures."
Colors for Your Every Mood, p. 60.

"It symbolized...in India."
Ibid., p. 64.

"In Christian art...Mary's robe."
"Quest for Color," p.73.
The Color Compendium, p. 281.

"Ultramarine blue...lapis lazuli."
Philip Ball, *Bright Earth: Art and the Invention of Color* (New York: Farrar, Straus and Giroux, 2002), p. 236.

"Darkened, dull blues...loneliness."
Wassily Kandinsky, *Concerning the Spiritual in Art*, trans. M.T.H. Sadler (New York: Dover, 1977), p. 38.

"Research shows...anyone."
Colors for Your Every Mood, p. 76.

Green (page 28)
"Green has become...surgery."
Betty Wood, *The Healing Power of Color* (Rochester, Vermont: Destiny Books, 1984), p. 32.

"Studies have proven...houseplants."
Jill Morton, *Color Matters*, http://www.colormatters.com/factarch-2001.html (accessed July 23, 2003).

Intensity (page 43)
"The Birren Color Equation ...tints."
Principles of Color, p. 47.

Temperature (page 45)
"Temperature contrast...stables."
Johannes Itten, *The Elements of Color*, ed. Faber Birren, trans. Ernst Van Hagen (New York: John Wiley & Sons, Inc, 1970), p. 45 (hereafter cited as *Elements of Color*).

Complementary Relationships (page 46)
"In *The Elements of Color*, Johannes Itten writes of complements, 'Two such colors...water.'"
Elements of Color, p. 49.

"Complementary relationships...achieved."
Ibid.

Dominance (page 52)
"According to Johannes Itten, 'emphasizing...character.'"
Elements of Color, p. 34.

Proportion & Area of Extension (page 53)
"Johannes Itten explains: 'Contrast of extension...extent.'"
Elements of Color, p. 59.

Personal Color Analysis (page 59)
"In his book *The Art of Color*, Itten...[of people with certain colorings]."
Johannes Itten, *The Art of Color*, trans. Ernst van Haagen (New York: John Wiley & Sons, Inc., 2002), p. 25 (hereafter cited as *Art of Color*).

"Color expert Suzanne Caygill...overlapping. 'In discovering...others.'"
Suzanne Caygill, *Color: The Essence of You* (Millbrae, California: Celestial Arts, 1980). p. 3.

"The study of nature's colors...'objective rules of general validity.'"
Art of Color, p. 30.

Tints (page 92)
"After the drab, sober, war years...Americans."
Color Compendium, p. 302.

"These pastels...automobiles."
Margaret Walch and Augustine Hope, *Living Colors: The Definitive Guide to Color Palettes Through the Ages* (San Francisco: Chronicle Books, 1995), p. 108 (hereafter cited as *Living Colors*).

Emotional & Symbolic Color Schemes (page 99)
"Symbolic meanings...'Our cultural backgrounds...environment...'"
Leatrice Eiseman, "The Many Moods of Color," Pantone, http://www.pantone.com/ (accessed February 23, 2003).

Natural (page 102)
"Examples of color schemes... Paleolithic period..."
Story of Dyes and Pigments, p. 16.

Clashing (page 114)
"Traditionally, 'clash'...sixties..."
Color Compendium, p. 303.

"Peter Max...color."
Living Colors, p. 111.

FURTHER READING

Albers, Josef. *Interaction of Color*. Westford, Massachusetts: Yale University, 1971.

Ames, Jim. *Color Theory Made Easy*. New York: Watson-Guptill Publications, 1996.

Cabarga, Leslie. *The Designer's Guide to Color Combinations*. Cincinnati: North Light Books, 1998.

Cabarga, Leslie. *The Designer's Guide to Global Color*. Cincinnati: HOW Design Books, 2001.

Cooper, Mimi with Matthews, Arlene. *ColorSmart: How to Use Color to Enhance Your Business and Personal Life*. New York: Pocket Books, 2000.

Finlay, Victoria. *Color: A Natural History of the Paintbox*. New York: Ballantine Books, 2003.

Gage, John. *Color and Culture*. Berkeley and Los Angeles: University of California Press, 1993.

Kennett, Frances. *Ethnic Dress*. Great Britain: Reed International Books Limited, 1995.

Kobayashi, Shigenobu. *A Book of Colors*. Tokyo: Kondasha International Ltd., 1984.

Kobayashi, Shigenobu. *Color Image Scale*. Trans. Louella Matsunaga. Tokyo: Kondasha International Ltd., 1990.

Kobayashi, Shigenobu. *Colorist*. Trans. Keichi Ogata and Leza Lowitz. Tokyo: Kondasha International Ltd., 1998.

LeClair, Charles. *Color in Contemporary Painting*. New York: Watson-Guptill, 1991.

Leland, Nita. *Exploring Color*. Cincinnati: North Light Books, 1998.

Owen, Jones. *The Grammar of Ornament*. (First published in London, 1856) New York: DK Publishing, 2001.

Quiller, Stephen. *Color Choices*. New York: Watson-Guptill, 1989.

INDEX